D1537343

2000 BIENNIAL EXHIBITION

WHITNEY

2000 Biennial Exhibition

Maxwell L. Anderson, Michael Auping, Valerie Cassel, Hugh M. Davies,
Jane Farver, Andrea Miller-Keller, Lawrence R. Rinder

Whitney Museum of American Art, New York
Distributed by Harry N. Abrams, Inc., New York

BIENNIAL

N
6512
.W54
2000

This book was published on the occasion of the
"2000 Biennial Exhibition" at the Whitney Museum of American Art,
New York, March 23–June 4, 2000.

Significant support has been provided through an endowment
established by Emily Fisher Landau and Leonard A. Lauder.

Additional funding has been provided by the National Committee of
the Whitney Museum of American Art, the Whitney Contemporaries,
Melva Bucksbaum, The Greenwall Foundation, France Telecom
North America, and Reuters America.

Research for Museum publications is supported by an endowment
established by The Andrew W. Mellon Foundation and other generous
donors.

A portion of the proceeds from the sale of this book benefits the
Whitney Museum of American Art and its programs.

Cover: Doug Aitken. Still from *Electric Earth*, 1999

ISBN 0-87427-123-x (Whitney)
ISBN 0-8109-6829-0 (Abrams)
ISSN 1043-3260 (series number)

© 2000 Whitney Museum of American Art
945 Madison Avenue at 75th Street
New York, NY 10021
www.whitney.org

All rights reserved. No part of this publication may be reproduced or
transmitted in any form or by any means, electronic or mechanical,
including photocopy, recording or any other information storage and
retrieval system, or otherwise without written permission from the
Whitney Museum of American Art.

Second printing

LONGWOOD COLLEGE LIBRARY
FARMVILLE, VIRGINIA 23901

This publication is made possible by a generous gift from Emily Fisher Landau.

LONGWOOD LIBRARY

1000330581

"The Millennial Biennial." This phrase was often invoked by the six-member curatorial team invited to shape the first Biennial of the new century. The six curators are: Michael Auping, Chief Curator, Modern Art Museum of Fort Worth, Texas; Valerie Cassel, Director, Visiting Artists Program, The School of The Art Institute of Chicago; Hugh M. Davies, Director, Museum of Contemporary Art, San Diego; Jane Farver, Director, List Visual Arts Center at MIT, Cambridge, Massachusetts; Andrea Miller-Keller, independent curator based in Hartford, Connecticut; and Lawrence R. Rinder, Director, CCAC Institute, California College of Arts and Crafts, San Francisco and Oakland. These colleagues bring complementary credentials and experiences to the task of identifying the works of art most deserving of inclusion in the 2000 Biennial. They vary widely in background, hail from different parts of the country, espouse divergent points of view about the important art of our time, and have taken independent paths in their thinking about contemporary art.

We had four formal meetings—in Chicago, New York, and San Diego—and frequent exchanges by telephone and on a private website built to enable the curators to stay abreast of each other's work. We were constantly aware of the challenge of meeting not only our own expectations, but those of the visitors, artists, colleagues, and critics for whom the distillation of many months of debate would be experienced in and outside the Whitney Museum's walls in the spring of 2000. From the moment the curatorial team was announced in February 1999, our enterprise has been noisily scrutinized by the art world and various motives imputed to it. My own motive for shaping the 2000 Biennial in this hexadic fashion has less to do with the pressures of time than with curiosity: what would result from assembling a national curatorial group, and from the fresh thinking that these individuals would bring to a time-honored but ever-contentious exercise?

What was clear from the outset was that we were organizing the exhibition not exclusively for the art world, but equally, if not more, for the benefit of the broader public. This was one of three principles that guided the process of selecting works, conceiving an installation and publication strategy, and providing interpretive tools for exhibition visitors.

Undeterred by the prospective outcry that attends every Whitney Biennial, we pressed forward with two other principles. We sought to pay heed to cities and communities other than New York and Los Angeles by having six curators from different parts of the United States review the scene in their own regions and travel to other regions as well. While some regarded this decision-making scheme as akin to an electoral primary, ultimately it was highly productive. The curators surprised and educated each other with their individual nominations of both new and known artists from all over the country.

Lastly, we agreed to avoid a construct that would in any way restrict the choices of artists and objects, deciding instead to champion what we believe is the best and strongest work produced in America since the 1997 Biennial. Selections were therefore made without regard to subject matter, aesthetic approach, or critical categories. Moreover, we felt that the collective contributions of six curators would mitigate the kind of subjectivity that tends to favor one group of artists over another, would be more likely to capture the tenor of the moment, and, ultimately, would better reflect the multivalent character of American creativity. Although we never sought to flatten peaks of independent judgment, the quest for diversity through critical even-handedness governed our every debate. And it is in this spirit that we take pride in unveiling the "Millennial Biennial," a tribute to the ever-rewarding enterprise of art-making.

I would like to thank Leonard Lauder, Joel Ehrenkranz, and the rest of the Whitney's Board of Trustees. The Public Art Fund, led by Tom Eccles, with the able assistance of Laura Raicovich, gave unstintingly of its time and support.

The staff of the Whitney performed with its usual combination of professionalism, quiet skill, and passion for living artists. Foremost among them was Maura Heffner, the administrator of the exhibition, who devoted herself to the project and provided much-needed expertise gained during work on the past two Biennials. Anne Wehr, Biennial assistant, coordinated the curatorial aspects of the catalogue, with the competent assistance of Alpesh Patel. I would like to single out Glenn Phillips, who assisted in the organization of the film and video components of the exhibition, as well as Jenni Kim, Amelia Tuminaro, and Nelson Ortiz. Lana Hum, the exhibition designer, gracefully accommodated the many temperaments that define such a project and produced an inviting and informative display. Eugenie Tsai,

Associate Director for Curatorial Affairs, shouldered responsibilities associated with the administration of the project from the beginning.

As with every Biennial, many departments were involved at an intimate level in the planning and implementation of the exhibition. I would like to thank the following individuals and their department members: Christy Putnam, Associate Director for Operations; Suzanne Quigley, Head Registrar, Collections & Exhibitions; Melissa Phillips, Associate Director, Public Programs, Helena Rubinstein Chair of Education; Barbara Bantivoglio, Associate Director for Marketing; Mark Hough, Chief Development Officer; Alexandra Wheeler, Director of Development; and Mary Haus, Director of Communications.

The Publications and New Media Department was responsible for the shaping of this catalogue from raw idea to final, elegant product. The award-winning designer J. Abbott Miller of Pentagram designed the book and worked with the Department on the exhibition identity and graphics. The informative texts for both the catalogue and exhibition were written by Todd Alden, Susan Harris, Alexandra L.M. Keller, Paula Massood, Nancy Princenthal, Ingrid Schaffner, and Andrea K. Scott.

Significant support for this exhibition has been provided through an endowment established by Emily Fisher Landau and Leonard A. Lauder. Additional funding has been provided by the National Committee of the Whitney Museum of American Art, the Whitney Contemporaries, Melva Bucksbaum, The Greenwall Foundation, France Telecom North America, and Reuters America.

We are especially indebted to the artists who participated in the exhibition. Each rewarded us by their faith in the Whitney and enriched the curators and staff by their contributions, good humor, and helpfulness. We thank you all.

In closing, I would like to pay tribute to the six curators who gave so generously of their time and talents. Each is a remarkably accomplished individual and had no end of legitimate reasons to decline the offer to participate. My role was largely limited to that of pragmatist, devil's advocate, and timekeeper. We will all benefit from the rigor they injected into the project, but no one will learn more from their efforts than I have, and I thank them warmly.

Maxwell L. Anderson, *Director*

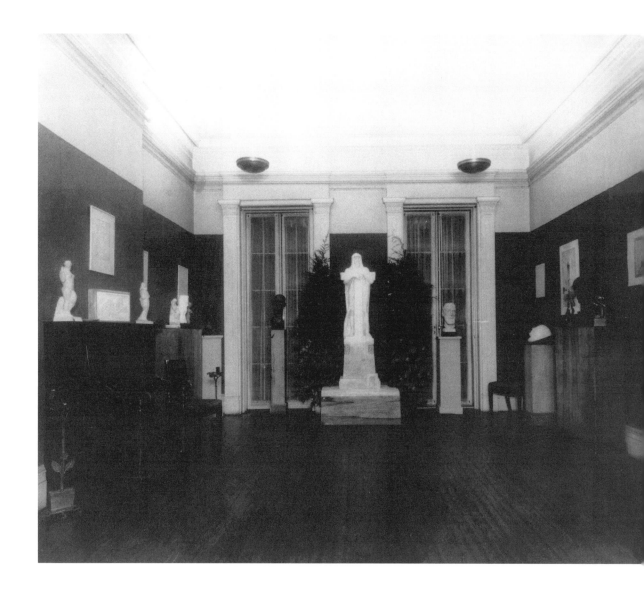

Installation view of the "First Annual
Sculpture Exhibition," 1928.
Whitney Studio Club, 10 West 8th Street,
New York

The seventy-year history of the Annuals and Biennials mounted by the Whitney Museum of American Art stands in a long tradition of institutionally organized exhibitions of current art. Beginning in the later eighteenth century, art academies in Europe initiated exhibitions of their members' work. The Salons of Paris and the annual exhibitions of the Royal Academy in London were generally closed affairs, with exhibition opportunities limited to members, the selection and prize juries made up of members—and membership itself determined not only by talent but by the relationship of a candidate's work to the kind of art advocated by the academy.

Throughout the nineteenth century, the Paris Salons and Royal Academy exhibitions perpetuated established standards and justified accepted art—as did America's National Academy of Design, founded in New York in 1826, which held fast to conservative, academic principles even as the stiff winds of change began to blow through New York in the early twentieth century.

Enter Gertrude Vanderbilt Whitney. Almost three decades before the founding of the Whitney Museum of American Art, she began to envision the policies which would become a formal mandate of the institution that opened in 1931. A trained sculptor, Mrs. Whitney was disturbed by the unabated rejection of fellow American artists, particularly those who sought to break free of conservative, European-based styles and subject matter propounded by the National Academy of Design. In 1908, she bought four of the seven works sold from the landmark exhibition of The Eight, the rebel artists who regarded daily life and urban scenes as suitable themes for art.

One of the greatest difficulties facing these marginalized artists in their efforts to find exhibition spaces for their art was the rigid jury system that operated at the National Academy of Design—the traditional system that had attended academic exhibitions from their inception. In 1914, a year after the Armory Show gave modernism a huge boost in America, Mrs. Whitney made a direct attack on the academic jury system by inaugurating the Whitney Studio, an artists' exhibition space, in her own studio. Two years later, she became the most generous benefactor of the Society of Independent Artists, formed in 1916 to mount non-juried shows open to all artists, not just those whose work conformed to the National Academy's standards. In 1918, the Whitney Studio Club opened, and Mrs. Whitney instituted annual survey exhibitions of its members' work. Each artist-member could exhibit a self-selected work—in other words, there were no juries. Membership, moreover, was open to all. In 1925, the Whitney Studio Club annual exhibition was so large that it was held off-site at the Anderson Galleries. Three years later, with a membership of four hundred artists and a waiting list of another four hundred, the Whitney Studio Club closed its doors. Director Juliana Force explained that it had "not only fulfilled its purpose, but has outgrown itself" as an artists' club. Annual exhibitions were suspended, but the Club was briefly replaced by the Whitney Studio Galleries (1928–30), which continued to mount exhibitions of contemporary art.

The Whitney Museum of American Art opened its doors in 1931 with a mandate to support living artists. It was not an institution that spoke in a dogmatic voice, but rather one that respected the diversity and subjectivity of America's art and artists. To fulfill this mandate and to eliminate the elitism that attended National Academy exhibitions, Mrs. Whitney initiated a series of Biennial (and later Annual) exhibitions which, like their predecessors at the Whitney Studio Club, were non-juried and essentially artist-driven.

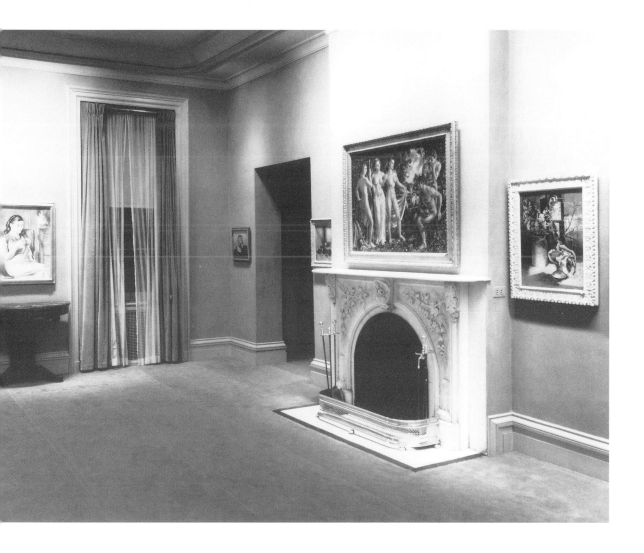

Installation view of the "First Biennial
Exhibition of Contemporary American
Painting," 1932. Whitney Museum
of American Art, 10 West 8th Street,
New York

A retrospective look at the vicissitudes of these exhibitions over the past seventy years reveals that no matter how many changes were made in the structure, selection process, or scheduling of the Annuals and Biennials, they continued to uphold a primary principle established in the early 1930s: to support the work and the concerns of living artists and thereby exhibit art that reflected a commitment to heterogeneity and individuality. The "2000 Biennial Exhibition," though outwardly different in some respects from previous Biennials, emerges from this historical overview as the most recent in a long line of surveys designed to present the broad range of achievements in contemporary American art.

The Whitney Biennial exhibition series differed in several significant respects from contemporaneous programs. Unlike those long in place at other American art museums (The Art Institute of Chicago, Pennsylvania Academy of the Fine Arts, Corcoran Gallery, Carnegie Institute), the Annuals and Biennials mounted at the Whitney were non-juried and offered no prizes, financial or honorary. There was, in other words, no system of hierarchical judgment that made winners of a few and losers of most.

The democratic scope of the Whitney's Biennial system was spelled out by the Museum's director, Juliana Force, in the foreword to the catalogue for the first Biennial:

To make this exhibition representative of the various trends in painting throughout the country one hundred fifty-seven artists have been invited to contribute canvases of their own selection. This is a departure from the policy of other exhibitions similar in character where the jury system has obtained. Also, the Whitney Museum of American Art will award no prizes, but has set aside the sum of twenty thousand dollars each year for the purchase of works of outstanding excellence from the exhibitions.... [W]e trust that this exhibition will represent in a broad way some of the

most notable characteristics of American painting today....It is our belief that the three principles on which these exhibitions have been founded, no jury, a participation in the selection of the works contributed by the artists and no prize awards, will serve to make these biennial exhibitions representative of the best work produced in this country in the plastic and graphic arts.

The 157 artists invited were selected by the Museum's curatorial staff—who were themselves trained as artists: Karl Free, Hermon More, and Lloyd Goodrich (More and Goodrich later became the Museum's second and third directors, respectively). The $20,000 purchase fund, instead of the prizes awarded at other institutions, was another way of giving support to American artists. The works were also for sale. As the prospectus accompanying the first Biennial announced, "Every effort will be made to effect sales and no commission will by charged for this service."

By 1938, although financial difficulties made it impossible to set aside a specific purchase fund, the Museum regularly bought —and continues to buy—works from Biennials, assuring each new group of artists representation in the Permanent Collection, initiating the practice of supporting artists *through* the Biennials, and building a Permanent Collection that reflects ongoing developments in American art.

While these practices continue in large measure to this day, the specific features of each Biennial and of the system itself have undergone a number of permutations over the last seventy years. Some of these were primarily logistical, others were responses to new exigencies in the art world, while still others emerged from a process of institutional self-evaluation. In one way or another, all contributed to the growth of the Whitney from an artist's exhibition space into an art museum.

Between 1932 and 1936, the Museum mounted a Biennial of painting or sculpture (the latter including prints and drawings

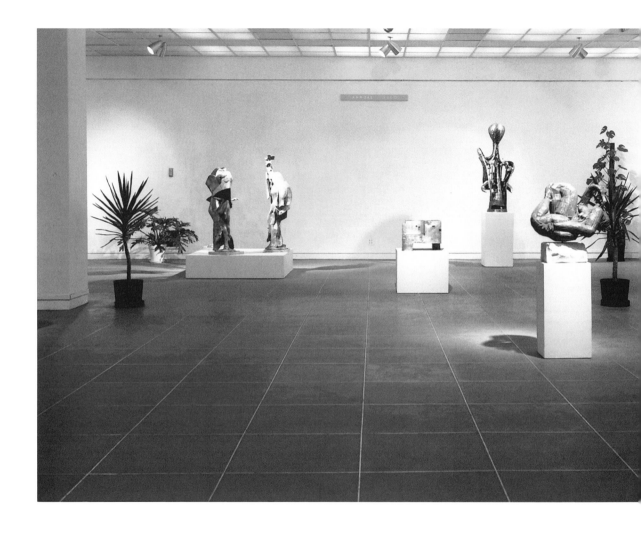

Installation view of the "Annual Exhibition:
Contemporary Sculpture and Drawings,"
1960. Whitney Museum of American Art,
22 West 54th Street, New York

as well). Beginning in 1937, two Annuals were held each year, again similarly organized by media. This structure endured (with slight modifications during World War II) until 1956, when a single Annual was held that encompassed all media. Between 1959 and 1972, Annuals again alternated between sculpture (sometimes with prints or drawings) and painting. The present all-media Biennial system was initiated in 1973.

Whether an Annual or Biennial, whether in the 1930s or the 1990s, these exhibitions have always opened to mixed reviews and controversy. Some critics, however, looking beyond the art of the moment, have seen the inclusive spirit that underlies the shows. Thus Henry Geldzahler, writing in 1969: "From its founding, the Whitney has had a sense of responsibility and fairness to all the styles that at any moment make up the totality of contemporary art. This sense of fairness has always made the Annual exhibitions of painting and sculpture at the Whitney anthologies rather than attempts to define styles." Ironically, it is on the matter of fairness that Whitney Annuals and Biennials have often raised critical hackles, some critics objecting to the exclusion of favored artists, others to the selection process.

In the first few years of Annuals and Biennials, the Museum strove to present as broad a range of American art as possible. By 1940, the exhibitions had included the work of 635 artists from 35 states. The 1940–41 Annual also marked the first major change in the exhibition structure: instead of allowing artists to select their own works, the curators now collaborated in the selection process. "The principle of giving the artist the right to choose his own work is an excellent one," wrote Lloyd Goodrich in February 1940, "but a good many new factors have arisen that interfere with its working out well in practice." Among the factors he enumerated were the competition from other museums to get an artist's best work for their exhibitions and the practice of dealers, who tried to keep the best for themselves. Too many selections, in other words, were being

made on a basis other than quality; curatorial judgment had to be imposed "if the Museum is to retain its leadership in its own field, if it is to continue...to put on the finest if not the largest American exhibition of the year."

In today's Biennials, although artists still work with curators to select the pieces for exhibition, the selection is primarily determined by the kind of curatorial judgment exercised in any major art institution. Does this shift from the artist-driven organization of the earlier Annuals and Biennials compromise the Museum's original mandate as an advocate for American artists? Perhaps yes, from the local perspective of individual artists. But, in a broader, long-term view, artists—and American art itself—are better served when represented by an institution whose professionalism earns international respect.

Early in its history, the Whitney's curatorial judgments, then exercised in the selection of artists invited to participate in the Annuals and Biennials, generally favored American realism, even though modernists such as Stuart Davis were always included. This somewhat conservative tendency, which reflected Mrs. Whitney's preference for realist art, continued even as Surrealism and various forms of abstraction made headway at other institutions here and abroad. By 1945, however, in the first postwar Annual, press reports announced that the Whitney was "going completely modern" with the show's broad representation of abstract forms of expression. In 1949, the Museum decided to deaccession its collection of American art prior to 1900 and use the proceeds to increase its funds for the purchase of contemporary American art. This epochal decision set the stage for an exclusive concentration on the Museum's founding mission, the support of living artists.

Such support also means a willingness to reevaluate the criteria by which art is judged. Throughout the 1960s, as artists increasingly violated boundaries between traditional media— and even made new media appropriate for high art—museum

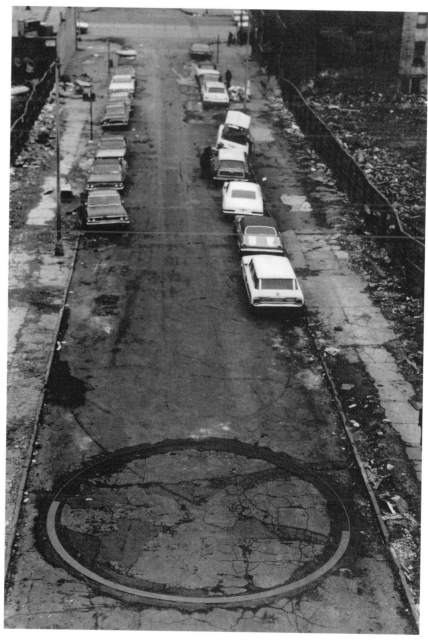

Richard Serra. *To Encircle Base Plate Hexagram Right Angles Inverted*, 1970. Steel, 8 x 1 in. (20.3 x 2.5 cm), 312 in. (792.5 cm) diameter. Installed at 183rd Street and Webster Avenue, The Bronx, New York, 1970–72. Photograph by Peter Moore

curators became less assured about conventional distinctions. In his catalogue foreword to the 1968 Sculpture Annual, director John I.H. Baur spoke of "the growing tendency of both painting and sculpture to escape their traditionally self-contained limits and become events in the environment." Not coincidentally, this was the first Annual to include site-specific sculpture, represented by Dennis Oppenheim and Michael Heizer.

In 1973, the shifting character of American art led the Whitney to abandon the Annual-by-medium system in favor of Biennials that welcomed all media—those once marginalized and those newly defined. The 1970 Sculpture Annual had included off-site works for the first time (Robert Smithson's *Spiral Jetty*, in Utah; a Richard Serra sculpture in The Bronx; and a Keith Sonnier sound piece on a SoHo rooftop). In the 1975 Biennial, the works of seventeen video artists were exhibited. Two years later, photography received a prominent place in a Biennial, while films were included for the first time in 1979, film and video installations in 1981, and Performance art in 1989.

The extraordinary range of art activities seemed, to Tom Armstrong, director from 1974 to 1990, to preclude any kind of comprehensive survey. He therefore instituted a "thematic" focus for his first two Biennials—the 1975 Biennial presented works by artists who had not become known through one-artist shows in New York or participation in previous Biennials; the next Biennial was devoted to artists who first made a decisive influence on art in the 1970s.

In these years, as vanguard artists moved beyond the East Coast, the Museum also sought to make the Biennials more national in scope and foster curatorial travel as part of the selection process. An earlier five-year grant from the Ford Foundation had enabled curators to travel around the country. Beginning in 1975, NEA support continued to fund nationwide curatorial visits to artists' studios. Toward the end

TOP LEFT:
Benni Efrat. *Out and About*, 1980,
from the "1981 Biennial Exhibition."
Film installation, color
Photograph by Peter Moore

BOTTOM LEFT:
Allen Ruppersberg. *A Lecture
on Houdini (for Terry Allen)*, 1972,
from the "1975 Biennial Exhibition."
Video, black-and-white; 40 minutes

TOP RIGHT:
Stan Brakhage. *Sincerity III*, 1978,
from the "1979 Biennial Exhibition."
16mm film, color, silent; 35 minutes.
Film-makers' Cooperative, New York

BOTTOM RIGHT:
Constance De Jong and Tony
Oursler. *Relatives*, 1988, from
the "1989 Biennial Exhibition."
Performance with 25-inch video
monitor and prerecorded video
Photograph © Paula Court

of Armstrong's tenure, a regional advisory committee was engaged to help the Biennial curators identify significant artists from various parts of the United States. Another alteration in Biennial policy that responded to the evolving nature of contemporary art was the abandonment of the one-work-per-artist system. The 1977 Biennial curators asked each artist to contribute multiple works, which more accurately reflected the way many artists thought of art-making as an iterative process that did not necessarily culminate in a single object.

Tom Armstrong had sought to treat the complexity of art production by classifying artists according to their career development or status, but after two Biennials, he returned to a nonstructured system. David A. Ross, director from 1991 to 1998, approached the selection process from a different angle. Ross had inherited a system that had often been derided as "curating by committee"—the long practice of engaging several (or all) members of the Museum's curatorial staff in Biennial decision-making. Beginning with the 1993 Biennial, he acknowledged the role played by individual subjectivity, even within a group, by assigning each Biennial to a single curator. In some cases, the curator then opted to work with an advisory committee, other Museum curators, or, as in the last Biennial, an outside co-curator, but the perspective remained that of the curator-in-charge rather than the institution.

The latest version of the Biennial, staged for the year 2000, in many ways evolved naturally from past approaches. The curators are once again a team, but they are independent of the Museum. They were chosen not only for their expertise in contemporary art, but also, to make the selection as inclusive as possible, for their deep involvement in different regions of the country. The group dynamic proved to be surprisingly stimulating. Our aversion to the potentially leaden results of 'curating by committee' was dealt with by the decision, early on, to foment open debate about the selections and to ensure

Installation view of the
"1993 Biennial Exhibition."
Whitney Museum of American Art,
945 Madison Avenue, New York

that individual perspectives were carefully weighed. The result is a robust cross-section of contemporary artists—painters; sculptors; photographers; installation, film and video, and performance artists; and artists using other media. If generalizations can be made, there is a notable dulling of the sharper edges of social commentary that greeted so much work of the past decade. Rather than espousing political or anti-institutional critiques, more artists in the current cycle seem to engage in work that is either intensely personal or focused on formal issues without a precisely defined social premise. Some works address the ironies of art practice in a consumer culture; others invite us to step outside our protected role of observer and engage in the work's dynamics, by using it, purchasing it, or entering it. Oppositional stances, when they appear, are usually leavened with humor that does not indict the viewer for inaction.

Lacking a prevailing spirit of *épater les bourgeois*, contemporary art runs the risk of homogeneity. Yet there is a remarkable multiplicity of styles and issues in the works exhibited here, each one having been included solely on its own merits, rather than as illustrative of a trend or a theme. The market, moreover, was kept at bay; no dealers were solicited for advice. The thrill was in taking risks on unproven talent while finding reassurance in the continued inventiveness of more established artists.

The results will be as hotly contested as earlier entrants into the venerable history of Whitney Annuals and Biennials. At the end of the day, however, the Whitney remains a museum founded for artists and for the public. The features that distinguish this display from past Biennials will likely be forgotten, while the power of select works presented in it will grow over time. Providing artists with this highly visible platform for critical assessment is an enormous responsibility—and a privilege.

Maxwell L. Anderson
Director

The slogan for the last Whitney Biennial was "LOVE IT, HATE IT, DON'T MISS IT." Historically, the Biennial has often informed and interested the public rather than pleased it, and this has been our strategy as well. As curators, we have found past Biennials to be consistently useful and informative, always bringing some new artists to our attention and challenging our own critical perspectives.

At our first meeting in Chicago in April 1999, a year before this Biennial was scheduled to open, we each brought in a preliminary, and entirely unofficial, list of artists whom we felt merited recognition in the 2000 Biennial. The lack of consensus in these initial lists surprised us. We soon agreed that we did not want this exhibition to occupy only the common ground the six of us shared. Although we acknowledged that the presence of some of our individual passions would strengthen the exhibition, we were also adamant that we wanted it to be a single show, not a sequencing or jumble of six visions. Moreover, given this principle, as well as the realities of space, time, budgets, and curatorial differences, there was never a chance that any one curator's passions would rule the day. While we consciously rejected the option of breaking the Biennial into six separate, "pure" shows, perhaps a future group of curators will take this alternative route—it is, after all, a strength of the Biennial that its format has remained flexible and open.

What have we learned about the art being created in the United States as this century turns? It is a robust time: the visual arts are full of content, full of invention, and full of personal commitment. Some of the most interesting work continues to be in the area loosely called installation art, some of it site-specific, some of it not. At the Museum itself, several artists are engaging the public directly in the galleries, in the restaurant, and outside on the sidewalk. In cyberspace, the Internet is a nascent but increasingly intriguing medium of artistic exploration. "Net art," whose form—and sometimes content—derives from the unique conditions of the World Wide Web, this year takes its rightful place in the Biennial.

Perhaps it is good news that we found no evidence of either millennial jitters or millennial grandiosity. Nor do the end of the nineties seem to us to have been a time of radical innovation.

While some (although not all) of us searched for art that was "transgressive"—work that violates existing art world canons—we found very little of it.

On another front, the once fairly clear delineation between gallery objects and film and video presentations is now often blurred. Contemporary aesthetics and technological improvements have led to an increase in the number of artists who want their moving images projected on a large scale in a gallery context. Given the relatively limited exhibition area, we are experimenting here with a dedicated projection gallery that will show film and video works on a rotating schedule, just as more traditional films and videos are screened for the Biennial.

As curators from six different regions of the United States, we had the opportunity to move the emphasis away from New York. The results of our deliberations nevertheless suggest that this city remains our country's most vital artistic center—though certainly not the only one. While New York seems to be the place where artists from all over the United States and, more and more, artists from around the globe continue to gather to share work and exchange ideas, there is not complete consensus among us as to New York's "centricity." And while this Biennial might have stretched even further in its inclusion of artists working outside the mainstream art market, it is, we hope, a concerted step in that direction.

Of greater interest to the state of the visual arts is that the vast majority of the artists selected do not now live where they were born. Some have permanently relocated to another place; others seem to be nomads who frequently sojourn in faraway cities, still others are not American-born, but have chosen to work in this country. These ongoing migrations have generated important aesthetic insights as the artists, reflecting on their journeys, broaden their perception of the world—and ours as well. In this sense, the 2000 Biennial may be the most "international" ever mounted.

The 2000 Biennial is probably not the exhibition any one of us would have done individually. For each of us, there are works we would not have included, and, more painfully, individual artists we championed who have been excluded. But we have worked diligently together, listening to and learning from each other,

and even though many personal choices were omitted, we stand unified behind this exhibition. Since diversity is a positive fact of life in the art world today, it seems appropriate for a survey of contemporary American art to weave together the divergent perspectives of half a dozen professionals from across the country.

Most important, we were free to set our own parameters every step of the way: how the artists would be selected, if there would be a theme (there is not), and what the ideal balance would be among emerging, mid-career, and senior artists. We all felt strongly that the 2000 Biennial should not be an exhibition about names or buzz, but rather a presentation of intriguing and carefully selected works of art.

The sum total of our selections reflects, we hope, all of these considerations. We thank Whitney Museum director Maxwell L. Anderson for inviting us to take on this challenge, and we hope we have lived up to the trust he placed in us. In closing, we would like to acknowledge the accomplishments of recent Whitney curators. It is the solid foundation laid by their cumulative good work in presenting contemporary art at the Whitney over the past two decades that made it possible for us to jump into this assignment. Above all, we thank the participating artists, who allowed us to bring together their images and ideas in eight months of intensive dialogue and thereby to share their visions with all who visit the 2000 Biennial.

Michael Auping Jane Farver
Valerie Cassel Andrea Miller-Keller
Hugh M. Davies Lawrence R. Rinder

ARTISTS' PLATES

Dennis Adams investigates collective amnesia, social exclusion, and the ways in which history and culture are shaped. His work includes site-specific projects in public spaces that integrate photography, text, and architecture. Engrossed for the past decade in the idea of transaction, Adams has also produced a series of kiosks for the exchange of money, tickets, and information. Notorious public figures, such as kidnapped socialite Patty Hearst or anti-Communist zealot Senator Joseph McCarthy, often provide fodder for Adams' historical excavations. While *Outtake* represents a shift toward video/performance, the artist's conceptual concerns remain the same.

The source of *Outtake* is a film from the early 1970s written by Ulrike Meinhof, later imprisoned for her involvement with the terrorist Red Army Faction (RAF), also known as the Baader-Meinhof Gang. Her film, entitled *Bambule*—a word of African origin meaning "dance" or "riot"—was a dramatization based on documentary research that critically addressed the dynamics of authority in state-run orphanages for adolescent girls. *Bambule* was shelved by German television authorities when it was suspected that Meinhof had participated in the escape of RAF leader Andreas Baader from prison; it was not publicly shown in Germany until 1995. In 1976, Meinhof died in a German prison.

For *Outtake*, Adams extracted one take of *Bambule*, comprising 416 individual still images of a frantic adolescent girl being chased through the orphanage corridors by two nuns. He then handed out the images one by one, in their original sequence, to passers-by on Berlin's Kurfürstendamm. As the stills were distributed, a small digital videocamera supported from a uniquely designed apparatus attached directly to Adams' arm shot close-ups of the ongoing distribution. Through this process, seventeen seconds of footage from the original Meinhof documentary are slowly drawn out to the 136 minutes Adams needed to complete his transactions.

Still from *Outtake*, 1998–99.
Video installation, color,
sound; 136 minutes.
Kent Gallery, New York,
and the artist

DOUG AITKEN

Doug Aitken actively engages the viewer in open-ended video meditations on entropy and emptiness. Much of his work can be exhibited as either an installation or a single-channel projection. Aitken is not only an artist, but has also directed a number of music videos, a genre occasionally referenced in his earlier work. More recently, he has mined the terrain of abandoned landscape in works such as *Monsoon* (1995), shot in Jonestown, Guyana, the site of a notorious mass suicide of religious cultists. The eerie, anticlimactic imagery captures the jungle's reclamation of this tragic site and the approach of a tropical storm that never quite arrives. Entropic absence also provided the framework for *Diamond Sea* (1997), in which Aitken spent a month in a remote diamond-mining region of Namibia that had been closed to outsiders since 1908 and is now populated by wild horses and sophisticated, computerized mining equipment.

Aitken has lately turned his attention to the desolation of the American urban landscape, equating it with the blur of information that is a hallmark of the digital age. *Electric Earth* is a hypnotic multipart installation that traces the nocturnal wanderings of a young man along the deserted streets of Los Angeles. Through the magic of editing, time loses logic—as the protagonist passes an airport at sunrise, dawn suddenly lapses into dusk. Aitken's art, as vivid and elusive as a dream, occupies a space he describes as "a twilight of perception where ideas and iconography flicker and reinvent themselves."

Still from *Electric Earth*, 1999. Eight-laserdisc installation and architectural environment, dimensions variable.

Collection of Norman and Norah Stone; courtesy Thea Westreich, Art Advisory Services, New York, and 303 Gallery, New York.

Additional support provided by Fondazione Sandretto Re Rebaudengo Per L'Arte, Turin, Italy

GHADA AMER

From a distance, Ghada Amer's canvases look like finely drawn,
delicate abstractions. At closer vantage, it becomes clear that
the lines are not made from paint or ink, but from meticulously
embroidered thread. The apparent abstractions resolve themselves
into renderings of women, drawn from pornographic magazines,
heads tilted, mouths open, posed and inviting. Amer presents
a tense opposition between the concentrated precision of dainty
needlework and sexually suggestive postures, between the
formality of rectilinear composition and the insubordination
of flagrant sexuality, raunchy and self-gratifying. Tension is also
generated by the physical act of viewing, which necessitates an
intimate, active scrutiny that comes uncomfortably close
to voyeurism. Amer's work creates a parody of commercial
pornography's formulaic images. Part of the parody involves the
hand-embroidered fabric, from which loose threads abound, fixed
in place by gel. Visually untangling them to reveal the figures
they obscure is like being drawn into a spider's web. What Amer
entangles are two disparate definitions of female labor: sex work
and craft work.

Born in Egypt in 1963, and resident in France from the age
of eleven, Amer now lives and works in New York. The idea
of femininity she addresses is framed by this bicultural experience
of Western consumer culture's objectification of the female body
and Islam's restrictive code of female behavior. The veil, or chador,
a central symbol of resurgent fundamentalism throughout the
Middle East, was important to the development of her artistic
vocabulary. In exploring the cultural restrictions of dress, Amer
realized that regimentation of a "woman's place" occurred in
the West as well. In her recent pieces, threads are stitched against
grounds painted in deeply saturated tones of orange, rose, and
violet. Though sensual and evocative, their critical edge remains
sharply honed.

Untitled (John Rose), 1999.
Acrylic, embroidery, and
gel medium on canvas,
72 x 72 in. (182.9 x 182.9 cm).
Collection of Gilles and
Kelly Bensimon

MARK AMERIKA

38

Grammatron is an experimental multimedia environment
developed in 1997 specifically for the medium of the web by
Mark Amerika, under the auspices of Brown University and
the National Science Foundation. A thematic hybrid of cyberspace,
Cabala mysticism, and critical theory, the nonlinear narrative
spans more than two thousand linked pages of text, still and
animated images, and forty minutes of original soundtrack.
Much of the material is "sampled" from other websites, altered
by Amerika beyond recognition, in keeping with his motto:
"surf, sample, manipulate."

The story's protagonist, Abe Golam, is an "info-shaman"
whose alternate persona is Grammatron, a genderless digital
being. Abe's surname alludes to the medieval Jewish legend
of the golem, a robotlike personage made of clay and brought to
life, who is considered a prototype for man-machine myths from
Frankenstein to the Terminator. The character of Golam is an
avatar for Amerika himself, who is also the founder of the Alt-X
online publishing network. Both creator and character grapple
with the question of how narrative is composed, published,
and distributed in the digital age.

Digital stills from
Grammatron, 1997–present
(*www.grammatron.com*). Website

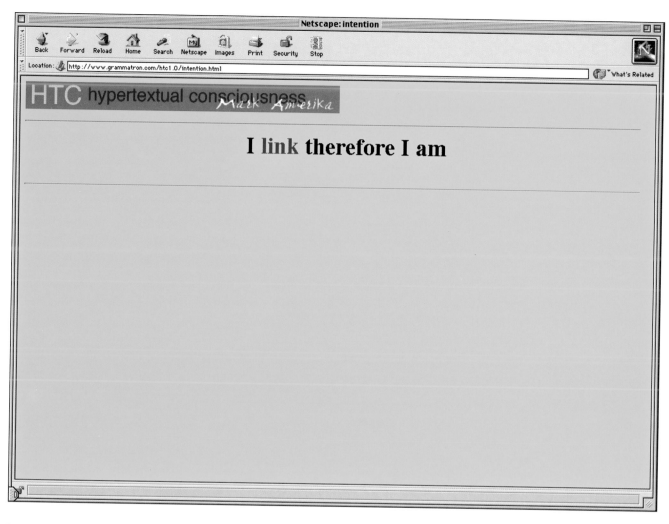

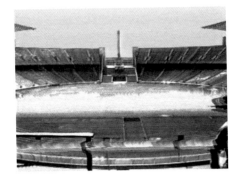

LUTZ BACHER

Lutz Bacher's 36-minute black-and-white video projection *Olympiad* consists of footage of the artist's walk through Berlin's Olympic Stadium. It derives its title from the like-named documentary of the 1936 Berlin Olympic Games by the German filmmaker Leni Riefenstahl. Riefenstahl's film was widely acclaimed for its innovative cinematography and epic scope, but also criticized as a powerful instrument of Nazi propaganda. Bacher rejects Riefenstahl's pictorial language, which conjures up Greek ideals of harmony, balance, and symmetry. In contrast, Bacher's silent, plodding walk through the cold, Neoclassical remnants of a nearly empty Olympic stadium is bereft of contemporary life, except for a handful of other tourists, a dozen or so swimmers in the pool, and an idle young man whom her camera confronts for what seems to be an interminable—and extremely uncomfortable—minute.

The most striking visual effects in Bacher's *Olympiad* are derived from the artist's use of corrupted videotape, which, abetted by a variety of postproduction techniques, gives the images an extremely degraded look. These technical effects include a relentless series of glitches, image flares, freezeframes, all-over jagged patterns, tracking problems, and other discontinuities— all of which make it difficult for the viewer to look comfortably at the monitor. Bacher's carefully considered, disruptive visual regime confronts the aesthetics of Riefenstahl's Nazi spectacle. Similarly effective is Bacher's "soundtrack," an eerie muted silence which is all that remains of the static-filled soundtrack of the original corrupted tape. This lost sound speaks louder and more abrasively than words.

Stills from *Olympiad*, 1997.
Video projection installation,
black-and-white, silent;
36 minutes. Pat Hearn Gallery,
New York, and Rupert
Goldsworthy Gallery,
New York

CRAIG BALDWIN

A hybrid of the genres of science fiction and thriller, with a strong documentary impulse as well, *Spectres of the Spectrum* tells the story of a grandmother (deceased, but entirely present), a father and a daughter, and their role in the underground rebellion against the New Electromagnetic Order. Woven into the film's narrative is not a history of telecommunications but, as one character puts it, "a media archaeology" of the "electromagnetic imperialism" perpetrated by communications corporations and the U.S. government.

Influenced by the horror films of William Castle, which he watched as a child, as well as the collage aesthetic of Robert Rauschenberg, Craig Baldwin constructs *Spectres of the Spectrum* out of found footage (including archival footage of nuclear explosions, the anti-government rebels in the Mexican region of Chiapas, and the 1950s television show "Science in Action"), as well as clips of other science fiction films, from Georges Méliès' *A Trip to the Moon* (1902, the first sci-fi film) to *Frankenstein* and *Metropolis*. "I like to skirt the margins and take what I need," Baldwin says, "like a nomadic hunter-and-gatherer. I call it surfing the wave of obsolescence."

Spectres of the Spectrum takes place in 2007, when the globalization of media has become so pronounced that the characters speak of the "Disney spy satellite" and the aggression perpetrated by the forces of NAFTA (North American Free Trade Agreement). The fictional struggle of the characters occasions an exploration of technology's relation to ideology, capitalism, and spirituality, and makes clear how science has become ever more politicized.

Stills from *Spectres of the Spectrum*, 1999. 16mm film, color, sound; 88 minutes

SCIENCE IN ACTION

Lew Baldwin launched the website *Redsmoke* in 1995 as a creative
diversion from his work as a web designer. The original concept
for the site was a fictitious rock band, but the artist says it
"quickly evolved into a depository for the subconscious." Like
Alice in Wonderland falling down the rabbit hole, the viewer is
treated to a series of apparently random and unrelated pages,
some stream-of-consciousness doodlings, others more complex
ideas. Deep within the site is the episodic story "Platters,"
about a man who finds a recording detailing the horrific life
of a "programmed" human worker who has now escaped.
The parallel narratives are relayed exclusively through animation,
using a software program called Flash, which allows the
story to unfold with no interaction required from the viewer.
A soundtrack of electronic music composed by Baldwin
accompanies the animation.

 The navigation of *Redsmoke* is intuitive; the viewer is given
no "click here" guidance and there is no persistent menu or
toolbar. The opening page offers no explanatory text and its
design changes frequently. In addition, Baldwin adds new pages
to the site on a weekly basis. The unpredictable and nonlinear
experience of *Redsmoke* mirrors the nature of the web medium
and ensures that the journey itself is the destination.

Digital stills from
Redsmoke, 1995–present
(*www.redsmoke.com*). Website

RINA BANERJEE

Rina Banerjee's sculptural installations bring together different
materials and concepts that address her concerns with issues
of hybridity, identity, nationalism, and sexuality. Born in Calcutta,
Banerjee moved to the United States from London at the age of
seven, earned a degree in polymer engineering in 1993, and later
received an MFA from Yale University School of Art. Banerjee sees
herself as a hybrid, neither Indian nor American, someone who is
perceived by mainstream Western culture as a distorted composite
of different parts—she has even compared herself to Mary
Shelley's Frankenstein. Banerjee has come to understand the
world and how it deals with difference. But she also recognizes
hybridity as a complex phenomenon, one that constantly mutates
in the postcolonial global village we now inhabit.

Banerjee's mixed-media installations explore stereotypical
perceptions and representations associated with the exotic and
the feminine in both Western and Eastern cultures. The works,
compelling in their conjunction of the beautiful and the
grotesque, typically include such sensuous materials as silk sari
cloth, the brilliant red pigment kumkum, used in many Hindu
ceremonies, and incense. In *Infectious Migrations*, however,
Banerjee uses fewer clichéd Indian materials, thus broadening
the possible range of interpretation. Part of a series called *An
Uncertain Bondage Is Deserved When Threatening Transmission*, which
she started as a response to the AIDS crisis in India, *Infectious
Migrations* incorporates an abstracted female form from which
emanate transparent acrylic tubes filled with vivid red pigments.
These elements prompt a consideration of disease and the
concomitant issues of migration, transmission, contamination,
and exchange. Banerjee continues to forge metaphorical
relationships between materials and content—combining and
arranging components to articulate a complex exploration
of cultural identity formation.

Infectious Migrations, from the series *An Uncertain Bondage Is Deserved When Threatening Transmission*, 1999. Incense sticks, kumkum, Vaseline, turmeric, Indian blouse, gauze, fake fingernails and eyelashes, chalk, foam, feathers, fabric, Spanish moss, light bulbs, wax, Silly Putty, quilting pins, plastic tubing, latex and rubber gloves, acrylic, and dry pigment, dimensions variable. Collection of the artist

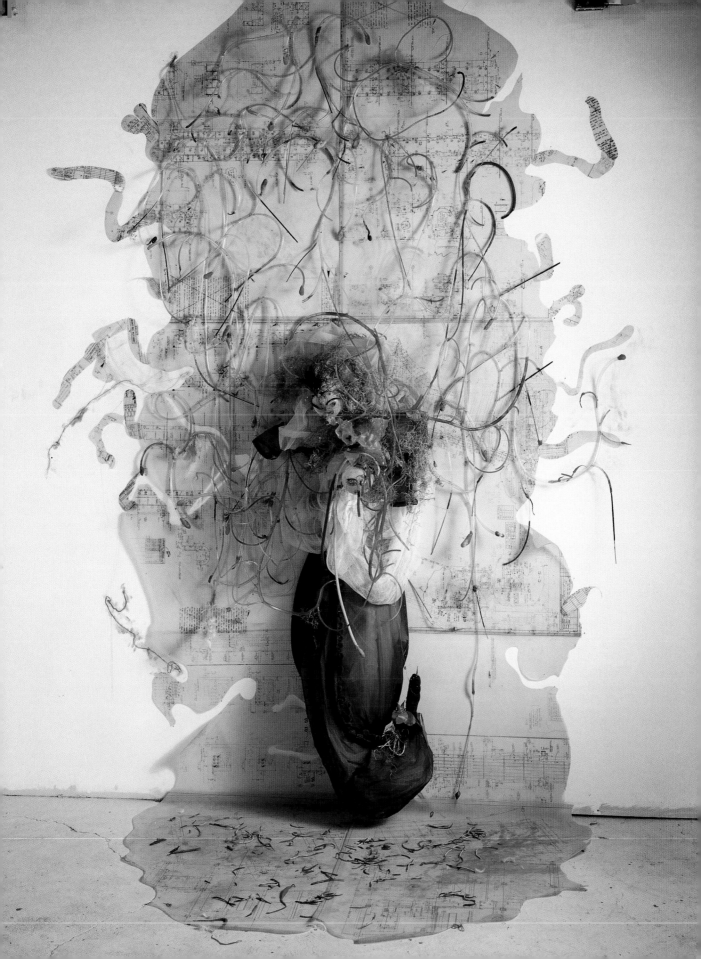

In *okay bye-bye*, so named for what Cambodian children shouted to the U.S. Ambassador in 1975 as he took the last helicopter out of Phnom Penh in advance of the Khmer Rouge, Rebecca Baron explores the relationship of history to memory. She questions whether "image and memory can ever exist in the same space." Building on excerpts from letters, found Super-8 footage of an unidentified Cambodian man, and other partial images, Baron combines epistolary narrative, memoir, journalism, and official histories to question whether something as monumental as the genocidal slaughter of Cambodians during the Pol Pot regime can be examined effectively with traditional methodologies.

In treading a very fine, generic line between documentary and personal diary, *okay bye-bye* suggests that treating history as a discourse different from other forms of memory is misleading. The fragments of letters Baron reads are not presented in chronological order, as in traditional history. Similarly, both the found footage and excerpts of the mainstream feature film *The Killing Fields* are slowed down, sped up, refilmed in black-and-white, and otherwise reshot to disrupt the usual distinction between hard evidence and narrative. Baron also interweaves the history of Cambodia with that of Southern California— "The history of Southern California is a history of forgetting," her narrator says. Through all these means, Baron resists the unifying impulses of conventional histories. Following photographs of the victims of a Cambodian concentration camp from their status as mug shots to their commodification as part of a gallery exhibition, and comparing Richard Nixon's cult of personality to Pol Pot's utter lack of one, Baron proposes that what is worse than forgetting the past is "forgetting the relationship between the past and the present."

Still from *okay bye-bye*, 1998.
16mm film, color, sound;
39 minutes

VANESSA BEECROFT

Since 1993, Vanessa Beecroft has staged live performances
in art spaces around the world. An amalgam of theater, fashion,
sculpture, and architecture, Beecroft's events typically involve
the orchestration and display of nude or semi-nude women who
stand around staring blankly out at the audience as the audience
looks at them. Twenty glamorous model-thin women posed mute
and expressionless for two-and-a-half hours in the Guggenheim
Museum rotunda—some clad in red bejeweled bikinis and
matching 4-inch spiked heels designed by Tom Ford of Gucci,
others sporting only the spikes. Erotically charged with the
physical immediacy of real bodies in real space and time, even
as they remain sexually and emotionally aloof, these "tableaux
vivants" are about the act of looking. The audiences who watch
Beecroft's visual spectacles are thus participatory and as much
on display as the performers, photographers, videographers,
and the artist herself.

Beecroft's work for the 2000 Biennial is a departure from
her "armies" of conventional female stereotypes; here she has
called upon the U.S. Navy. The original version of this event was
held at the Museum of Contemporary Art, San Diego. Titled *VB 39
US NAVY*, it featured a group of extraordinary male specimens in
white summer dress uniforms, standing motionless but with
a powerful physical presence, for the aesthetic delectation of the
audience. In the spring of 2000, Beecroft, in collaboration with
the Whitney Museum, Public Art Fund, and Deitch Projects,
New York, will stage a new live event of this military formation on
the flight deck of the aircraft carrier *Intrepid*, part of the Intrepid
Sea Air Space Museum in New York. Expanding the dialogue
beyond the question of gender specificity, the Biennial version
of this work reinforces the visual focus of Beecroft's enterprise
while raising questions about the cultural homogenization of the
entire human species.

VB 39 US NAVY, 1999.
Event at the Museum
of Contemporary Art,
San Diego, 1999

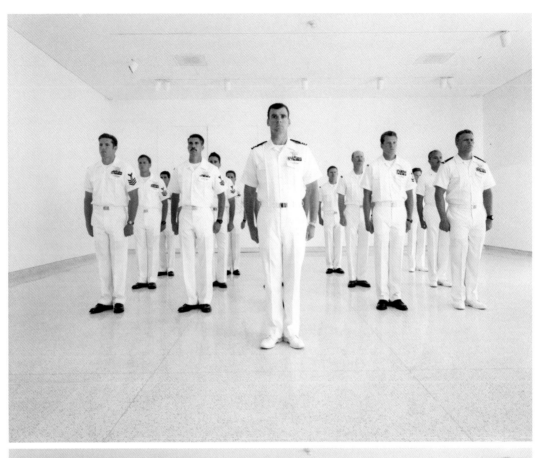

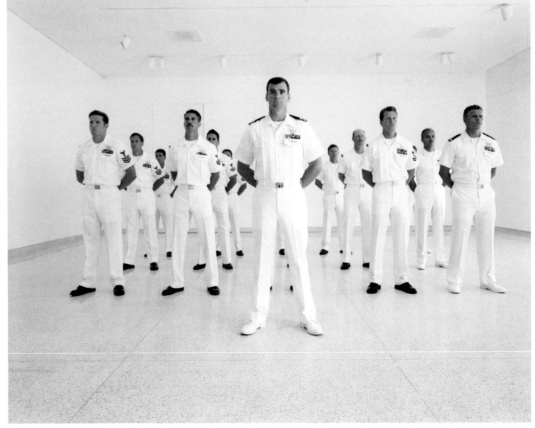

"I take pleasure in being able to accomplish what someone else accomplishes with less to work with." These words, spoken by Dan Cleveland, the focus of Rolf Belgum's debut documentary, *Driver 23*, are as applicable to Cleveland's experiences as they are to Belgum's video. Cleveland is a Minneapolis-based aspiring musician who works days as a courier—the driver 23 of the title. The film documents Cleveland's desire to become a star as the front man for a "progressive rock band" called Dark Horse. While armed with an almost maniacal ambition, Cleveland, as his friends and ex-bandmates point out, can't even sing. Furthermore, he is being treated for an unnamed "disorder," whose symptoms are an obsessive attention to detail that inspires him to design and construct Goldbergian contraptions for performing simple tasks such as moving musical equipment, lifting weights, and recording music. That all of these devices are made out of duct tape, old suitcases, bricks, and bungee cords and only intermittently work speaks to Cleveland's dubious success.

Belgum's documentary, originally shot on Hi-8 video for about $750 (before being transferred to 35mm film), also works with little from a technical, but not an aesthetic, standpoint. The film is firmly rooted in the American documentary tradition of direct cinema, with Belgum following Cleveland and observing his struggle to succeed over a three-year period. Although the strength of the film lies in Belgum's flexibility in allowing Cleveland's dramas to drive the narrative with minimum authorial intervention, what makes the film truly poignant are the events, such as Cleveland's marital problems, that neither subject nor filmmaker directly explicate.

Still from *Driver 23*, 1998.
Hi-8 video transferred to
35mm film, color, sound;
72 minutes

BEN BENJAMIN

San Francisco-based Ben Benjamin was among the first wave
of designers doing commercial work on the web in 1995.
At this point, he also began to work on his own project, *Superbad*,
a seemingly endless fun house of graphics, images, and text.
There is no fixed entry point because Benjamin changes the
homepage every day and keeps adding to the overall content.
Superbad is laced with references to popular culture, from
the rock band Iron Maiden to the cult film *Planet of the Apes*,
and also features stunning abstract animation and texts that
lampoon the homespun narratives one often encounters while
surfing the web.

 Superbad is developed using the basic programming language
of the Internet, Hypertext Mark-Up Language (HTML). Benjamin
eschews plug-ins—specific applications sometimes required
to view websites—meaning that viewers don't need any software
other than their web browser to fully experience his site. The
digital files are very light, generally less than thirty kilobytes
each, so that even a viewer on a slow modem doesn't have to wait
while the page downloads. Much of the site's content pokes fun
at the design language of the medium itself. For example, any
page on the web allows a visitor to view its source code simply
by selecting a menu item in the browser's toolbar. Benjamin
inserts hidden messages in his HTML code for diligent viewers.
Superbad abounds with inside jokes for those interested in the
medium on its own terms, but the site is equally entertaining
for a novice in search of a few hours of glee.

Digital stills from
Superbad, 1995–present
(*www.superbad.com*). Website

© **Chairman Brand**

Since the release of her first video, *A New Year* (1989), Sadie Benning has explored the related themes of alienation and self-definition. With *Flat Is Beautiful*, she continues the intensely autobiographical impulse that is a constant in her work, yet this latest work moves into new territory. Unlike her earlier diary-style, first-person video shorts, *Flat Is Beautiful* is a 56-minute featurette that, while remaining autobiographical, takes a third-person look at the experiences of someone else: Taylor, an androgynous twelve-year-old girl undergoing the difficult and often painful transition from childhood to adolescence and facing questions about her gender and sexual identity.

In capturing Taylor's attempts to define herself in a world of seemingly fixed identities, Benning's film also blurs and challenges its own formal and generic boundaries. Shot with Benning's signature Fisher-Price PXL2000 "Pixelvision" camera, the film also includes Super-8 and animated collage sections and is often referred to as an experimental live-action cartoon. Additionally, the characters in *Flat Is Beautiful* wear two-dimensional masks, concurrently inhibiting and expanding the potential for identification, and, in Benning's words, becoming a "metaphor for what is going on underneath."

Benning, who cites feminist filmmaker Chantal Ackerman as an influence, uses techniques such as the long take to create a moving and ironic comment on the flatness surrounding Taylor, which belies the tumultuous transitions taking place in her life. In Benning's film, flat may be beautiful but, like Taylor's prepubescent breasts, it is not absolute.

Still from *Flat Is Beautiful*, 1998. Video, black-and-white, sound; 56 minutes

ROBIN BERNAT

A book artist and poet, Robin Bernat has recently begun using the moving image to explore "the manner in which we experience the dual nature of existence." *three préludes by Chopin* is part of a larger installation called *effortless*, in which three short video sequences appear simultaneously on three separate monitors, each mounted on a pedestal that rests on a pool of melted beeswax.

Each segment in the tripartite, haiku-like piece (totaling only eight shots) is accompanied by a Chopin prélude. Initially, Bernat's sequences seem to form a particularly stately and beautiful portrait of an oscillating lawn sprinkler. The elements of any frame are extremely limited and thus take on heightened significance. All the sequences are shot in slight slow motion. In the first shot, the wind against the leaves and the sprinkler's graceful back-and-forth motion give the mundane and the banal a newly seen beauty.

The work's simplicity, as well as the unmoving camera, also call attention to basic properties of cinema and video: depth of field (the sprinkler defines both the diagonal and the depth of space), light (reflected in the water, sometimes shown in extreme close-up), object relations (through a lyrical shift in focus in which an iron gate and drops of water fade in and out of each other's fore- and backgrounds), and editing (Bernat exclusively uses fades rather than abrupt cuts).

In the first two sequences, image and sound are almost exactly matched. But in the final part, the image of the sprinkler on the verdant grass lingers well beyond the last piano note, leaving the viewer with a sense of the purely visual.

Stills from *effortless:*
three préludes by Chopin, 1998.
Video, color, sound; 3 minutes.
Solomon Projects, Atlanta

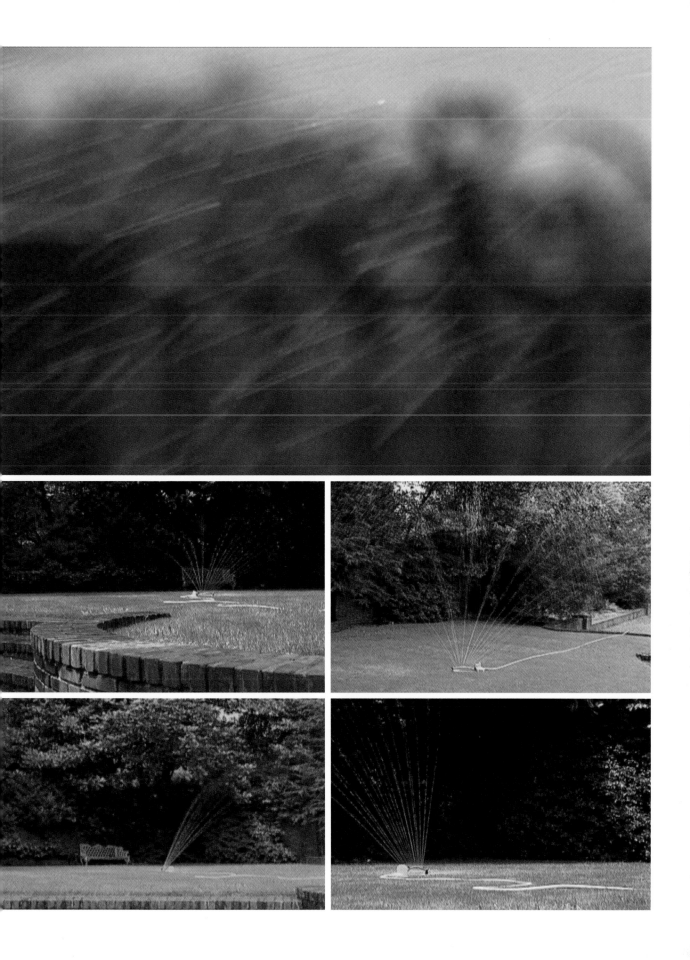

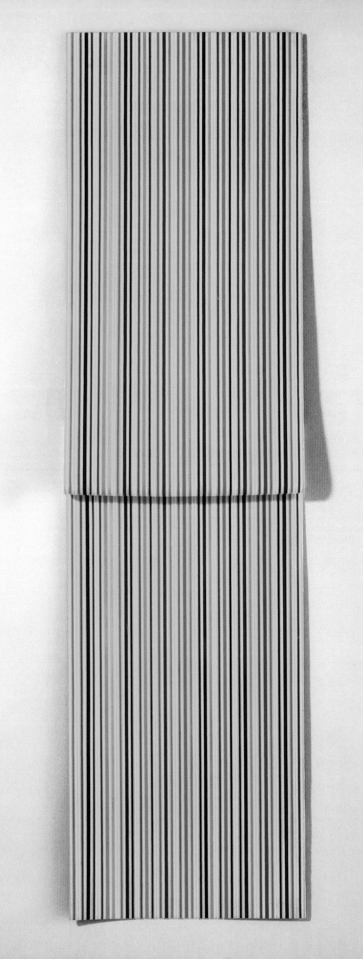

LINDA BESEMER

Draped like fabric over metal dowels, Linda Besemer's striped and
plaid paintings are a hybrid of image and object. They are made
by applying successive, patterned layers of acrylic paint onto
plastic panels, then peeling off the double-sided sheets of paint
and hanging them unevenly, so that both sides are exposed. These
works also muddle such conventional distinctions as figure and
ground, inside and out, surface and support. The result is visually
and conceptually confounding. As one critic has noted, the "final
surface is at the top, and below it its beginning."

Like other young California-based painters, including Laura
Owens and Monique Prieto, Besemer evokes the bright, saturated
canvases of Color Field abstractionists (in Besemer's case, Kenneth
Noland is especially relevant). Her work also invokes challenges
posed to boundaries between painting and sculpture by such
Postminimalists as Lynda Benglis, who poured latex directly
onto the floor to create freestanding puddles and mounds of fluid
color. But Besemer is primarily interested in abstraction's drive
to independence from both history and narrative. Abstraction is,
she says, "the only place where visual form can disrupt
a linguistic system."

Zip Fold #1, 1999. Acrylic,
fiberglass, and aluminum,
72 x 24 in. (182.9 x 61 cm).
Collection of Kenneth L.
Freed; courtesy Angles Gallery,
Santa Monica, California

DAWOUD BEY

The young men and women portrayed in Dawoud Bey's large
color photographs are seen twice or three times each, and in
remarkable detail. (The 5 1/2-foot-high prints are produced with
a massive 20 x 24-inch Polaroid camera, of which only five exist.)
But Bey's subjects are not simply or openly revealed. Though he
comes in very close—much closer than in his earlier photographs
—the angles of these new photographs are oblique, both visually
and psychologically. The sitters, appearing in diptychs or triptychs,
are pictured in the slimmest of profiles, or with their heads
bowed, or from behind, with hands raised in meditation. Their
straight gaze into the camera is one of great caution, as in the
young man who peers from deep within a black hood that seems
at once monastic and streetwise. Bey's photographs evoke
associations ranging from the format of religious altarpieces to
three-way mirrors. The spectrum of emotional states is just as
broad. Urban minority youth, who are often represented one-
dimensionally in the mass media, are here granted their human
complexity, for Bey portrays them as alternately wary, tough,
and penetratingly curious.

Inspired by photographers such as Walker Evans, Aaron
Siskind, and Roy DeCarava, Bey began his career with street
photography, working in black-and-white with a 35mm camera
first in Harlem, then in Puerto Rico, Mexico, and elsewhere in
the United States. In the late 1980s, he moved away from
involuntary, "candid" subjects and in 1991 shifted his practice
into the studio. He now also holds workshops in museums
and universities throughout the nation, educating young men
and women about the visual language of photo-portraiture
and its uses—not the least of which is self-reflection.
Both teaching and photographing have become crucial to
this process of self-reflection. Portraiture, in Bey's work,
captures the subjects confronting themselves.

Demitri, 1998. Internal dye
diffusion transfer prints
(Polaroids), three panels,
30 1/2 x 70 1/2 in. (77.5 x
179.1 cm) overall. Rhona
Hoffman Gallery, Chicago

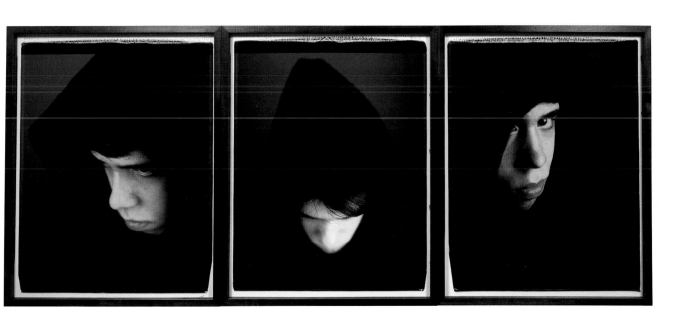

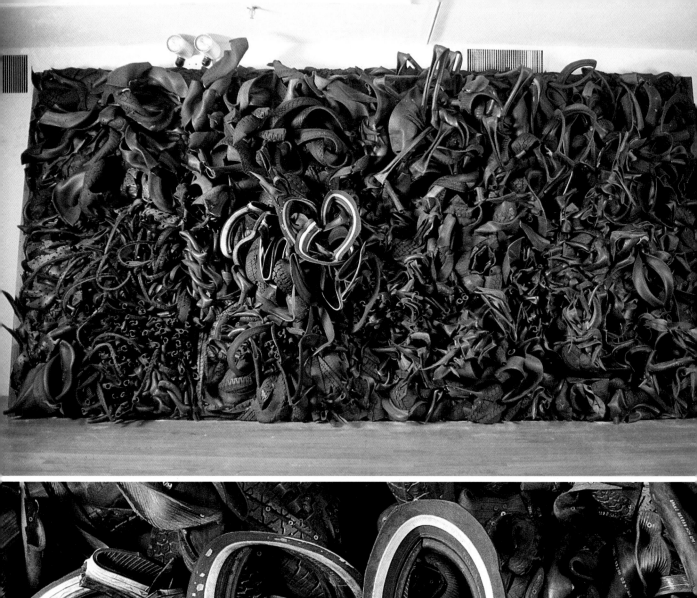
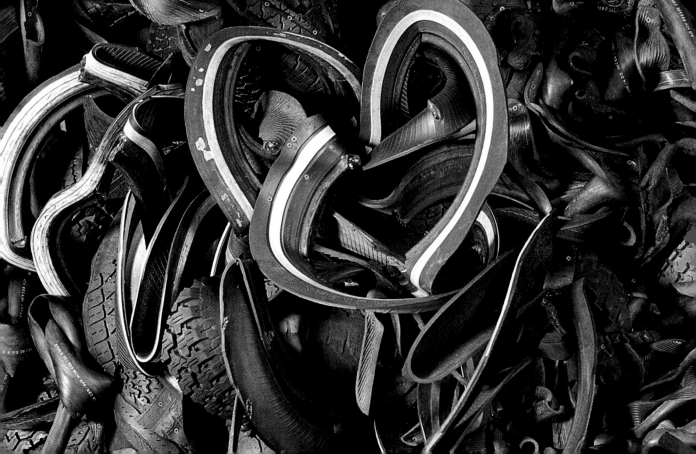

Chakaia Booker uses old rubber tires to give form to social commentaries that address issues from black identity to urban ecology. In *Homage to Thy Mother (Landscape)*, hundreds of tires have been rendered—and apparently wrestled—into a massive, high-relief wall sculpture. As in other, more figurative works, such as the 1995 *Repugnant Rapunzel (Let Down Your Hair)*, Booker's touch is transforming, as tires are retooled into a sensual being with entirely new allusions. The ropes and knots of sliced rubber create an abstract relief, but the surface can be read as a chunk of upturned terrain—perhaps a piece of post-industrial reef or junkyard pasture land.

The use of tires in art can be traced back to such earlier twentieth-century icons as Marcel Duchamp's readymade *Bicycle Wheel* (1913). Booker, however, extracts an intense concentration of meanings from the tires. Their black color signifies African skin, while their patterned treads resemble tribal decorations and the welts of ritual scarification. The tires' resilience and versatility represent, to Booker, the "survival of Africans in the diaspora." In this context, her work intercepts that of David Hammons, an artist well known for elevating humble trash to potent images of African-American life. Finally, because discarded tires are tires that have been worn down by travel over countless roads, they also symbolize the journey of life. In reclaiming these tires for her art, Booker engages in a resourceful act of recycling, transforming one of today's most indestructible waste products into things of furious beauty.

TOP: *Homage to Thy Mother (Landscape)*, 1996. Rubber tires and wood, 96 x 192 x 24 in. (243.8 x 487.7 x 61 cm). Collection of Jon and Melissa Butcher

BOTTOM: *Homage to Thy Mother (Landscape)* (detail)

M.W. BURNS

M.W. Burns' audio works transform viewers into listeners, drawing them into the washes of sound that fill a given space—a dense rumble, heard from a distance and emitted from wall-mounted speakers, which gradually coheres into the sound of many simultaneous voices. In *Conveyer*, Burns' work for the 2000 Biennial, one of the voices intones a litany of communications in an inward-spiraling sequence: "…a parking lot attendant recalling a message someone gave him which conveyed an idea described in a film discussed by a doorman in a story that had been shared during a conversation regarding how a coat check clerk made reference to a note about receiving a call…." Under the strain of listening, one becomes acutely aware of the ambient din —the voices, noises, coughs, and conversations typically blocked from conscious listening.

The found music of avant-garde composer John Cage tuned concertgoers' ears to the "unintended sounds" all around them. Almost fifty years later, Burns' work with sound remains a relatively unusual practice in contemporary art. His earlier installations often included architectural elements that framed otherwise empty apertures. Now that he uses sound alone, Burns regards it in relatively sculptural terms, "as a tool" that can "make and remake space."

Run-On, second installment of
*Excerpts from Notes on Details
of Observations Made in Transit*,
1999. Sound installation,
dimensions variable.
Collection of the artist

١٢٦٠ أنت م

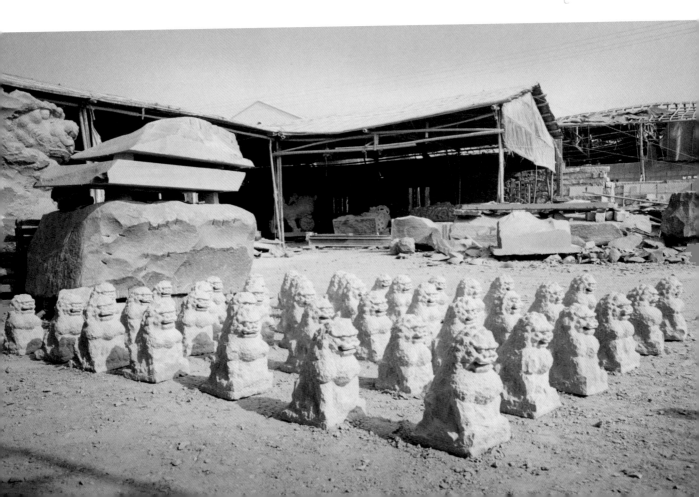

CAI GUO-QIANG

Cai Guo-Qiang, best known for his *Projects for Extraterrestrials* 69
(begun in 1989), a series of large-scale, site-specific gunpowder
explosions staged in Japan, Denmark, Taiwan, South Africa,
and elsewhere, believes that it is "necessary to think about the
small planet earth from the angle of the entire universe." His
projects, always ambitious in scale, typically require community
participation and draw on a broad foundation of religious,
philosophical, and aesthetic traditions.

Since moving to the United States in 1995, Cai has been
creating interior sculptural installations, often incorporating
traditional Chinese forms of healing into human environments.
Feng shui—literally "wind and water"—figures prominently in
his work. A complex ancient Chinese belief system of knowledge
based on how *qi*—invisible energy—flows through the universe,
feng shui is founded on the notion that people and nature should
exist in harmony. In *How Is Your* Feng Shui?: *Year 2000 Project for
Manhattan*, Cai draws on ancient tenets and contemporary
technology to enable museum visitors to consider the physical
and spiritual forces in their urban surroundings. Ninety-nine small
stone lions and three computer monitors are set into individual
niches in an environment simulating a Buddhist grotto. Browsing
computer software (created by Cai with the assistance of a *feng
shui* specialist), visitors may discover bad *feng shui* in their home
or workplace and seek to acquire, through the artist, one or more
lions. The lion, traditionally king of all beasts, is often used
symbolically to preside over negative energies. The artist goes
to the problematic location, situates the lions, and photographs
them. These photographs then replace the lions in the installation.
As the number of lions in the gallery decreases, those scattered
around other New York sites increase. *How Is Your* Feng Shui? seeks
to provoke people into reexamining their living environment and
spiritual destiny.

TOP: Preparatory sketch
for *How Is Your* Feng Shui?:
Year 2000 Project for Manhattan,
1999. Ink on paper, 8 1/4 x
11 1/2 in. (21 x 29.2 cm).
Collection of the artist

BOTTOM: Fabrication of
stone lions for *How Is Your*
Feng Shui?: *Year 2000 Project
for Manhattan*

INGRID CALAME

Ingrid Calame creates hard-boiled new roles for the classic
gestures of postwar abstraction. In *b-b-b, rr-gR-UF!, b-b-b*, the stains,
drips, and pours familiar from the work of Jackson Pollock, Helen
Frankenthaler, and Morris Louis appear completely devoid of the
luminosity and spontaneity for which these artists are so famous.
Instead, Calame carefully traces her gestural images as outlines,
then transposes them into layered silhouettes of enamel paint on
a translucent support, which itself seems to drip down the wall
and puddle on the floor. Calame finds her forms on the streets
of Los Angeles, where she traces the "the lacy stains left by the
evaporation of nameless liquids." Back in the studio, she creates
an archive, labeling each stain according to date and location
and filing it for future use.

Calame carries forward a cool Southern California "anti-
tradition" of painting, as seen particularly in the work of Ed
Ruscha, whose 1967 book of photographic portraits of parking
lot spaces showed the pavement stained with tar and oil. By
layering sequences of stains selected from her archive onto the
translucent support, she aims to establish a cinematic point of
view (she received an MFA in film studies in 1996). The result is
a unified pictorial structure molded from what Calame calls
a "constellation" of parts. Themes of crime and detection are also
evinced by her flat-footed traceries, which suggest violent
outbursts and arrested action. On a more comic note, Calame's
titles suggest an onomatopoeic soundtrack of the babble of fluids,
mixed with human grunts and hums of satisfaction.

TOP: *b-b-b, rr-gR-UF!, b-b-b*,
1999. Enamel on mylar,
348 x 300 in. (883.9 x 762 cm).
Karyn Lovegrove Gallery,
Los Angeles

BOTTOM:
b-b-b, rr-gR-UF!, b-b-b (detail)

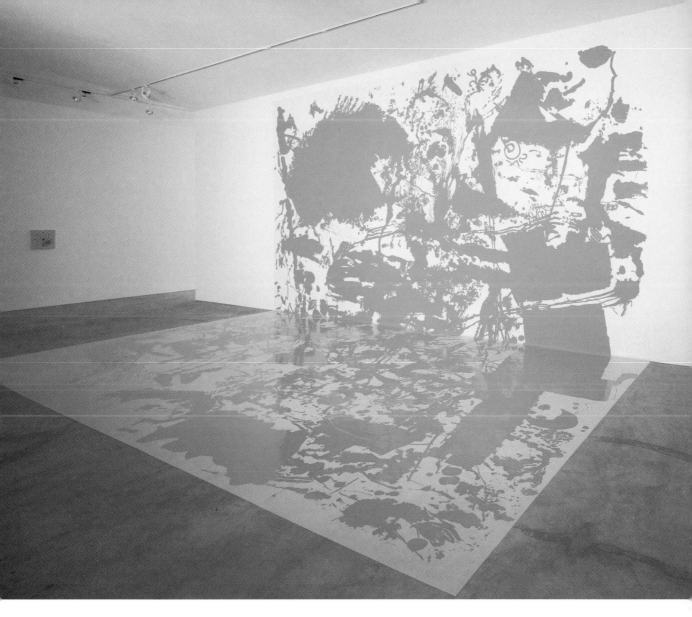

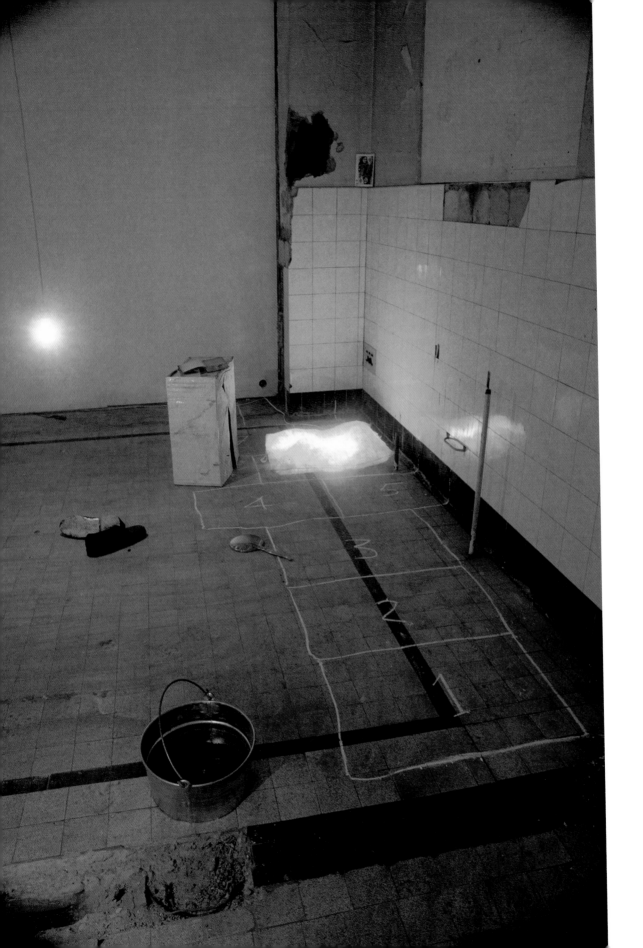

To Luis Camnitzer, the idea of being an artist is "an alienating myth." His real job, he believes, is to be an "ethical being." One of the first artists to incorporate political activism into Conceptual art, he co-founded the New York Graphic Workshop in 1965, soon after coming to New York from Uruguay. In his print shop, he made big, expressionist, and inexpensive etchings, intended for wide distribution; guerrilla-style word works soon followed, including language-based installations. In 1983, he began to focus on imprisonment and torture, at first by examining the then recently overthrown Uruguayan dictatorship. Five years later, at the Venice Biennale, he created an installation exploring what he called "the parallel between the experience of a political prisoner and that of an artist" who works within the confines of a purely formal and solipsistic definition of art. "The image of the jail [is] a metaphor for the artist's self-deception."

The Waiting Room, first shown in the 1999 Liverpool Biennial, evokes both detention rooms and prison cells. It is dimly lit by incandescent bulbs that cast barred shadows. On the floor is a wrinkled pillow illuminated from within (by a fluorescent tube), with a bed indicated by a hopscotch game drawn on the floor in front of it. Scattered around the room is an assortment of altered objects, among them a photo-etched knife, a hand mirror with a photograph of a broken mirror in place of reflective glass, a pail cut in half so that it appears sunk into the floor—all creating an atmosphere of "slightly distorted reality." The only other furnishing is a freestanding door frame, built of gas pipes, through which viewers may walk. "The doorway only serves to separate the willing from the rebellious," Camnitzer says. "In the end, all will succumb anyway and the waiting will be over."

The Waiting Room, 1999.
Installation with mixed
media, dimensions variable.
Collection of the artist

JEM COHEN WITH FUGAZI

Shot over ten years, Jem Cohen's *Instrument* is a collaborative portrait/document of the politically progressive punk band Fugazi, a group that relentlessly refuses to work within the mainstream of the music industry and instead produces its own records, eschews merchandising, and demands low ticket prices for its concerts.

Mixing black-and-white and color, Super-8, 16mm, video, concert footage, fan interviews, and even an eighth-grade public access television show on which two members of the band were interviewed, *Instrument* is deeply reflective of Fugazi's modus operandi. Unlike most rock music documentaries (and Cohen is quick to point out that this is not a documentary, but a "musical document"), in which the filmmaker provides a portrait and performance record—and also hopes to catch the band in unintentional revelations (bad behavior, psychological intimacy)—*Instrument* is a collaboration between Cohen and Fugazi. It bears the mark of significant input from the band, ranging from music composed specifically for *Instrument* to the band's participation in the actual editing process. Frequently, the band is shown playing in concert, but the musical accompaniment is of such a completely different tempo that it clearly has no relation to the image. Any attempt by the viewer to see Fugazi's members as rock stars and thus avoid focusing on the band's social messages is thereby confounded.

Instrument does not have the typical narrative arc of "rockumentaries" (as parodied by Rob Reiner in *This Is Spinal Tap*), which build to a triumphant crescendo or conclude in failure and the chaos of band breakup. By thwarting our traditional expectations of a band documentary, *Instrument* offers a tacit yet strident critique of the corporatization of music.

Portraits of Ticket Buyers: Parking Lot, Trenton, New Jersey, stills from *Instrument*, 1999. Video, 16mm film and Super-8 film transferred to video, color, sound; 115 minutes

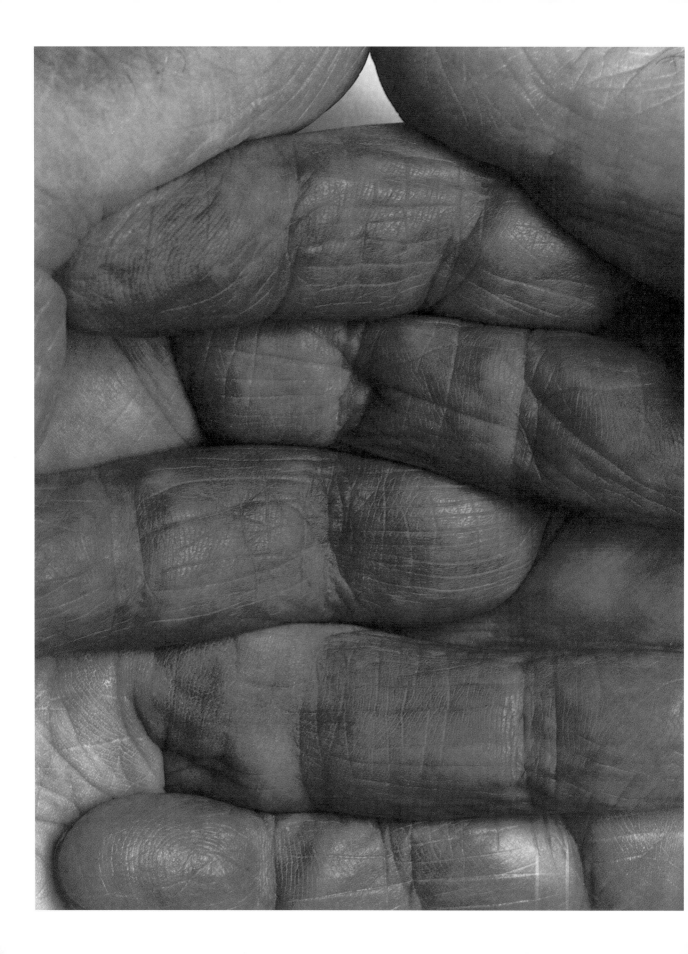

John Coplans began his career as an abstract painter, participating in the first survey of British postwar abstract art at London's Redfern Gallery in 1957. But he quit painting in 1962 to explore other careers: first as founding editor of *Artforum*, later as a museum curator and author. At the age of sixty, he took up photography and has since become known for self-portraits that investigate his manifestly nonclassical torso through large-scale close-up shots of his septuagenarian body. Coplans' photographs— all of which he refers to as self-portraits—never reveal his face, however, which confers a kind of abstract quality on the images. Coplans considers his work to be about "an investigation into my relation to myself and the universal," but his subject is also the non-idealized, and—for some—abject terrain of the aging male body that American youth-and-beauty-oriented culture excludes from its popular representations and from its field of vision.

Coplans presses the viewer into looking very closely at his aging hands in *Self-Portrait (Interlocking Fingers, No. 1)*, a work whose sheer scale—37 x 29 inches—magnifies the abstraction: we are confronted with a prosaic wrinkle in time, but also with a glimpse into a mortality that our antiseptic contemporary culture prefers not to look at. On a personal level, Coplans' entwined fingers are a poignant gesture of hopefulness, an affirmation of art and life in the still-capable hands of the aging artist.

Self-Portrait (Interlocking Fingers, No. 1), 1999. Gelatin silver print, 37 x 29 in. (94 x 73.7 cm). Andrea Rosen Gallery, New York, and the artist

PETAH COYNE

Two graceful cascades of drapery, one white, the other black, both lavishly trimmed with tassels and bows, fall from high overhead in Petah Coyne's installation. They are covered—as is the freestanding wall on which they are hung—with a layer of melted white wax, which formed beaded tracks where it fell, "like rain," says Coyne, "or tears." Barely discernible near the top, under the hoods of waxy cloth, are the averted heads of two life-size female figures—commercial statues of saints, though Coyne refers to them as nuns. On the other side of the wall, where the unpainted gray drywall and its wood framing members are left exposed, additional fragments of the "nuns" are also revealed: humbly sloping shoulders, hands lifted in prayer, and reverently inclined faces. The bulk of the sanctified bodies, however, remains hidden within the wall.

Coyne was for many years an abstractionist whose ceiling-hung work tended to be ominously dark and heavy; subsequent sculptures, still suspended from the ceiling, grew more buoyant, their frothy, white, wax-covered forms heady with ribbons and birds. Her recent work is made of braided and knotted hair forming lacelike webs that snare taxidermied animals and figures of saints. Coyne's installation for the 2000 Biennial seems to move even closer toward explicit figuration and frank narration— but it is also more private, speaking with paradoxical openness of withdrawal and concealment. Isolating facial and gestural expressions of reverence and supplication, Coyne suspends the figures in a state between immobilizing emotion and spiritual exaltation.

Untitled #945A (maquette for *Untitled #978*), 1999. Stuffed bird, ribbon, tassels, wood, fiberglass, drywall, plaster, and wax, 96 x 48 x 12 in. (243.8 x 121.9 x 30.5 cm). Galerie Lelong, New York, and the artist

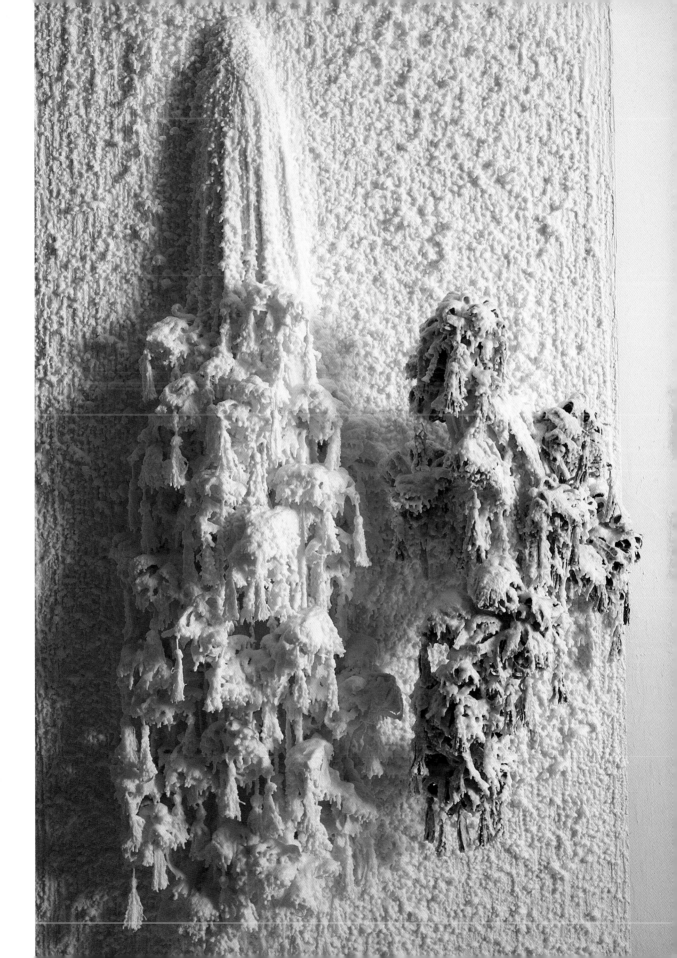

JOHN CURRIN

John Currin's paintings of the female figure are at once seductive and unnerving. With stunning technical virtuosity, Currin conjures the high art of Old Masters and the low-down allure of girlie magazine pinups. Currin began his career in 1989 with a series of imaginary portraits of suburban high school girls, loosely based on found yearbook photographs. Subsequent series have depicted society matrons and nubile young women. Though male subjects make occasional cameo appearances in his oeuvre, Currin's primary interest in the female form has led some to charge misogyny. But as curator Laura Hoptman observes, "this criticism is the result of only the most cursory visual investigation. A more complex reading focuses on his fascination with and compassion for women."

Currin cribs freely from the annals of art history: *The Old Fence* recalls the luminous flesh of Lucas Cranach's Eve and the contrapposto of Botticelli's Venus, and the placement of one sylph's hand near the other's belly suggests the Visitation theme of Christian art. Although Currin borrows, he does not, like some artists of the 1980s such as David Salle, appropriate his imagery. Rather, he mimics the Northern Renaissance and in doing so, as here, he underscores the extravagance of his formal mastery and his deep involvement with the tradition of painting.

The Old Fence, 1999.
Oil on canvas, 76 x 40 in.
(193 x 101.6 cm). Carnegie
Museum of Art, Pittsburgh:
Purchase, A.W. Mellon
Acquisition Endowment Fund

E.V. DAY

Exploding Couture is an ongoing series of installations that represent, E.V. Day says, female figures "extracting themselves from the props of social conventions." In each installation, a spectacular evening dress, cut into hundreds of pieces and suspended midair by monofilaments attached to floor and ceiling with turnbuckles, appears caught in a violent explosion. For *Bombshell*, Day created an 8-foot-high reproduction of the white dress immortalized by Marilyn Monroe in *The Seven Year Itch*. In *Black Bombshell* (1999), Day used a black gown fashioned from silk, tulle, and sequins. These works deliberately confuse sex and militarism, orgasm and detonation, invoking the mixed messages endemic to the 1950s, when the term "blond bombshell" was used as an epithet for Monroe. The plastic wires holding the *Black Bombshell* in place, for instance, are attached in patterns modeled on the crosshairs and concentric circles of gun sights; *Bombshell*, left more intact, is arranged to suggest the configuration of a mushroom cloud.

The *Exploding Couture* series is more celebratory than analytical. Rather than present conventional femininity, Day captures the process of active transformation. The *Bombshells* express, as one critic has noted, the "delirium…of a rapturous 'liftoff.'"

Bombshell, from the series
Exploding Couture, 1999.
Dress, monofilament, and
turnbuckles, 192 x 240 x 240
in. (487.7 x 609.6 x 609.6 cm).
Track 16 Gallery, Santa Monica,
California, and the artist

WILLIAM De LOTTIE

William De Lottie is an artist who has been engaged in a decades-long wrestling match with the nature of painting. After making a series of sensual, heavily pigmented, monochromatic unstretched canvases throughout the 1970s, De Lottie introduced an unpredictable range of new materials—ravaged stretcher bars, bright standing lights, pure pigment hanging inside large industrial vinyl bags, aluminum pipes, C-clamps, and, recently, adolescently belligerent fabrics.

De Lottie's compositions are typically nonhierarchical, with each of the individual components equally aggressive, raw, and enigmatic. *Love Letters Straight from Your Heart, Part I* begins with a black-and-white latex ground on the wall and includes a number of elements projected 5 or 6 feet out on aluminum poles, such as rectangles of fluorescent fabric and a hunk of foam with a red fur patch. On the verso of these rectangles are photocopies of found photographic reproductions, including a drawing made by an Arab child, Isaiah Berlin as a boy (who resembles the artist at the same age), Adolf Eichmann at his trial in Israel, and a Teutonic-looking blond woman in a bathing suit. *Love Letters* is lit with three high-wattage quartz lamps that add an intensity to the colors and a delicate array of shadows. A group of metal folding chairs is set up at a distance, facing the piece.

De Lottie passionately embraces complexity, indeterminacy, and change. None of his installations (which he sometimes calls "systems") is ever fixed. Each mutates, either in response to a new site, or, more frequently, in his own studio at his whim. Frequently, and with seemingly little regret, De Lottie cannibalizes older works to make new ones.

The artist lives in rural eastern Connecticut and is usually fully employed at several non-art-related jobs. Although well-informed about contemporary art issues, De Lottie places himself outside the mainstream art world.

TOP: *Love Letters Straight from Your Heart, Part I*, 1999. Fabric, aluminum plates and poles, photocopies, latex paint, and quartz lamps, 120 x 216 x 360 in. (304.8 x 548.6 x 914.4 cm). Derek Eller Gallery, New York, and the artist

BOTTOM: *Love Letters Straight from Your Heart, Part I* (detail)

ROMAN DE SALVO

San Diego-based Roman de Salvo transforms everyday materials into playfully imaginative, unexpected objects that evoke surprise and often humor. *Face Time*, a project created especially for the 2000 Biennial, consists of reusable café trays with designated divisions that hold a three-item "Biennial Meal" served during the exhibition at Sarabeth's Restaurant at the Whitney. Formally, de Salvo's trays conjure up a TV dinner, cosmetics case, and laptop computer wrapped up into one. Made of gray vacuum-formed thermoplastic (the industrial material commonly used in electronics manufacturing), each tray is divided into three food compartments; where one might expect a computer screen, there is a folding upright section containing a mirror.

The title of de Salvo's project refers to the vernacular phrase "face time," meaning communication involving the physical presence of people. This recently coined argot has emerged to distinguish face-to-face contact from the increasing amount of time spent communicating through various electronic means. *Face Time* is a reflection of the commodification of time in today's cyberworld.

The trays themselves are updated versions of the TV dinner, popularized in the 1950s, which also commodified time by assimilating the social ritual of dining into the rhythms of mass culture. For some viewers, an unexpected glimpse into the computer screen-mirror will interrupt familiar eating patterns, provoking laughter, disgust, and discussion.

De Salvo's direct engagement with his audience extends the legacy of Conceptual artists such as Hans Haacke and Vito Acconci, who incorporate spectator participation into the structure of their work. *Face Time* ultimately asks the viewer to reflect on the social relations of technology, food, and time in a context— the museum restaurant—where one does not expect to be confronted with art, or, for that matter, face time.

Face Time prototype, 1999.
Medium-density fiberboard,
mirror, and enamel,
8 x 11 1/2 x 14 in.
(20.3 x 29.2 x 35.6 cm).

Collection of the artist;
courtesy Quint Contemporary
Art, La Jolla, California

In 1987, when an art collector arrived at his door in Bessemer, Alabama, Thornton Dial had already been making "things" out of found materials for forty-five years. He had never exhibited them, however, nor had he designated them as "art" or as the work of an "artist." After his "discovery," Dial began to make large-scale paintings on canvas whose narratives dance between figuration and abstraction and between cultural traditions.

Swirling forms and colors applied in textured layers tap the deep roots of African-American culture and the pulse of its regenerative inventiveness and spirituality. Dial's surfaces, often painted with thickly applied brushstrokes, incorporate the detritus of everyday life: wood, rope, scrap metal, cloth, animal bones, old carpeting, metal fencing, pinecones, fishing lures, rubber gloves, paintbrushes. "Everything in this world gets used up, gets buried in the ground," Dial notes. "I dig it up and give it another life."

Dial's narratives are often allegories of African-American cultural and historical struggles, referring, for example, to civil rights, the diaspora, and economic displacement. But like all of his work, *Stone Walls (Diana's Land)* and *Bad Picture (Diana's Last Ride)*— each from his five-work cycle *The Death of Princess Di*—resist facile categorization. Incorporated into the abstract painterly surface of *Stone Walls* are recycled, bent-metal flora that Dial originally made many years ago as flower holders for neighbors and friends to set on graves; also attached are metal fragments from the patio furniture workshop operated by the Dial family. Ultimately, what Dial weaves into the fabric of his contemporary allegory of a princess is a cycle of death and life: in Dial's art of regeneration and renewal, the end is always the beginning.

LEFT: *Stone Walls (Diana's Land)*, 1997–98. Mixed media on canvas, 132 x 144 in. (335.3 x 365.8 cm). Collection of William S. Arnett

RIGHT: *Bad Picture (Diana's Last Ride)*, 1997–98. Mixed-media assemblage, 87 x 105 x 41 in. (221 x 266.7 x 104.1 cm). Collection of William S. Arnett

KIM DINGLE

During the 1990s, Kim Dingle became known for her paintings and installations depicting tales of exuberant, uninhibited, and irrepressible girlhood. Her accomplished but decidedly homespun facture and unconventional themes explore the alter ego of prim and proper girls who act out various states of primal aggression in their own version of a *Lord of the Flies* regime.

63MG 4ME, a modified vintage 1963 MG Midget (with vanity California license plates that read "63MG 4ME") installed on top of a large pink comforter, combines Dingle's personal obsession with "wild girls" with another obsession: cars. The MG is painted pink and the bodywork is done by Miss Dingle (as the artist playfully refers to herself). Dingle calls the work a Priss Mobile, anthropomorphizing it as an "adolescent, a big baby car on a big soft blanket." The hubcaps are adorned with lacy, fancy socks, while the black rubber tires stand in for patent leather Mary Janes. But there is also a dark side to the prim and cuddly Priss Mobile: the engine drips bloodred oil.

The obsession of Californians—and California artists— with cars is well known. What distinguishes Dingle's work from earlier, male efforts—for example, Joe Goode's *1969 Calendar of L.A. Artists in Their Cars*—is its gender-twisting excavation of the dark side of sugar and spice and all things nice. In the fast lane of a fantasy world free from the repression that civilization exacts from its "good girls," Dingle's *63MG 4ME* embodies unstoppable girlhood id.

63MG 4ME, 1999 (detail).
MG Midget with mixed media,
approximately 48 x 144 x 53
in. (121.9 x 365.8 x 134.6 cm).
Sperone Westwater, New York,
and the artist

ANTHONY DISCENZA

In Anthony Discenza's video projections, the flow of information
that constantly streams through television takes on the properties
of a physical medium. Quickly surfing from channel to channel
for hours at a time, Discenza tapes raw material, which he then
edits into abstractions. Forms, colors, pictures, and patterns
shift rapidly on screen, accompanied by the sounds of television
similarly stretched and compressed into incoherent noise.
Phosphorescence consists of seven sequences linked by such titles as
"The Shoreline at Dawn" and "Fossil Records." While watching,
the mind races to recognize familiar faces and formats (talk
shows, news, shopping programs), then relaxes to entertain larger
frames of reference. The screen divides, almost cell-like, into
horizontal dark and light bands which briefly resemble a Mark
Rothko painting. In other sequences, pictures roll and collapse on
screen, appear temporarily highlighted, as though X-rayed,
or frantically distorted, as though atomized.

Discenza's digital collages, forged in the rapid fire of media
culture, bring to mind Nam June Paik's video sculpture and Robert
Rauschenberg's silkscreen paintings. Ultimately, it's the notion
of residue that intrigues Discenza, who describes what he sees
in TV's endless emissions as "toxic and tragic." "In response,
I have attempted to literalize and accelerate their decay through
automatic, alchemical processes intended to collapse the source
material back on itself." What remains are futuristic fossils,
sampled from an environment that is daily inundated by them.

Still from *Phosphorescence*,
1999. Video, color, sound;
14 minutes. Collection of
the artist

TARA DONOVAN

Tara Donovan refines massive amounts of material into quiet, yet commanding sculptural installations. *Ripple* covers a room-size piece of floor with gossamer threads of cut and teased electrical cable. The billowy surface is patted gently into shape, leaving impressions that radiate concentrically outward from its center. As is typical of Donovan's art, the labor involved borders on the obsessive in its intense, compulsory process. The creation, placement, and disbursement of fragile mass often blur the focus of the work—it is at once process and product. Other sculptural installations by Donovan have involved hundreds of shards of torn tar paper, pieces of roofing felt, half a million toothpicks, and sixteen thousand balloons filled with sand. And since Donovan never uses adhesives to attach individual elements, each time a piece is installed she must reenact the time-consuming process of assembling and, later, dismantling it.

Donovan's repetitive, tasklike processes and use of industrial materials aligns her with such Postminimalist artists as Eva Hesse and Richard Serra. She brings to this tradition an absorbing sense of scale, which itself seems informed by Earth art, another important movement of the 1970s. Gazing over the terrain *Ripple* makes of the floor, one might think of Robert Smithson's *Spiral Jetty* (1970) or, more generally, of ancient earth monuments: Donovan's miniature mounds expand to the proportions of mountains in a landscape that one enters with the mind's eye. Ultimately, Donovan's art is about the fluidity of the movement from process to object, and from object into timeless abstraction.

TOP: *Ripple*, 1998. Cut electrical cable, 191 x 191 in. (485.1 x 485.1 cm). Reynolds Gallery, Richmond, Virginia, and the artist BOTTOM: *Ripple* (detail)

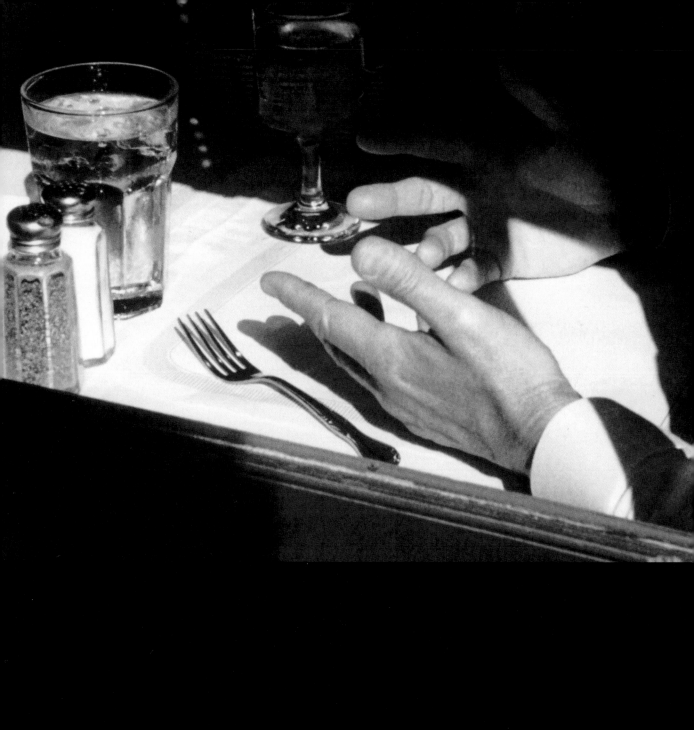

Nathaniel Dorsky's *Variations*, a montage of meticulously composed
and edited images ranging from the near abstract to the
extraordinarily specific, from bustling city life to sublime nature,
takes us into the realm of pure vision. The second in a projected
trilogy of films, *Variations* explores answers to a question the artist
posed: "What tender chaos, what current of luminous rhymes
might cinema reveal unbridled from the daytime world?"

Dorsky's aim in *Variations*, as in all his work, is to bring cinema
back to "a direct connection with the visual world—the simplicity
of seeing." Clarity of vision and meaning derives less from the
content of the images than from associations among them:
objects are perceived through screens, veils, and other visual
obfuscations; they are observed as reflections; they are seen only
as shadows; they appear to us not as objects but as beautiful
abstractions. Yet individual shots can also have the opposite effect:
in looking at a pair of boots, we are drawn to the "thingness"
of a thing—in this case the bootness of the boots.

Variations' visual impact is so striking that we forget it is silent.
Silence, often a badge of courage in avant-garde and experimental
film traditions, is an integral and vital presence in Dorsky's work.
Moreover, *Variations* is projected at silent speed (18 frames-per-
second, as opposed to the standard 24 fps), the better to maintain
what Dorsky has called "the flow between the viewer and the
screen" and "the flickering threshold of cinema's illusion."

Still from *Variations*, 1992–98.
16mm film at 18 fps, color,
silent; 24 minutes

JAMES DRAKE

James Drake explores geographic and emotional borders, the
blurred areas between affluent societies and developing countries,
between hope and desperation, freedom and incarceration, male
and female. A native Texan based in the border town of El Paso,
Drake spends years patiently learning about and interacting with
members of fringe communities, photographing their daily lives
and small transformations. In a previous series of photographs,
Tongue-Cut Sparrows (1998), he observed women gathered outside
a local jail and disclosed the secret language of signs they used
to communicate with incarcerated loved ones.

In this most recent series, *Que Linda La Brisa (How Lovely the
Breeze)*, Drake documents the world of a group of Mexican
transvestites and transsexuals, whom he came to know through
his involvement with an organization dedicated to improving
the lives of "sexual professionals" through the prevention and
treatment of disease and abuse. His aim is not voyeuristic,
but rather to show people pressed by the tension of marginalized
existences. To cross over into these subcultures, he first builds
a relationship of trust with his subjects. The people photographed
in *Que Linda La Brisa*, most of whom came to America from central
Mexico, are shown at home getting ready for work (which takes
place primarily at a bar called La Brisa, located in the border town
of Juárez, Mexico). Their lives seem imprisoning, regulated by hard
routines and dangerous business. An alarm clock and a picture
of Christ stand over an unkempt bed in a squalid pink room.

TOP: *Lorena's Bed*, from the series *Que Linda La Brisa (How Lovely the Breeze)*, 1999. Chromogenic color print, 15 1/2 x 23 1/4 in. (39.4 x 59.1 cm). Pamela Auchincloss, Arts Management, New York; Rhona Hoffman Gallery, Chicago; Adair Margo Gallery, El Paso, Texas; and the artist

BOTTOM: *Lisa and Tanya*, from the series *Que Linda La Brisa (How Lovely the Breeze)*, 1999. Chromogenic color print, 15 1/2 x 23 1/4 in. (39.4 x 59.1 cm). Pamela Auchincloss, Arts Management, New York; Rhona Hoffman Gallery, Chicago; Adair Margo Gallery, El Paso, Texas; and the artist

THERESA DUNCAN
AND JEREMY BLAKE

Prior to the release of *The History of Glamour*, animation artist Theresa Duncan produced a popular line of CD-ROM games for girls. After seeing the work of artist Karen Kilimnik, whose paintings and drawings feature waiflike young women from the pages of fashion magazines, Duncan was inspired to examine both the dark and the potentially empowering implications of glamour. Like Kilimnik, she uses the iconography of popular culture to create a new "grammar of glamour."

With the collaboration of digital artist Jeremy Blake, who was responsible for both the art work and the art production, Duncan wrote and directed *The History of Glamour*, a short, animated video about teen singer-songwriter Charles Valentine and her meteoric rise to celebrity.

The History of Glamour is a pseudo-"rockumentary" that explores the nature of celebrity by providing a portrait of Valentine as an artist. Combining the hallmarks of portrait documentary with the more recently established conventions of the celebrity biography (a mainstay of MTV), the video details Valentine's rise to fame, from farm girl in Ohio to the paragon of glamour for New York's image- and opinion-makers. Along the way, the video satirizes the empty cult of celebrity in both the art and fashion worlds, most markedly in its send-up of Diana Vreeland and a much-discussed recent show by artist Vanessa Beecroft.

In addition to the drawings by both Blake and Kilimnik, *The History of Glamour* features music by Kathi Wilcox of Bikini Kill and Brendan Canty of Fugazi. The result is a hybrid work that creates a new video grammar, and a new glamour grammar, by combining the codes of fiction with reality, fashion with art, and animation with MTV.

Still from *The History of Glamour*, 1998. Video, color, sound; 39 minutes

LEANDRO ERLICH

Leandro Erlich's installation *Rain* consists of three freestanding, self-enclosed structures punctuated by house windows. Each structure's four-sided "exterior" is actually created out of an interior perspective of a house—painted sheetrock, window trim, and wainscoting. Similarly, the structure's "interior" is actually lined with exterior brick. In the otherwise darkened space of the gallery, the viewer peers through the windows and catches glimpses of a simulated rainstorm. Through a number of windows, we see water droplets falling during flashes of high-intensity light that suggest lightning bolts and make the "rain" glitter like diamonds—all to an accompanying soundtrack of thunderclaps. The effect of *Rain*, at once poetic and discomforting, turns on the artist's reversal of the familiar order of things: the outside becomes inside, the inside becomes outside.

Erlich's installation destabilizes our "natural" view of rain, overturning common perceptions of what is real and what is not. Like the Surrealist strategies of René Magritte, the "contrived natural phenomena," as Erlich calls them, evoke the psychological space of the uncanny, the disturbing realm in which the familiar becomes strange.

Rain, 1999 – 2000 (detail).
Mixed media with water and
light, three parts, 96 x 192 x
264 in. (243.8 x 487.7 x 670.6
cm) overall. Kent Gallery,
New York; Moody Gallery,
Houston; and the artist

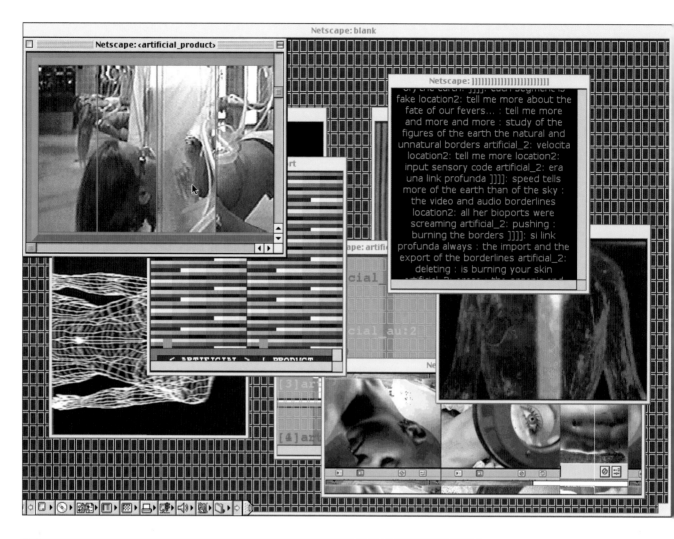

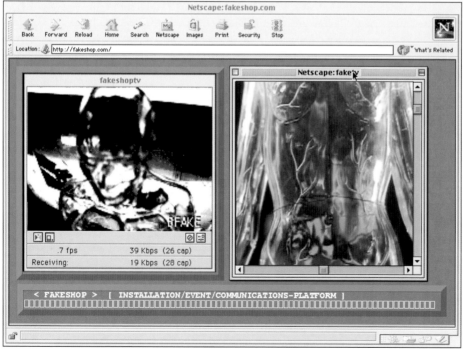

Fakeshop is an ongoing electronic art project that combines elements of installation, performance, and web design. Its core members are Jeff Gompertz, Prema Murthy, and Eugene Thacker. Founded and designed by Gompertz, the website serves a dual function: broadcasting live events in real time through the use of Internet technologies such as CU-SeeMe video-conferencing and RealAudio broadcasting, and later exhibiting extracts from these performances in what Gompertz describes as "a series of multimedia tableaux vivants." A visit to the website automatically opens a series of windows that reproduce text along with still and moving images, accompanied by a soundtrack, which together document and develop Fakeshop's live performances. The live aspect of the project develops in close collaboration with other digital artists, musicians, and theorists.

In 1999, at an arts festival in Linz, Austria, Fakeshop re-created *Multiple Dwelling* (1998), a performance inspired by the writings of French critical theorists Gilles Deleuze and Félix Guattari on the concept of a "Body Without Organs." A literal interpretation of the idea is offered by another source for the project, a scene from the Hollywood movie *Coma*, in which the bodies of involuntary organ donors float, suspended in air. Ultimately the project suggests a body not bound by palpable matter, but, like the Internet, dispersing in all directions through transitory particles.

Digital stills from
Fakeshop, 1997–present
(*www.fakeshop.com*). Website
Core members:
Jeff Gompertz, Prema Murthy,
Eugene Thacker;

Contributors:
Ricardo Dominguez, Terence
Kelleman, Yasahiro Kondo,
Diane Ludin, Vlastamir
(Volcano) Mikic, Bruno Ricard

VERNON FISHER

For twenty-five years, Vernon Fisher made polyglot paintings, and the occasional freestanding sculpture, in which he combined the languages of modernist abstraction, photo-based figuration, popular culture, and original fictional texts, stenciled and stamped right through the imagery. Born in Texas, where he still lives, Fisher has what might be called a Southern gift for narrative, and discernible inclinations toward the Texas-born Robert Rauschenberg as well as West Coast artists, among them Ed Ruscha. In his new paintings, Fisher dispenses with written narrative, but not with an especially adroit variety of Conceptualist brainteasing. The *Zombie* series refers back to his earliest works, painterly abstractions that invoked a kind of sublimity he now finds "a little embarrassing." Heavily textured, richly colored fields of scumbled and cracked acrylic paint are enlivened with remarkably real-looking houseflies, made of cast epoxy; the flies seem to have landed momentarily on the canvases, and also, with equal randomness, on the walls beside them.

Titular suggestions to the contrary, the *Zombies* are not, Fisher says, a eulogy for modernism. "As the flies alight on the paintings and wall indiscriminately," he writes, "I'm hoping the work will be seen as an affirmation of transience and conditionality." Abstraction in these works is seen not as a corpse but as a living corpus, a body of matter dense and nourishing as any other, and perfectly capable of being lit upon in ways having nothing to do with its own (presumed) purpose. The flies, then, can be seen as switching devices between readings of the painted surface as figure and as ground, as image and as object—or as a straight story with its own comic punch line.

TOP: *Taza*, from the *Zombie* series, 1999. Acrylic on canvas with cast epoxy, 84 x 84 in. (213.4 x 213.4 cm). Charles Cowles Gallery, New York, and the artist BOTTOM: *Taza* (detail)

SUZAN FRECON

Suzan Frecon's art is radically self-contained. To frame a 1995 exhibition, she offered the following passage from the writings of a twelfth-century Christian monk: "A work of art can only be comprehended by looking at it—and no description is substitute for this." When talking about her abstract paintings, Frecon focuses on techniques and materials (these include hand-ground pigments, antique papers, and gold leaf). Yet even these spartan comments in no way limit the experience of looking at works which the critic John Yau aptly dubs "philosophical objects."

Frecon's oeuvre consists of two distinct bodies of work— paintings and watercolors. The paintings are fields entirely blocked in by solid geometric shapes. Close in value, the colors are reminiscent of the jewel-like tones of Byzantine icons. When a passage of burnished gold appears to bring light into the painting, the effect is immediately contained, never flashy. There is neither background nor foreground, and there are no negative shapes: every inch of surface is equally weighted. Clearly, a shift of any single element would necessitate a complete restructuring of compositions that read as architectures without space. Frecon's watercolors, though completely different in spirit, embody the same sense of contiguousness. Loose lines and organic shapes strike a balance with the blank paper supporting them. Frecon sometimes even predetermines the number of marks she will make prior to picking up the brush. For her, painting is a discipline in the most rigorous sense of the word.

LEFT: *untitled (nwe)*, 1998. Oil and gold leaf on panel, 38 7/8 x 24 x 1 1/2 in. (98.7 x 61 x 3.8 cm). Lawrence Markey Gallery, New York, and the artist

RIGHT: *strokes then turn*, 1999. Watercolor on paper, 17 1/2 x 13 1/4 in. (44.5 x 33.7 cm). Collection of Sarah-Ann and Werner H. Kramarsky

BRIAN FRIDGE

Brian Fridge's video *Vault Sequence* develops the inventive cosmological imagery the artist previously explored in three-dimensional media. *Globe Diagrams*, a series of sculptures begun in 1993, were created out of store-bought, graphite-marked globes that Fridge refers to as "toy models of cosmic events."

Vault Sequence consists of about seven minutes of unedited black-and-white video images of slowly swirling steam and ice crystals suspended in the brightly lit vault of the artist's home freezer. The low-fidelity production values and visual syntax of Fridge's abstractions conjure up both the look of television snow—the visual equivalent of white noise—and a galaxy of stars as seen in time-elapsed science photography. *Vault Sequence*, however, also has the feel of a nifty discovery made during a homespun science project, a quality that is punctuated by the fact that Fridge's "freezer" almost puns on his own frosty patronym.

Fridge is reinventing transcendental cosmology—the theological conception of the starry sky as a harmonious, heavenly manifestation —as his own random Do-It-Yourself Freezer Cosmos. In place of transcendent fixtures there are what the artist describes as "video star clusters, video nebulae, video galaxies and video black holes, each representing the universe." As he mischievously notes with Duchampian wit, "the universe is useful because it is self-defined and at the service of nothing and is in this respect similar to art."

Stills from *Vault Sequence*, 1997.
Video, black-and-white, silent;
7 minutes. Collection of
the artist

DARA FRIEDMAN

Dara Friedman's *Bim Bam* consists of two films, one projected
directly above the other, with similar but not identical images
of a woman repeatedly opening a door, crossing the threshold,
and then slamming the door. Both of the images are turned
sideways, resulting in a virtually abstract composition defined by
two horizontal bands of color. With both doors closed, the viewer
gazes at two superimposed, midnight-blue rectangles. As the
top door opens, a radiant light spills out from a central void that
is framed in green. When the bottom door opens, a similarly
dazzling light pours out from a space framed in orange.
The effect recalls Mark Rothko's Color Field paintings suffused
in otherworldly light.

A soundtrack with a door slamming runs independently
of the film loop and sets up unpredictable rhythms and tensions
that reinforce the work's abstract and narrative aspects.
The relentless and unsynchronized repetition of the jarring noise,
along with the emotionally violent image, reveals Friedman's
excellent sense of timing and narrative wit as she exposes the
mechanics of filmmaking.

Bim Bam demonstrates a sophisticated approach to form
and structure, augmented by a wry approach to narrative.
Like Friedman's previous works, it conveys the influence of her
teacher, Austrian filmmaker Peter Kubelka, one of the leading
figures in the Structuralist film movement of the 1960s, in which
film was reduced to its formal essence.

Still from *Bim Bam*, 1999.
16mm film installation with
two slot-loading projectors,
metal armature, CD player,
and speakers, dimensions
variable. Collection of
George Lindemann

JOE GIBBONS

In *Multiple Barbie*, Joe Gibbons plays a psychiatrist treating a Barbie
doll afflicted with multiple personality disorder. He treats the
supine and out-of-it Barbie with a variety of pharmaceuticals
and attempts to let out her other personalities in the hope that,
if given voice, they might just go away. The result is murder,
as Barbie's homicidal "Bobby" personality fatally smashes his head
in with a Barbie-sized hammer.

Gibbons presents *Multiple Barbie*, shot with a Fisher-Price
PXL2000 "Pixelvision" camera, as a fixed-camera, single-take film,
but one periodically disrupted by close-ups of Barbie that appear
to reflect her psychosis. The *mise-en-scène* is spare, consisting only
of Barbie, in the extreme foreground of the frame, and Gibbons,
who speaks to the mute Barbie, and is clearly seen manipulating
her head for responses.

Given the stunning number of psychoactive and other drugs
Gibbons has put Barbie on, as well as her muteness, one comes to
see Barbie/Bobby's actions as a subversion or rebellion against the
Barbie stereotype—Barbie in revolt. And indeed, *Multiple Barbie*
relies on Gibbons' gift for deadpan humor (Amy Taubin has called
him the "Keaton of the avant-garde"). *Multiple Barbie* also
exemplifies Gibbons' shift away from technique, which had once
preoccupied him, and which he came to reject as the retrograde
formal preoccupation of the avant-garde.

Still from *Multiple Barbie*, 1998.
Video, black-and-white, sound;
9 minutes

ROBERT GOBER

Like a scene from a strangely disturbing fairy tale, Robert Gober's
sculpture of a sink and legs stages an unexpected glimpse
into a traumatic, but uncertain, childhood narrative. The work
also evokes the aesthetic strategies of René Magritte, the Belgian
Surrealist painter who turned the fastidious illusionism
of everyday objects into uncanny provocations. Gober's sculpture
surprises us by unexpectedly juxtaposing a sink and a pair of
legs (both common elements in the artist's lexicon) and uprooting
each from its original, functional context.

Wax renderings of leg fragments—here they seem to be
a child's legs—dangle down in place of water spigots. Adorned
with socks, sandals, and even actual human hair, Gober's work
gains at least part of its disturbing power from its evocation
of reality itself rather than an aesthetic substitute. Like virtually
all his sculptures, however, the components (except the hair)
are laboriously hand-crafted in the studio.

In a preparatory sketch, the spigot holes in the face of Gober's
sink suggest a pair of evil eyes, indicating that the sink might be
inhabited by *mana*, a spirit presence—the kind of ancient,
animistic thinking that often breathes terrifying life into the fairy
tales of E.T.A. Hoffmann and the Brothers Grimm, while blurring
the boundaries between the living and the dead. Gober's sink
and legs open a psychological subterrain of fear and dread: we are
confronted with a hidden narrative suddenly brought to light.
Opaque and open-ended as its lack of title suggests, Gober's work
ultimately leaves us grappling with disturbing feelings that cannot
be adequately resolved or even named.

Untitled, 1999. Plaster,
beeswax, human hair,
cotton, leather,
aluminum, and enamel,
33 1/2 x 40 x 24 3/4 in.
(85.1 x 101.6 x 62.9 cm).
Philadelphia Museum
of Art; Gift (by exchange)
of Mrs. Arthur Barnwell

JILL GODMILOW

Jill Godmilow has experimented with the documentary film
over the course of her thirty-plus years as a filmmaker. Many
of her earlier films, particularly *Far from Poland* (1981), question
a documentary's claims to truth by combining actual footage
with reenactments and fiction in an attempt to explore two areas:
the subjects on screen and the means by which cinema is used
to communicate.

Godmilow's *What Farocki Taught* is an example of metatextual
filmmaking *par excellence*. The film is an exact replica of German
filmmaker Harun Farocki's 1969 documentary *Inextinguishable Fire*.
Farocki's original is a 23-minute-long, black-and-white film in
German, about Dow Chemical's development of napalm B during
the Vietnam War. *What Farocki Taught*, in color and in English,
restages the original film shot-for-shot, often superimposing
Inextinguishable Fire's shots (complete with subtitles) over the newly
staged scenes. The purpose of Godmilow's version is to engage in
what she calls a "dialogue" with the original.

Framing the remake of Farocki's film is Godmilow's voice-over
in a prologue and in an epilogue in which she appears on camera.
In these sequences, Godmilow explains the appeal of the original:
Farocki's critique of corporate complicity in the Vietnam War
and his agitprop style of filmmaking. In *What Farocki Taught*,
Godmilow extends Farocki's arguments through an even more
self-conscious approach to form, referencing the original through
image and sound and expanding the target in the epilogue
from Dow Chemical to an entire corporate culture that willfully
distances itself from the effects its products have on people.
What Farocki Taught challenges spectators to question conventional
approaches to documentary at the same time that it enables
Farocki's original film to receive the American screening it was
denied upon release.

*The Napalm research group
at Dow, studying the evening
news,* stills from *What Farocki
Taught,* 1998. 16mm film,
color, sound; 30 minutes

Players

shuki from Israel
jae from Taiwan
boris from Russia
tina from US

Will someone betray boris in the year 2000?

Ken Goldberg uses robotics and the Internet to investigate the effects of distance and technology on human perception, posing the question "how do we know what we know?" To describe his inquiry, he has coined the term "telepistemology," conflating the words "telecommunications" and "epistemology," the latter the study of human knowledge. Goldberg's latest project, *Ouija 2000*, was created in collaboration with a team of engineers and designers at the University of California, Berkeley, where Goldberg is an industrial engineering professor.

Visitors to the website manipulate a Ouija board, located in Goldberg's laboratory, via the mouse on their computer, responding to a series of questions posed on the site. The collective movements of up to twenty viewers at a time are transmitted to a computer which moves the Ouija's planchette, mounted on a telerobotic arm, across the board. In this way, *Ouija 2000* exploits the interactive potential of the Internet. A live streaming video of the board's progress is visible on the webpage, allowing a disparate group of players to watch the outcome of their combined efforts. In his tongue-in-cheek introduction to the project, Goldberg describes Ouija boards as "the world's oldest telecommunications devices." Equating occult mysticism with the web, the artist slyly critiques the mystification of new technologies and satirizes our increasing reliance on the Internet for "reliable" information.

Digital still from *Ouija 2000*, 2000 (*ouija.berkeley.edu*). Website. Commissioned by the University of California, Berkeley Art Museum (originally presented as Ken Goldberg/MATRIX 186/ *Ouija 2000*). Project team: Billy Chen, Rory Solomon, Steve Bui, Bobak Farzin, Jacob Heitler, Derek Poon, and Gordon Smith; Graphic design: Gil Gershoni; Illustration: Dave Garvey; Flash: Paulina Wallenberg Olsson

KOJO GRIFFIN

Self-trained as an artist, Kojo Griffin studied child psychology
at Morehouse College, a specialty that has given him a clear visual
subtext for his richly layered figurative paintings, which explore
the dynamics of interpersonal and especially family relationships.
Griffin's subjects are children who are victims of physical,
emotional, or sexual abuse. Their iconic images radiate simple
loneliness. Lending the paintings paradoxical immediacy is the
technique of substitution, as practiced in psychotherapy: instead
of children, Griffin's characters are stuffed animals or other
innocent playthings who enact episodes of violence, neglect,
anguish, and molestation. The figures are set against backdrops
that have visual complexity but not spatial depth, an effect
produced with luminous applications of acrylic and oil on wood,
over which Griffin stamps woodblock prints of Chinese characters
and sketches the outlined figures of twisted strands of DNA
and schematic renderings of machine parts. These latter suggest
the cyclical nature of abuse and the socialized mechanizations
of patterned behavior.

The Chinese hexagrams are from the *I Ching*, an ancient guide
for right living, which sometimes provides titles for Griffin's
paintings. The *I Ching* system is based on the idea that all
situations arise from a combination of the universal polarities
of the yin (feminine, passive, and gentle) and the yang
(masculine, active, and powerful). It offers guidance and cautions
against base influences. The *I Ching* characters Griffin includes
suggest strategies for avoiding such influences, but he ultimately
offers no solution for overcoming the explosive trauma of abuse
which occurs silently within familial and communal contexts.

No. 32 Duration; Line No. 3,
1999. Mixed media on panel,
60 x 48 in. (152.4 x 121.9 cm).
Collection of Linda Mitchell
and Jeffrey Diamond

There is our
room.
not now.
I want you to
treat me like a
English royal bitch.
I like thats
That's what would
really get me
I'm serious.

You melt
Them in the
streets

He hasn't
even fucking
Called me.

When I was cycling home
last night. guess who I met?
no.
Seconds.
There on the
lying on the ground.
out cold. we leaved a
Pissed we wanted to
 hear the press
 we have to Chat
 everythi
and will always be

I got her up after repeatedly
calling her name etc
and walked her home (hotel)
She could hardly walk
all over the place, man
totally Pissed!
at first I couldn't see it
was a person on the floor

well you think about
it, you are married or
whatever for life, in
a lot of ways relationships
are the most important —
and we get no training

It's funny how people —
Like the world and the
taxi driver — even after
they know you can't
hear — talk to you —
even when they're not
talking at them.

A profound fascination about the nature of—and the human compulsion for—communication lies at the heart of Joseph Grigely's inconspicuous and seemingly casual installations. This artist-philosopher-archivist-poet, deaf since childhood, has transformed the pragmatic method in which people communicate with him into a visually resonant series called *Conversations*. Composed of the ephemeral scraps of notebook paper, napkins, Post-its, business cards, and matchbook covers on which people have written in the daily course of Grigely's activities, the works are poetic renderings of conversations. Arrangements of paper rectangles and squares in irregular grids on the wall are accompanied by a small framed paragraph of Grigely's own thoughtful, typeset commentary. The ink smears, hurried scribbles, emphatic underscoring, and crossings out of the messages convey the humor and pathos in everyday social dynamics.

In the process of recording the banalities, fragments, and minutiae that characterize spoken dialogue, Grigely transforms an auditory experience into an evanescent visual image—effectively collapsing the distinctions between speech and writing, hearing and reading, image and text. In his exploration of language as subject and medium, Grigely is equally attentive to formal means in the arrangements of colored paper, the relationship between articulate marks and silent spaces, and the gridlike configurations of rectangles and squares. Grigely's mining of both formal and narrative possibilities yields rich and meaningful insights into the complexities and subtleties of human interaction.

Untitled Conversations, 1998–99.
Ink and graphite on paper,
dimensions variable.
Collection of the artist

HANS HAACKE

126 Because the work Hans Haacke is exhibiting in the 2000 Biennial
was not fully conceived by press time, he is represented in this
catalogue by a text and two photographs he took at the Whitney
Museum's recent exhibition, *The American Century: Art & Culture
1900–2000*, funded primarily by Intel Corporation. One photograph
shows the Intel Pentium III PC tower (left) and the prototype of a
future PC (right) that were installed in a vitrine in the exhibition's
Orientation Gallery as if they were sculptures. The other
photograph is of the closing image of the accompanying video,
which reads "Make Some Sense of America" (the advertising
campaign slogan for Part I of the exhibition). These photographic
interventions reflect the artist's ongoing efforts to interrogate
the social, political, and economic determinants of art and
the institutions of art. In several works of the past three decades,
including *On Social Grease* (1975) and *Mobilization* (1976), Haacke
has illuminated the complex agendas of corporate sponsorship
of museum exhibitions. The text Haacke publishes here recounts
the efforts of New York Mayor Rudolph Giuliani to suppress
an exhibition at the Brooklyn Museum of Art containing works
he found offensive.

Installation details of the
Orientation Gallery for
*The American Century:
Art & Culture 1900–2000*
at the Whitney Museum of
American Art, New York, 1999

Material on a new work of mine for the Whitney Biennial is not available in time for the production deadline (mid-October 1999) of this catalogue. In my works, I often allude to the context in which they are first seen. In that vein I submit for this catalogue two photos I took in the Orientation Gallery of the Museum's exhibition *The American Century: Art & Culture 1900–2000*, as well as a brief observation.

At this writing, Mayor Rudolph W. Giuliani of New York is trying to put the Brooklyn Museum of Art out of business because it is exhibiting the painting of a black Madonna by Chris Ofili, a black, Catholic artist from London. The Mayor's description of the work to the press is patently wrong, and it is not Catholic-bashing as he claims. This is a ploy to rally voters who believe his claim that the painting offends religious beliefs.

Irrespective of whether Ofili's work does what Rudolph Giuliani purports, it should be noted that, according to the mayor, the First Amendment and the doctrine of separation of church and state, embedded in the American Constitution, do not apply to public institutions and institutions receiving public funds. He seems to share that opinion with the Nazis, who mounted an exhibition entitled *Degenerate Art* in Munich in 1937. Attached to each of the works — all removed from German museums of modern art — was a sign denouncing the works as having been "paid for with the taxes of the German working people."

HANS HAACKE, October 1999

TRENTON DOYLE HANCOCK

Trenton Doyle Hancock considers all of his works
autobiographical, "a regurgitation of the things I have seen
and heard." Some, such as *Mound*, feature his "Coon" characters,
caustically named after a slur against blacks. For the opening of
a 1998 exhibition of his paintings and drawings, Hancock dressed
up as his alter ego, "Big Coon," and, having deprived himself
of sleep for three days, spent the evening sleeping in the center
of the gallery. He was periodically woken by the gallery director,
who spoon-fed him Jell-O. As he ate, party balloons of the same
color as the Jell-O popped out, like excrement, from behind
him. The spectacle served as a humorous reflection of Hancock's
own "production," in which he turns whatever life serves into
direct and potent art.

While Hancock's imagery is often spun from dreams and life
experience, much of his subject matter deals with basic human
needs and urges, the exploration of life's bottom lines—eating,
digesting, defecating—as typified in *And for My Next Trick, I'll....*
An elaborately drawn personage emitting a brown smudge faces
a group of fragmentary, outlined onlookers. The character's
visceral midsection, pictured on an attached, separate sheet
of paper, offers a cutaway view of biological business as usual,
annotated with the words "goo-goo" and "time after time."
The delicate lines and tender colors that characterize Hancock's
rendering sweeten these grotesqueries, drawing us, unguarded,
into aggressive, even combative, pictures.

TOP: *And for My Next Trick,
I'll...*, 1999. Acrylic and collage
on paper, 22 1/4 x 26 in.
(56.5 x 66 cm). Dunn and
Brown Contemporary, Dallas,
and the artist

BOTTOM: *Mound*, 1999. Acrylic
on paper, 42 1/2 x 37 3/4 in.
(108 x 95.9 cm). Dunn and
Brown Contemporary, Dallas,
and the artist

JOSEPH HAVEL

Sculptor Joseph Havel arrests and transforms everyday objects, making "nothing," as he puts it, into "perfect nothing." For *Curtains*, what started out as a pair of ordinary curtains becomes a floating presence that is in reality a freestanding sculpture. Havel started working with draped fabrics in 1997, when a crumpled bed sheet caught his eye. Paradoxically, the medium of these transformations is cast bronze, whose solid mass nevertheless captures every wrinkle, as well as the apparently lightweight volumes of the fabric. The results are of an offbeat monumentality: things do not become larger than life, they are simply lifelike.

Until these most recent works, Havel had been working primarily with found objects, creating organic forms out of lampshades, shirt collars, and other everyday items. Casting is a relatively recent feature. He chooses things that are curvaceous and capable of expressing buoyancy, while holding their structure, and then amasses them into elegant forms. In the shirt-collar works, Havel was ultimately dissatisfied with the critical response, which saw them in terms of gender and labor issues. His interests lie firmly in the unremarkable and fleeting. As critic David Pagel observed, Havel lets "ordinary materials rise to the occasion to flesh out the full possibilities of a few passing moments."

Curtains, 1999. Bronze, 104 x 24 x 46 in. (264.2 x 61 x 116.8 cm). Collection of the artist; courtesy Devin Borden Hiram Butler Gallery, Houston; Dunn and Brown Contemporary, Dallas; and Galerie Gabrielle Maubrie, Paris

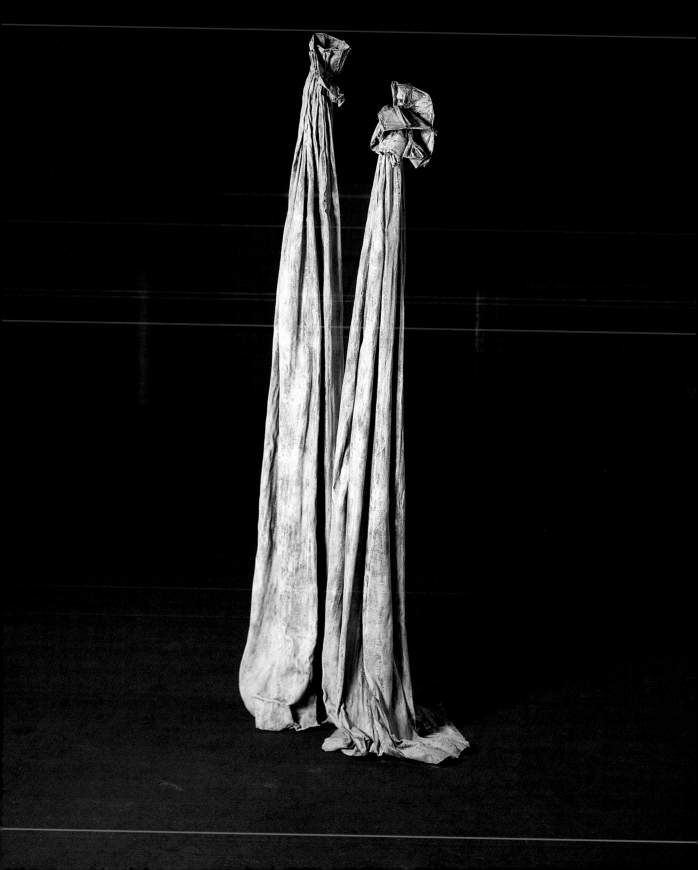

SALOMÓN HUERTA

Chicano artist Salomón Huerta subverts pictorial conventions
and challenges assumptions about identity in a series of portraits
—some full-length, others tight head shots—in which the back
of the subject faces the viewer. Occasionally, a head with close-
cropped hair turns to offer a near profile, but the identifying
features—eyes, nose, and mouth—remain imperceptible. Every
detail Huerta does include—such as the skin folds at the neck
or the curve of an ear—he paints with Renaissance precision,
yet the racial and sexual identity of the subject remains somewhat
ambiguous. Historically, portraits commemorate the sitter's
prestige, authority, or beauty. Huerta's anonymous images, by
contrast, with their monochrome backgrounds and standardized
postures, recall mug shots.

In another series, based on "drive-by" snapshots taken from
a moving car in South Central Los Angeles, Huerta shifts his
focus from people to dwellings. The neighborhoods in this area
are predominantly Chicano or Latino and the houses are typically
embellished with lawn ornaments or elaborate landscaping.
The artist edits these decorative elements out of the image,
just as the portraits are stripped of identifying characteristics.
His elimination of such details can be read as a criticism of the
recent sociocultural tendency to neutralize cultural differences;
alternatively, Huerta may be implying that the true nature
of identity lies not in overt physical characteristics but in what
can't be made visible.

TOP: *Untitled House*, 1999.
Oil on canvas, 14 x 14 in.
(35.6 x 35.6 cm).
Creative Artists Agency,
Beverly Hills, California

BOTTOM: *Untitled Head*, 1999.
Oil on canvas, 11 3/4 x 12 in.
(29.8 x 30.5 cm). Patricia
Faure Gallery, Santa Monica,
California, and the artist

ARTHUR JAFA

For Arthur Jafa, video projection can approach and even exceed
the condition of painting: he strives for a virtually static image
that holds the viewer's attention simply by means of the formal
relationships of composition, color, and subject. In addition
to these traditional, painterly elements, Jafa asserts video's ability
to activate an image from within by way of its seemingly internal
light as well as by its dynamic element of temporal change.
These elements of projected light enable Jafa to, as he says,
"make a moving image that is as transfixing as sound…that has
the vibrancy of live song."

In his recent video projection, *Untitled (Griffin)*, Jafa presents
an image of a luminous interior. The projection is imbued
with a diffused yet highly saturated light that seems to tremble
with internal energy. The tension between stillness and dynamism
endows this otherwise innocuous scene with a vague
portentousness. Insofar as the image appears to literally contain
energy, it begins to suggest something hidden or on the verge
of appearing. Jafa's subtle manipulation of the visual field takes
the banal and renders it ominous.

Still from *Untitled (Griffin)*,
1999. Video projection
installation, color, silent;
running time varies

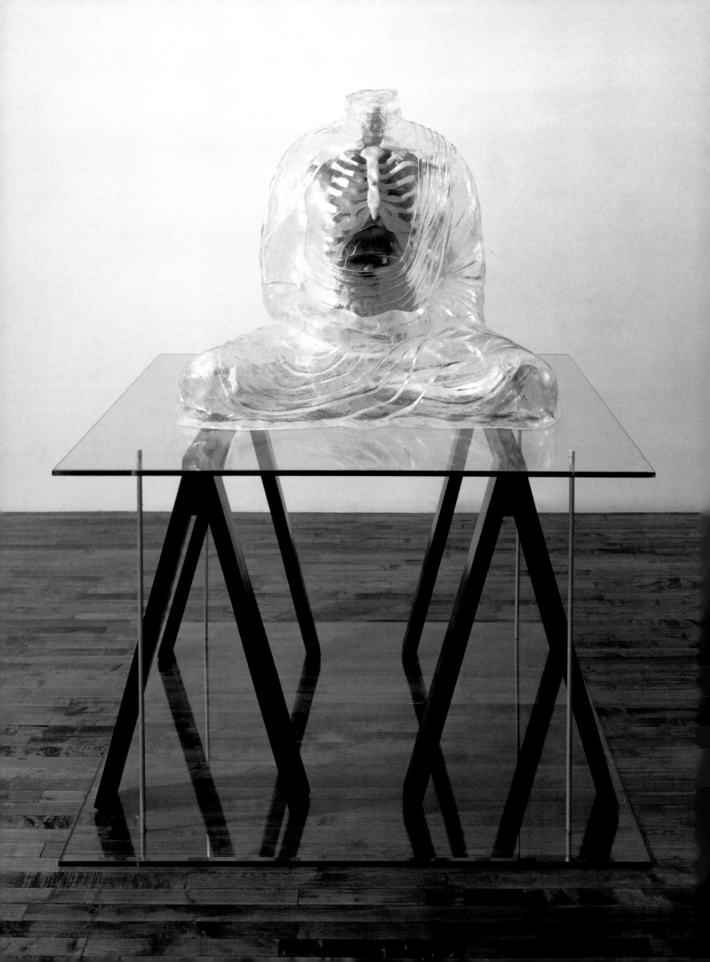

MICHAEL JOO

Michael Joo's sculptural installations examine cultural difference
and the fluid nature of identity. Meticulously crafted from
a diverse range of materials, Joo's work often engages a quasi-
scientific vocabulary, evident in the anatomical model, pacemaker,
and tinted intravenous bags that comprise his installation for the
2000 Biennial. All these objects serve to explore the relationship
between Eastern and Western worldviews, as seen by the Korean-
American artist. In his early work, Joo often used himself as
a subject, posing as a nude female pinup on decals adorning the
fuselage of an American B-29 bomber flown in the Korean War
or "swimming" on videotape through two thousand pounds
of the Chinese food additive MSG. Joo's references are Pan-Asian—
he has also cast his limbs as those of the Hindu god Siva and used
images of Hong Kong movie star and kung fu master Bruce Lee.

Joo's conceptual concerns transcend racial politics to touch on
universal themes. In *Visible*, one of three elements of his Biennial
installation, a large, urethane cast of a decapitated Buddha sits
in the lotus position. The transparent figure has the skeletal
and intestinal infrastructure of an instructional anatomical model.
The headless body is transformed into a vitrine, a distancing
device preventing the viewer from directly experiencing
the "visceral" and symbolizing the empty quest for spiritual
enlightenment. Joo is "interested in that moment in-between,"
and his formally complex sculptures, where identity is in a
perpetual state of flux, lead viewers to the intersection of the
physical and the metaphysical.

Visible, 1999. Urethane, nylon,
glass, wood, lacquer, and
aluminum, 60 x 48 x 48 in.
(152.4 x 121.9 x 121.9 cm).
Anton Kern Gallery,
New York, and the artist

KURT KAUPER

Kurt Kauper's *Diva Fictions* are exquisitely rendered paintings of imaginary opera singers posed majestically against vivid, monochrome backgrounds. Though Kauper's work employs a realist vernacular formally consistent with portraiture, he rejects that association, along with its implied veracity. Kauper prefers "the word painting, [which] immediately signals artificiality." Each diva is a fictional composite, drawn from a wide range of references and intended to reveal identity as an artificial construct. None of the women is conventionally beautiful. In fact, their faces are strangely androgynous, resisting an easy interpretation of gender.

Diva Fiction #8 stands enveloped in a burgundy cloak, her hands clasped in front of her. Elaborate gold embroidery adorns her shoulders, echoed by the toes of her shoes, which peek out from below her satin gown. Though her figure is turned in profile, she faces the viewer with a coy smile. The painting's dramatic impact is heightened by its slightly larger-than-life-size scale.

Kauper perceives a parallel between the arts of painting and opera because both are often considered irrelevant in the age of digital information. But his paintings defy obsolescence. In the words of critic David Pagel, they "flaunt the fact that art is not an anesthetic, and that painting, itself, is a diva: supreme, unassailable, and beyond belief."

Diva Fiction #8, 1999.
Oil on panel, 88 x 47 1/2 in.
(223.5 x 120.7 cm). Collection
of Heidi Schneider

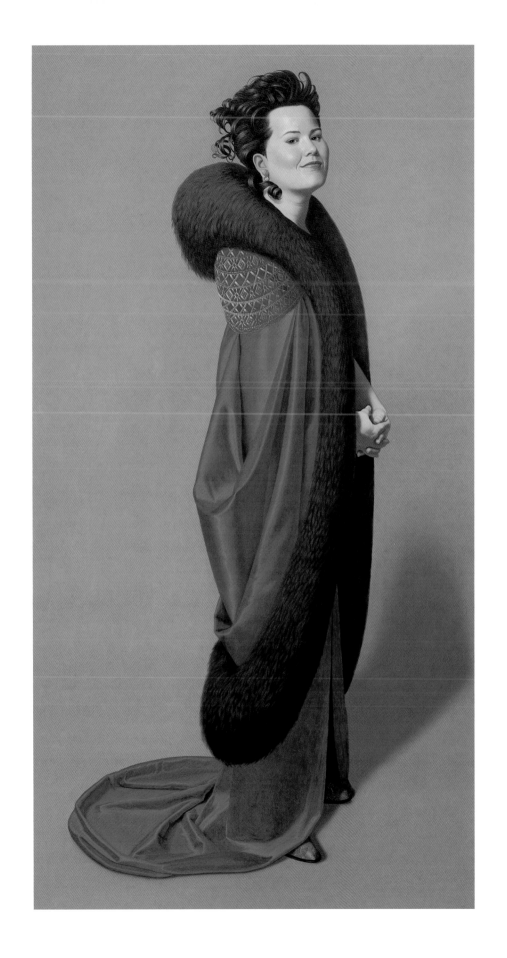

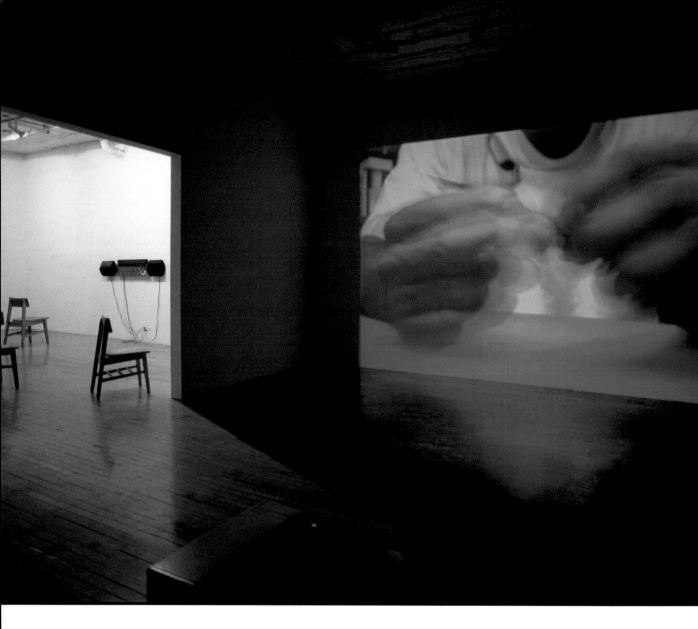

"I'm somewhat resisting your original request that it has to be something that I experienced. But as far as actually seeing, I'm not even sure. I heard about this piece. It was done in California, I believe in the 70s. But you know, it maybe wasn't even done. I *have* seen the location. What it is is a collector's home, who commissioned a work by an artist. The artist moved a wall, a property line wall, a stone wall. He gave the next-door neighbors an extra, I felt it was an extra six square feet of property. And that was the piece. I like telling people about it, because I like it a lot. But I don't think I actually saw it."
— Excerpt from *An Inadequate History of Conceptual Art*

Silvia Kolbowski's video and sound installation *An Inadequate History of Conceptual Art* proposes a reconsideration of the various histories of Conceptual art—works created from about 1965 to 1975, in which the idea was more important than the actual execution. Kolbowski's history was made from the perspective of the artists and the original reception of their works. One of Kolbowski's aims was to "question the 'smoothness' of the return of conceptualism"—the revival of exhibitions of Conceptual art in museums and galleries after a conspicuous absence during the 1980s.

For *An Inadequate History of Conceptual Art*, Kolbowski contacted sixty artists by mail, of whom forty agreed to "briefly describe a conceptual art work (not their own) of that period which they personally witnessed/experienced at the time." The audio track of their responses, arranged chronologically, consists of an unedited CD recording of the respondents speaking anonymously about their memories of particular events in the history of Conceptual art; some of these "memories," however, are at least partly erroneous, and in at least one case, coyly spurious.

The video contains only close-up shots of each artist's hands, filmed during the moment of recollection. These images are then edited to be out of sync with the recorded voices, strategically disrupting the authority of speech and the normally smooth syntax of history. The rhetorical effect of Kolbowski's editing introduces numerous "pauses" into these recollections and, just as important, into prior histories. While Kolbowski encourages a more nuanced reconsideration of Conceptual art, she also poignantly reminds us of the inadequacy of even her own efforts to record the facts. History, like memory, is subject to error and omission.

Installation view of *An Inadequate History of Conceptual Art*, 1999. Video and sound installation, dimensions variable. American Fine Arts, Co., New York, and the artist

HARMONY KORINE

Harmony Korine has said of his first feature film, *Gummo*,
"I wanted to create a new viewing experience with images
coming from all directions. I had to create some kind of scenario
that would allow me to just show scenes, which is all I care
about. I can't stand plots, because I don't feel life has plots."
Indeed, summarizing *Gummo*'s plot is neither easy nor particularly
illuminating. The film begins with the vivid account of a tornado's
effects, repeatedly returns to two paint-sniffing adolescent boys,
who hunt neighborhood cats and sell the corpses to a butcher,
periodically revisits two teenage girls and their explorations of
beauty and sexuality, and makes a brief stop so that the two boys
can kill, with rigorous disinterest, an acquaintance's vegetative
grandmother. *Gummo* has no particular narrative trajectory,
nor does it end in any conclusive way. This meandering reflects
Korine's insistence, following Jean-Luc Godard, that a film should
have a beginning, a middle, and an end, but not necessarily in
that order.

 Shot in Tennessee, where Korine grew up, and using mostly
family, friends, and local residents (Korine cast Nick Sutton in
one of the two lead roles after seeing him on a Sally Jesse Raphael
show called "My Child Died from Sniffing Paint"), *Gummo* presents
the viewer with a series of dispassionate vignettes remarkable for
their realism and complete lack of narrative rhythm. "To create
a cinema of obsession, a cinema of passion," as Korine puts it,
he has constructed a film in which the historical identity and daily
concerns and desires of its working-class characters are neither
romanticized (à la *Norma Rae*) nor patronized.

Still from *Gummo*, 1998.
35mm film, color, sound;
95 minutes

Warhol (1928–1987)

...aster, 1963

...crylic silkscreen on linen

...FINE ARTS, BOSTON; CHARLES H. BAYLEY PICTURE ...G FUND

Louise Lawler's photographs probe the institutional framework that fixes the boundaries of art and the spaces in which art is seen. The photographs used in her work created for the 2000 Biennial were taken at the Whitney's recent exhibition, *The American Century: Art & Culture 1900–2000*. All of these photographs show actual size, variously cropped images of museum wall labels for works by Andy Warhol. In *The American Century*, these labels had been affixed on top of Warhol's *Cow Wallpaper*, originally installed at the Leo Castelli Gallery in 1966 and, five years later, in a Whitney Museum Warhol exhibition.

Lawler's *On a Wall, On a Cow, In a Book, In the Mail* is a five-part work: three different photographs are installed on three different floors of the Museum, each in the same relative location. The other two works are a photograph postcard—available to Museum visitors—and an image created expressly for distribution in this exhibition catalogue, a space where the museum, and not the artist, frames or recontextualizes art into art history.

The shifting context of how art becomes art and of where it is seen, reproduced, and distributed is Lawler's subject. Warhol is especially relevant since his own works encouraged such shifts. The cow, for example, was an image borrowed from a book on animal husbandry that Warhol remade as wallpaper and exhibited as art. Ultimately, Lawler's own "framing" points to the always fugitive character of an art work—not timeless and universal, but fluctuant in a world of changing contexts and systems of distribution.

TOP: *Pink and Yellow and Black IV (Space Allotted)*, from the series *On a Wall, On a Cow, In a Book, In the Mail*, 1999. Catalogue page, 5 x 8 in. (12.7 x 20.3 cm). Metro Pictures, New York, and the artist

BOTTOM: *Pink and Yellow and Black V (1928–1987)*, from the series *On a Wall, On a Cow, In a Book, In the Mail*, 1999. Postcard, 4 x 6 in. (10.2 x 15.2 cm). Metro Pictures, New York, and the artist

RUTH LEITMAN

Ruth Leitman's feature-length documentary *Alma* can be read
on three levels: as a portrait of an idiosyncratic, middle-aged
Southern woman, Alma Thorpe, and her daughter, Margie;
as an essay on the move from disavowal to discovery; and as
an exploration of humor as both denial and defense.

 Alma is modeled on the Maysles Brothers' *Grey Gardens*,
a portrait of an eccentric mother and daughter who are related
to Jacqueline Kennedy Onassis, and is frequently compared to
Terry Zwigoff's *Crumb*, the fiction film *Whatever Happened to Baby
Jane?*, and to the literature of Flannery O'Connor. By Leitman's
own reckoning, the film "started as a piece about the past between
Margie and her mother, but Alma's mental health forced us into
the present." Leitman's three-and-a-half-year tenure with the
family, as well as Alma's increasingly unstable health, precipitates
the investigation into and discovery of secret family histories.
Alma's recollection of her "first date" is actually her rape at age
seven by an uncle. The remarkable repeated use of a head-and-
shoulder photograph of a young Alma and a lover, which is
finally revealed as the upper part of a full-frontal, post-coital
nude photograph, foreshadows Margie's eventual realization of
her own traumatic place in family history, as she discovers that
it was she who, as a little girl, took the picture.

 If Alma herself is Southern Gothic, Margie is Southern
Pragmatic. The film belies the stereotype that working-class
Southerners have little or no self-consciousness. Margie,
who co-produced *Alma*, is extraordinarily aware not only of
the gap between her mother's perception of life and its reality,
but also—potentially—of the breach in her own perceptions.
And Alma herself, even with her deteriorating physical health
and gradual descent into psychosis, is not without the capacity
for self-analysis.

Still from *Alma*, 1998.
16mm film, color, sound;
94 minutes

In Annette Lemieux's installation *Foot Play*, one of ten pairs of cast-wax feet faces a low brick wall, another plays on either end of a wood seesaw, and a third stands in a corner of the room, a dunce cap drawn down to its ankles. There is a single foot holding a paintbrush between its toes, and one nudging a rubber ball. As is generally true of Lemieux's work, which ranges across many media and a great deal of twentieth-century political and cultural history, *Foot Play* has a complex conceptual genealogy. It is in some ways a retrospective project, incorporating elements from Lemieux's earlier work, such as the bricks and seesaw. The feet had figured in a group of big 1988 paintings made with the artist's footprints, and also in freestanding sculptures of the early 1990s. Some of the associations invoked in *Foot Play* are personal (for instance, Lemieux was made to wear a dunce cap as punishment for chewing gum in school), some professional (as in the foot with a wick at its top, named *Bob* in homage to Robert Gober, who has made wax sculptures of human legs). Lemieux also cites Robert Wilson's "knee plays"—short, intimate preludes and interludes in *Einstein on the Beach* (1976) and other works—in which actors move to the front of the stage to perform vignettes, including a vaudevillian slapping of hands on knees and feet. But the elements of *Foot Play* mark universal emotional experiences as well, from alienation to flat-out, feet-on-the-floor jubilation.

Ultimately, *Foot Play*'s elaborate system of cross-references can be seen, in the kind of rich visual pun that characterizes Lemieux's work, as a set of footnotes, conjuring absent bodies of text. Caught off-balance, face to the wall, or in a moment of play, the missing figures enact a ghostly dance that is funny, melancholy, and deeply affecting.

Foot Play, 1997 (Left to right, top to bottom: *Kick the Ball, Paintin', Corner Piece, Duel, Halt, Bob, Break, Waitin',* and *Trip*). Mixed-media installation, approximately 168 x 360 in. (426.7 x 914.4 cm). McKee Gallery, New York, and the artist. *Corner Piece*: Private collection

LES LeVEQUE

At first viewing, *2 Spellbound*, by sculptor and installation artist
Les LeVeque, appears to be simply a condensed version of
Alfred Hitchcock's 1945 film *Spellbound*. But *2 Spellbound*'s complex
image and sound design is a visual and aural palimpsest bearing
the traces of twentieth-century cultural icons such as Sigmund
Freud, Salvador Dalí, Hitchcock, and even filmmaker Ken Jacobs
(and his 35mm experiment with kinetoscope footage).

By cutting Hitchcock's original film from 111 minutes to just
under eight, reversing every other frame, and accompanying
the images with electronic dance music and select sound bites
from the film, LeVeque prompts viewers to focus on Hitchcock's
highly evocative Freudian themes of trauma and memory.
The act of condensing the film speaks to Freud's concept of
condensation as a process of making manifest what is submerged
in the unconscious, an issue at the center of *Spellbound*'s narrative.
Furthermore, the frame reversals generate what LeVeque
calls a "hallucination of transference" as characters mirror or
are superimposed onto themselves or each other.

The speed with which the images progress transforms
Hitchcock's trademark slow-paced suspense-building into
a sense of the inevitable—of events and people progressing
toward an inescapable fate—an effect heightened by the pulsating
beats of the stereo soundtrack. The almost hypnotic effect
of the superimposed images, which form kaleidoscopic designs,
also blurs the distinctions between self and other so that the
characters become almost interchangeable. As they intermingle,
they participate in a complex, yet ecstatic dance that is as surreal
as the Dalí-designed dream sequence of Hitchcock's original.

Stills from *2 Spellbound*, 1999.
Video, color and black-and-
white, sound; 8 minutes

SHARON LOCKHART

Sharon Lockhart performs conceptual transfusions, instilling
her photography with properties of cinema (such as narrative),
while loading her films with conventions of photography
(a fixed camera angle, for example). All are informed by her
overriding interests in strategies of advertising and the precision
and romance of Northern European painting—as well as in
the hypnotic monotony and minimal action of dance and
experimental film of the 1970s, which appear in her 1997 film
Goshogaoka, featuring a Japanese girl's basketball team doing
warm-up drills. In the triptych *Enrique Nava Enedina: Oaxaca Exhibit
Hall, National Museum of Anthropology, Mexico City*, the protagonist
repairs a stone floor behind a transparent screen in a gallery
installation. The screen, oddly, puts him on display, like an art
work. It also serves as a framing device that animates Lockhart's
sequence of photographs (each the size of a small movie screen),
while Enedina holds our gaze in silent tension. Indeed, "yearning"
is a word Lockhart's work frequently conjures.

Lockhart is one of a new generation of artists working in
the photographic tradition associated with Jeff Wall and Cindy
Sherman. However, while Sherman constructed and starred in
her own works, Lockhart, like many of her peers, acts as director.
She casts her subjects like actors, scouts for locations, props
and lights each scene, frames the picture through the camera lens,
discusses what she's looking for in the shot with assistants, and
then steps back to assess the whole scene, while a professional
camera operator takes the picture. And yet, for all the control
that goes into making them, Lockhart's images ultimately take
on a candid reality of their own, as if the artist has only happened
upon the scenes.

*Enrique Nava Enedina: Oaxaca
Exhibit Hall, National Museum of
Anthropology, Mexico City*, 1999
(detail). Three chromogenic
color prints, 49 x 61 1/2 in.
(124.5 x 156.2 cm) each,
49 x 217 1/2 in.
(124.5 x 552.5 cm) overall.
Museum of Contemporary Art,
San Diego; Museum purchase,
Contemporary Collectors Fund

ANNE MAKEPEACE

For over fifteen years, Anne Makepeace has been writing,
producing, and directing a variety of fiction and nonfiction
films. In *Baby, It's You*, she directs the camera toward herself,
documenting an emotionally and physically painful year
in which she and her husband try to have a baby. The process
forces the over-forty Makepeace to consult with fertility doctors
and extended family members in what becomes an attempt
to understand the past as much as to create a future for herself
and her husband, writer Peter Behrens. Combining such disparate
documentary techniques as the voice-over, the interview, and
vérité camera work with sonogram and fiber-optic footage from
the medical procedures involved in hormone treatments
and egg harvesting, the film examines both the literal interior
and exterior traumas Makepeace endured.

Although Makepeace may be the film's immediate focus,
Baby, It's You is more broadly concerned with the construction
and definition of the contemporary family. Intercut with the
footage of Makepeace's experiences with modern reproductive
technologies are interviews with family members: Makepeace's
two brothers, an aspiring polygamist and a goat farmer; and
Behrens' two sisters, an artist in Boston and a lesbian in Montreal,
the latter raising a baby girl (the product of artificial insemination)
with her partner. Serving as the subtext to these stories is
Makepeace's exploration of a decades-old decision to have a then
illegal abortion, a choice that takes on new poignancy in light
of her present difficulties.

At the end of the film, Makepeace and Behrens "make peace"
with their inability to have a child and, subsequently, with each
other. Along the way, *Baby, It's You* offers a compelling examination
of an entire generation in the midst of redefining family life.

Still from *Baby, It's You*, 1998.
16mm film, color, sound;
56 minutes

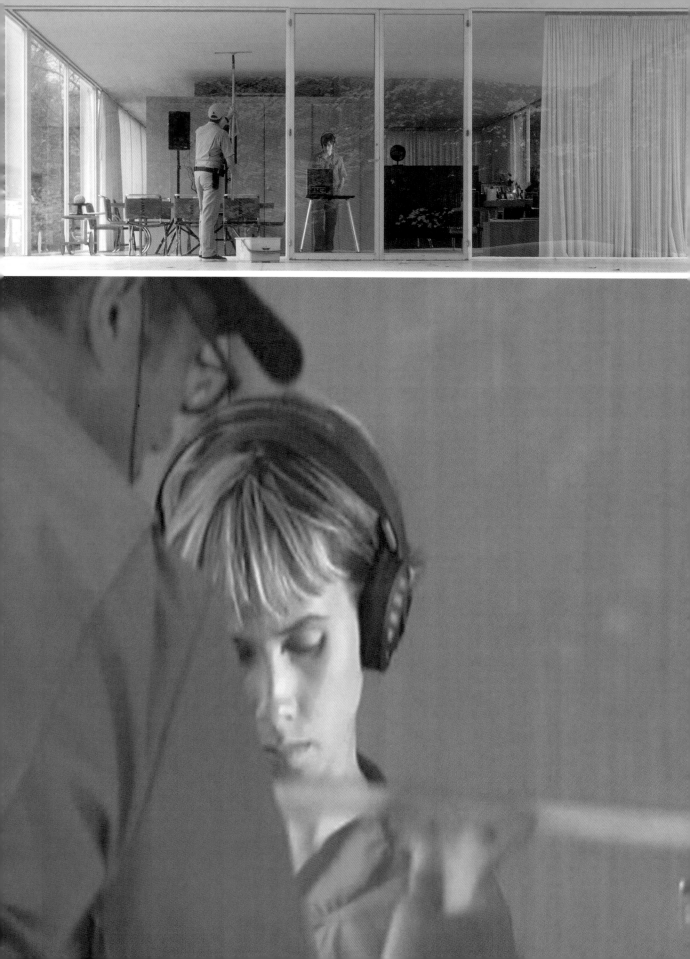

IÑIGO MANGLANO-OVALLE

Iñigo Manglano-Ovalle's *Le Baiser/The Kiss* is an installation that combines video projection with a three-dimensional representation of Ludwig Mies van der Rohe's Farnsworth House (1945–50), the only private residence in the United States designed by the legendary modernist architect. Manglano-Ovalle's video projection serves as the glass wall, the picture plane of traditional figurative painting. It shows the artist washing, over and over, the actual front glass wall of the Farnsworth House. The task reads as an endless but unsettling caress that slowly reveals the theoretical and practical flaws in Mies' architectural gem. Modernist architecture's ostensible clarity, purity, and perfect relation of form to function are pictured by Manglano-Ovalle as irremediably compromised by contingent realities—by class distinctions and by the messy details of lived experience. While the artist washes the outside wall, a woman wearing headphones stands inside as a kind of sensory renegade—she plays records at a portable DJ station while watching a television monitor, oblivious to the continuous caress being performed just beyond her. The music she presumably listens to—a remix by sound artist Jeremy Boyle of a guitar solo originally recorded in the 1970s by the rock band Kiss—can be heard through earphones hung inside the installation. But *Le Baiser*'s predominant sound is of windows being washed—a sound that suggests a big, smoochy kiss.

In previous work, Manglano-Ovalle used materials as diverse as DNA samples and immersion tanks to show that vehicles for exploring personal identity can double as mechanisms of external control. One important project involved wholesale role reversal, with the artist encouraging his "subjects" to make their own videotapes. The reversibility of the instruments of power is also an important motif in *Le Baiser*. A glass house can be a seat of omniscient surveillance and, reciprocally, a powerful trap.

TOP: Still from *Le Baiser/The Kiss*, 1999. Video installation and projection, CD audio recording, and mixed media, dimensions variable. Max Protetch Gallery, New York, and the artist

BOTTOM: *Le Baiser/The Kiss* (detail)

JOSEPH MARIONI

Joseph Marioni makes paintings of colors in which surfaces convey
an imagery of paint, not brushstrokes or gestures, and colors
have no symbolic value. Despite these apparently Minimalist
means, however, the works are lush, resonant, and, in the most
traditional sense, painterly. Who needs metaphor, they imply,
when just the medium of paint alone can create more than words
can describe? This challenge has sustained Marioni's work for
over thirty years, during which time the essentials of his art have
changed little.

Marioni paints with a roller, applying layers of paint in broad,
flat swags that drip downward. He cultivates signs of paint's
viscosity by tapering his vertical canvases almost imperceptibly
toward the bottom, in effect exaggerating the tendency of paint
to flow inward, away from the sides, as gravity pulls it down.
The canvas's lower stretcher bar is rounded, causing the paint
to collect and hang in pendulous drops that reveal a surprising
range of colors, all veiled behind the seemingly monochrome
facade. To underscore his art's structural nature, Marioni precisely
describes the medium of each painting as "acrylic and linen
on stretcher." In contrast, his titles offer only the most general
indications of what is in store for the patient viewer: *Blue Painting,
Red Painting, White Painting*—the words simply fail to capture
the extraordinary nuances of these deeply colored surfaces, which
change constantly with the light that pools, reflects, and shifts
with the viewer's gaze.

Blue Painting, 1997.
Acrylic on linen, 24 x 22 in.
(61 x 55.9 cm). Collection of
Charlotte Jackson

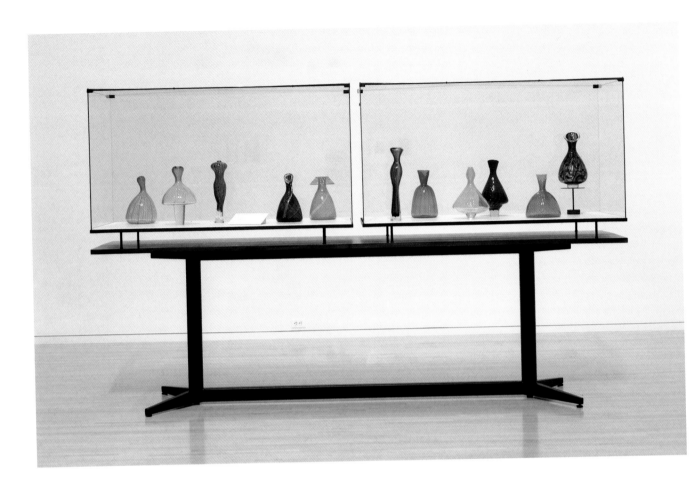

VENINI'S NEW LOOK In the 1952 Venice Biennale, Venini, the famous glass design company, entered a display of vases designed not by the factory's artists and architects, but by the glassblowers themselves. The unusual shapes and cloth-like patterning were based on the haute couture fashions which the owner's French wife wore when she visited the factory. Ginette Gagnous Venini was intimately involved in running the company with her husband, Paolo Venini, and could often be seen by the male workers in the furnace room as she ascended and descended the stairs to the office.

In the late 1940s, as Europe and the firm returned to life after the war, Ginette began wearing designs by Christian Dior. When his first collection debuted in 1947, it was heralded as the New Look. Dior's decadently abundant use of cloth and his regressive vision of femininity were so controversial that organized protests arose in the United States and Europe. However, the New Look soon became highly influential in art and design. The glass masters at Venini adopted its hourglass silhouettes and exaggerated forms. A few of these glass pieces were put into limited production and presented as designs of Paolo or Ginette Gagnous Venini.

JOSIAH MCELHENY

JOSIAH McELHENY

A master glassblower, Josiah McElheny practices his craft
in the context of Conceptual art. He aims to erase the customary
art historical distinctions between the fine and the decorative
arts while also playfully toying with the viewer's sense of the real.
Accordingly, he conducts meticulous research to make glass
objects (bowls, chalices, cups, figurines) based on traditional styles
and techniques that date from ancient Rome to modern Murano.
These "period pieces" are then framed within tableaux that
resemble museum displays, complete with documentation.

In the case of *An Historical Anecdote About Fashion*, we are
presented with a modern vitrine that houses a group of colorful
glass vases. The accompanying text (reproduced here) identifies
these vases as the manufacture of a famous Venetian glass
company whose workers were inspired by the late 1940s New
Look fashions worn by their boss's wife. Hence, the ultrafeminine
silhouettes, which, the wall text reminds, once provoked riots
in the streets when a Christian Dior model was attacked
by patriotic French women, outraged by the couturier's excess
amid postwar deprivations. These costumes are as fragile as
the enchanting narrative they appear to authenticate. They are
part of an exquisite fabrication, not unlike those in the fiction
of Jorge Luis Borges, whose influence McElheny has cited, where
fantasies become insistent realities by way of a few tweaks to
time-honored systems of representation.

Installation details of
*An Historical Anecdote About
Fashion*, 1999. Blown-glass
objects in glass and metal
case, text, drawing, and
photograph, dimensions
variable. Henry Art Gallery,
University of Washington,
Seattle; Kayla Skinner Fund
and Henry Contemporaries
Acquisition Fund purchase;
courtesy Donald Young
Gallery, Chicago

FRANCO MONDINI-RUIZ

In *Infinito Botanica NYC 2000*, Franco Mondini-Ruiz extends his
social sculpture *Infinito Botanica* to the sidewalk in front of
the Museum. In 1995, the corporate lawyer-turned-artist returned
to San Antonio, Texas, his hometown, and bought a sixty-year-old
botanica shop in a working-class, Mexican-American neighborhood.
The traditional Tex-Mex botanica sells a wide range of products
used by faith healers—herbs, powders, good-luck charms, candles,
religious statuary, and *cositas* (knickknacks). Mondini-Ruiz also sold
contemporary art works by local artists. His self-declared aim is
to "juxtapose layers of contemporary art, Mexican pre-Columbian
and colonial art, local folk art, flora and fauna, sweets and junk.
This layering became an ongoing installation, allowing me to make
a meager but very picturesque living."

At the original San Antonio site, Mondini-Ruiz's selection
and arrangement of objects became what he described as
"culturally and socio-economically loaded metaphors for the South
Texas 'caste' of characters who live out their lives in a mostly
unarticulated matrix of history, myth, racism, and cultural
confusion." Mondini-Ruiz's store has been compared by some
critics to Pop artist Claes Oldenburg's *The Store* (1961), a shop
where Oldenburg sold plaster items he had made to resemble food,
clothing, and jewelry, and which played on the idea of art as
commodity. Mondini-Ruiz's store, by contrast, is more like a mix
of shopping and socializing designed to interrogate the relationship
between class and culture, art and exhibition, "high" and "low,"
cultural history and individual identity. His reincarnation of *Infinito
Botanica* for the 2000 Biennial is "an artistic and surreal
interpretation of a local street vendor," selling inexpensive trinkets,
candles, baked goods, vernacular art, and mystery bags containing
surprises such as Aztec copal incense from Mexico, hummingbird
God soap, and golden good-luck frogs.

TOP: Installation view of
Infinito Botanica: New York at the
Center for Curatorial Studies,
Bard College, Annandale-on-
Hudson, New York, 1999

BOTTOM LEFT: Exterior
of Infinito Botanica in
San Antonio, Texas, 1995–99

BOTTOM RIGHT:
Installation detail of
Infinito Botanica @ ArtPace
at ArtPace, A Foundation
for Contemporary Art,
San Antonio, Texas, 1996

ERROL MORRIS

Errol Morris, best known for his film *The Thin Blue Line* (1988),
is one of the few documentarists to enjoy a public reputation on
a par with fiction film directors. *Fast, Cheap & Out of Control*,
a multinarrative work whose common themes do not immediately
reveal themselves, was, by Morris' own reckoning, a film that
took shape organically. There was no set subject matter, only the
idea that the stories should not be directly related, and that the
subjects should not know one another. Gradually, it becomes
clear that the film's unifying themes are, unexpectedly, obsession
and animals. Morris weaves the stories together in such a way
that the spectator is able to make any number of other
connections among them.

The narrative range of the film, whose subjects include a lion
tamer, a topiary expert, a robotics specialist, and an authority on
the naked mole rat, has a concomitantly varied aesthetic. Morris
and his Oscar-winning cinematographer, Robert Richardson,
use diverse film formats—both color and black-and-white, 35mm,
16mm, Super-8, and video, as well as stock footage, clips from
old films, and animated cartoons. In addition to an aesthetic that
hovers somewhere between collage and pastiche, Morris uses
an Interrotron, a device of his own invention, which permits
an interviewee to simultaneously look at his own image while
directly facing an interviewer. Calling this "the difference between
the first person and the third person," Morris circumvents
documentary cinema's potential trap of exploiting the subject.

Fast, Cheap & Out of Control is ultimately an elegy about things
that, as the images and interviews attest, "are dying out as
we speak." Lion taming is a vanishing skill and topiaries are fast
disappearing. Robots and naked mole rats, on the other hand,
are beings of the future, who, via technology or their unique
environmental niche, respectively, may one day supersede, or
even replace, humans.

TOP: Still from *Fast, Cheap &*
Out of Control, 1997. 35mm
film, color, sound; 82 minutes

BOTTOM: Filming of
Fast, Cheap & Out of Control

MANDY MORRISON

In *Desperado*, video artist Mandy Morrison, garbed in cowboy boots and hat and wearing a gun belt, a John Wayne mask, and a gender-bending prosthesis that is both penile and clitoral, rides a mechanical bull and prowls, stalks, and dances in a highly artificial Western landscape. *Desperado* simultaneously engages and resists its objects of investigation: gender, pop culture, consumerism, and the uniquely American ideology of Manifest Destiny. The audiovisual vocabulary is that of the Western movie and country music—arguably two of the most iconically American cultural signifiers. The sometimes defiantly low-tech aesthetic— noticeable, occasionally even awkward superimpositions, the clearly fake film set, the editing together of several country songs with audible cuts—takes the elements out of their familiar contexts to reveal their ideological content. Furthermore, the polygendered protagonist, whose face is obscured but whose indeterminate sex is declaratively confrontational, cannot embody the heroism and masculinity of the cowboy code. The implicit critique is not about insufficiency but about excess—Morrison's gender desperado is too much, rather than not enough.

As with the installation pieces *Padded Room* (1999, addressing the ideological value of John Wayne's iconicity) and *Os* (1996, using *The Wizard of Oz* and Mickey Mouse as intertexts), Morrison is concerned here with the way America defines itself in terms of conquest—as she puts it, "a ceaseless quest of territory," both geographical and cultural.

Desperado is dedicated to Marion Morrison, John Wayne's original name. Morrison was drawn to the figure of Wayne not only because they share a surname, but even more because Wayne's macho image depended in part on the disavowal of his ambiguously gendered first name.

Still from *Desperado*, 1997.
Video, color, sound; 4 minutes

The Raft of the Medusa is a diptych based on Théodore Géricault's icon of French Romantic painting, also titled *The Raft of the Medusa* (1819). Brazilian-born Vik Muniz is constantly engaged in the process of refracting and translating recognizable images created by other artists or photographers (or sometimes both) into new languages and new materials. "I prefer representations of representations," the artist notes, "to the things themselves."

The Raft of the Medusa is part of Muniz's *Pictures of Chocolate* series, begun in 1997. Like all the artist's work, these photographs contain recognizable pictures within pictures, each one reflecting prior images which themselves reflect even earlier images. *The Raft of the Medusa* starts with a photograph of the Géricault painting, which Muniz translates into a drawing by tracing it on top of a lightbox using a needle and Bosco chocolate syrup to make the lines. He then translates the image one more time, taking a color photograph of the chocolate lines before the syrup dries. Until the *Chocolate* series, Muniz used only black-and-white photography, but discovered that this medium made chocolate look too much like blood.

The high tragic and pictorial drama of the storm-tossed raft in Géricault's painting—itself the representation of a real shipwreck that was a political scandal in its own time—is deflated by the bathos of Muniz's playful disarticulation into a crudely made drawing in chocolate sauce. (Muniz slyly refers to these humorous translations of high art as "low-tech illusionism.") At stake is the fidelity of images which Muniz subverts over and over; by translating his chocolate drawing into a large color photograph, the artist reminds us that even photography, at the dawn of today's digital era, can no longer be understood as the high-minded handmaiden of truth and history.

The Raft of the Medusa, 1999, from the series *Pictures of Chocolate*, 1997–present. Silver dye bleach print (Ilfochrome), two parts, 90 x 120 in. (228.6 x 304.8 cm) overall. Brent Sikkema Gallery, New York

SHIRIN NESHAT

Rapture, a 13-minute video on two facing screens, is a disciplined, passionate, and deeply ambiguous portrait of two worlds within Islam, one the domain of women, the other of men. Shirin Neshat was born in Iran and attended college in the United States; the 1978–79 Islamic revolution in Iran prevented her from going home for twelve years. Neshat's long sojourn in America profoundly affected her, not least because on her return to Iran she was compelled to "put on the veil and behave like a good Muslim." Back in New York, she began exploring, at first in still photographs, the meaning of the chador and of other veils and walls within Islamic culture. (Erroneously understood in the West as a simple indication of female repression, the chador can also represent a willed opposition to Western imperialism.)

Rapture begins with a small army of men passing through the narrow streets of an old city (filming was done in Morocco) before entering a walled fortress, while a less rigidly organized body of veiled women assembles on a barren plain. The men, dressed identically in white shirts and dark trousers, perform a number of elaborate rituals; the women, though veiled head-to-foot, perform less tightly prescribed movements and gestures. As in Neshat's previous video work, *Turbulent* (1998), viewers must balance their gaze between one set of actions and the other. But sometimes it seems that the on-screen women have the men's attention, particularly when they ululate—a haunting, wordless, but richly (and variably) meaningful vocalization. (*Rapture*'s soundtrack is by Iranian composer Sussan Deyhim, with whom Neshat has collaborated before.) The clear oppositions that *Rapture* seems, initially, to express soon give way to implications as multivalent as the chador itself. At the conclusion, when six women board a battered rowboat and set off across an open sea, their destination—whether freedom, redemption, or martyrdom—is left undefined.

Stills from *Rapture*, 1999.
Video installation,
black-and-white, sound.
Whitney Museum of
American Art, New York;

Purchase, with funds from
the Painting and Sculpture
Committee and the Film
and Video Committee 99.86

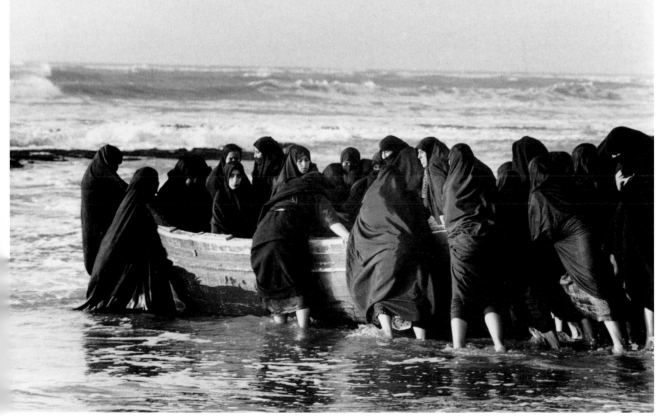

NIC NICOSIA

Middletown is a video exploration of the issues explored in
Nic Nicosia's *Real Pictures* series of photographs (1979–99). In this
black-and-white, extended single-shot digital video, the camera
repeatedly loops around Nicosia's suburban Dallas neighborhood,
taking in events both mundane and slightly bizarre. *Middletown*'s
elegantly unsettling surrealism derives partly from the intrusion
of the odd (a boy on a bicycle dragging a body, two men in suits
and cowboy hats strolling to an unknown destination) onto the
relentlessly normal street—in one long take. The tension between
the circuitous repetition of the camera's route and the unexpected
progression of some of the events (a woman seeks help from
a male neighbor, who returns to her house with a baseball bat)
reinforces the contradictions between the codes of realism
traditionally endemic to the absence of editing in the long-take
aesthetic, and the clear understanding that the seamless
environment is the result of highly complex staging and
choreography.

Middletown explores the false division between surface and
depth. Its placid streets are tinged with uncertainty, even menace.
Nicosia's camera work, dispassionate, unwavering, and visually
precise, speaks for both the ultimate impossibility of a perfectly
constructed reality and the myth of such perfection in suburban
life. *Middletown*'s artificial utopianism reveals an insidious
dystopia. Like the video's images, its soundtrack, evocative of
circus music (if the clowns were all either suicidal or homicidal),
is reassuringly repetitious, even as it threatens to lose control
of its own rhythm.

Still from *Middletown*, 1997.
Video, black-and-white,
sound; 15 minutes. P.P.O.W.,
New York, and Dunn and
Brown Contemporary, Dallas

PAUL PFEIFFER

Paul Pfeiffer is a New York-based artist who uses photography,
sculpture, video, computer photocollage, and digital technology
in his investigations of the human body and psyche. In his video
Fragment of a Crucifixion (After Francis Bacon), a black basketball
player is screaming in the middle of a crowded arena as it explodes
with flashing cameras. The title frames the piece in terms of the
psychological intensity and expressionism in the Francis Bacon
painting *Fragment of a Crucifixion* (1950); it also invokes an
association between popular sports heroes and religious icons.

In this video's very small format, a 30-second loop, the howling
athlete repeatedly moves back and forth within a contained grid
of space, curiously trapped in an endless moment and place
of either triumph or torment. The ambiguity is compounded by
the lack of audio or visual details such as other players, court
markings, team names, the score, and advertising logos—which
Pfeiffer has digitally edited out. Similarly, through the process
of painting, Bacon "transmutated" an abstracted human form
on a crucifix into a bestial figure—and its screaming mouth into
an expression readable as either agony or ecstasy. Pfeiffer's
basketball star is metamorphosed by digitized computer scanning
and pixelation into pure, if undecipherable, human subjectivity.

Still from *Fragment of a
Crucifixion (After Francis Bacon)*,
1999. Digital video loop, DVD
player, miniature projector,
and metal armature; image,
3 x 4 in. (7.6 x 10.2 cm).

The Project, New York,
and the artist

CARL POPE WITH KAREN POPE

Palimpsest refers to writing materials such as parchment which
are "recycled" for new use by scraping off the words or images
to produce a clean surface. In the Middle Ages, before paper was
introduced, such practice was common. But even when erased
in this way, palimpsests retain traces of their previous messages.

Palimpsest, Carl Pope's larger-than-life-size collaborative video
installation, is characteristic of the artist's provocative, issue-
oriented work, which he describes as a battle cry for social
and racial justice: "My body is a battleground. My body is the
parchment, the palimpsest."

Pope uses his own body to address the history of dehumanizing
inscriptions—both literal and figurative—on the black body.
His seven-minute documentary video is projected onto a trans-
lucent screen and also reflects on the opposite wall, illuminating
a poem written by the artist's twin sister, Karen Pope. This poem
also provides the video's voice-over, narrated alternately by both
Popes. The three-part video bears witness to three operations—
medical, symbolic, and linguistic. In the first, the artist brands
his back, a gesture which transforms the markings of the
dehumanizing slave trade into an act of defiance. The brand
is an ancient West African "adrinka" marking, Aya—a symbol
of resistance—which translates as "I am not afraid of you."
The second operation is the surgical cutting of the same symbol
into the artist's forearm, a gruesome process which, under
a harsh light, also causes the color of Pope's "black" skin to read
as "white," rebuking racist myths about the biological significance
of black skin. The third action documents the tattooing of Karen
Pope's poem onto the artist's body, meandering from the bottom
of his right leg up to the nape of his neck.

Unlike Chris Burden's self-mutilation in early 1970s
Performance art, Pope's transcriptions explicitly re-mark the
painful legacy of racism—branding, scarring, and wounding—
on the palimpsest of the individual and collective body.

Stills from *Palimpsest*,
1999. Text by Karen Pope.
Video installation with
sound and light-reflective
text, dimensions variable.
Collection of the artist

WALID RA'AD

Walid Ra'ad's *The Dead Weight of a Quarrel Hangs* is a three-part video
project that investigates the possibilities and limits of writing
a history of the Lebanese civil wars (1975–91). Produced between
1996 and 1999, each part of the series is a short, faux documentary
showing imaginary events constructed out of "innocent and
everyday materials," such as photographs, household items,
and home movies. Ra'ad calls his videos "hysterical symptoms"
that do not document actual events, but rather focus on the
physical manifestations and effects of traumatic events.

Part 1, entitled *Missing Lebanese Wars* (in three parts) depicts
events inspired by the diaries of Zainab Fakhouri, the wife
of the foremost historian of the civil wars. Each part "remembers"
different events: the regular Sunday gatherings of historians
at a racetrack; Zainab Fakhouri's separation from her husband and
her removal of seventeen objects from their house; and Dr. Fadl
Fakhouri's obsession with his son's bullet collection.

Part 2, *Secrets in the Open Sea*, includes a montage of newspaper
photographs of Lebanese political figures, followed by long shots
of the Mediterranean and then by a number of rectangular blue
screens of varying hues. A voice-over explains that the blue screens
contain images of militia members who were drowned or lost
at sea, thus connecting the ephemeral faces of war and the eternal
presence of the sea.

Part 3, *Miraculous Beginnings* (in two parts), constructs a fiction
from images found on a roll of film shot by Lebanon's late
president, Elias Sarkis. We expect momentous images, but all we
see are ordinary people and objects. The second part is a series
of remakes of surveillance footage in which the camera operator
is inexplicably drawn to sunsets rather than to people. *The Dead
Weight of a Quarrel Hangs* presents the Lebanese civil wars as
an abstraction of memories and media that asks how to make
sense of war.

Still from *The Dead Weight of
a Quarrel Hangs*, 1999. Video,
color, sound; 18 minutes

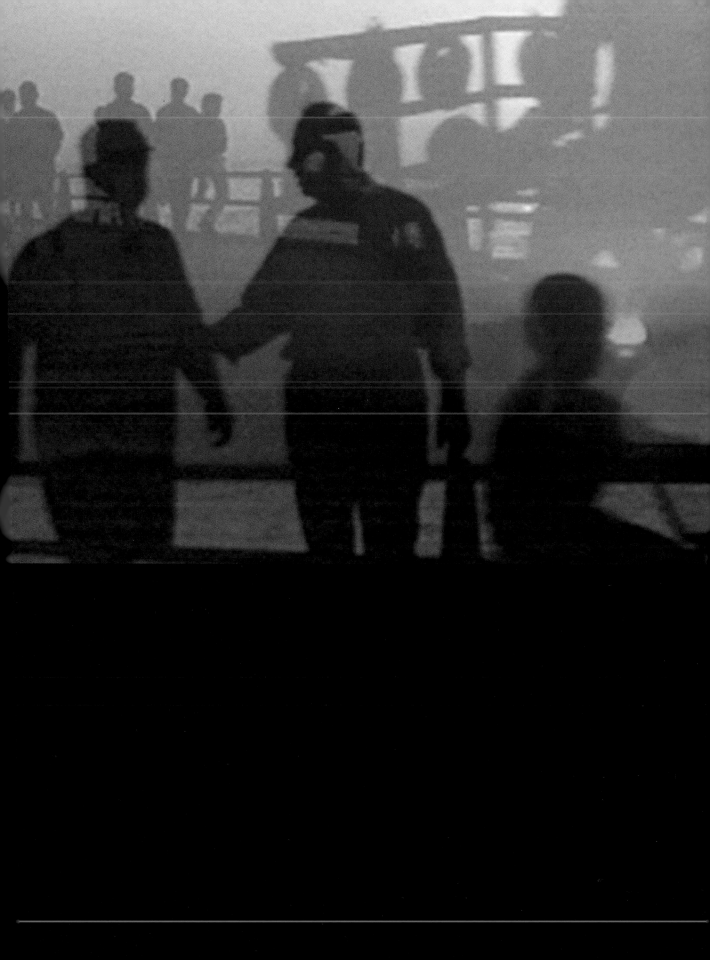

MARCOS RAMÍREZ ERRE

Marcos Ramírez, also known as "ERRE," from the Spanish pronunciation of the first letter in his surname, creates large-scale public installations informed by a political and social consciousness. In his widely acclaimed outdoor, site-specific works at inSITE94 and inSITE97—binational exhibitions in Tijuana and San Diego— he addressed the dynamics of the border between the United States and Mexico. For inSITE94, Ramírez called attention to the gap between poverty and wealth in Mexico by building a shanty and yard with discarded construction materials and setting it against the showy exhibition facade. For inSITE97, he installed a 33-foot-tall wood horse with wheels on the boundary line between the United States and Mexico. This evocation of the Trojan horse had two heads, raising questions about who was invading whom.

Stripes and Fence Forever (Homage to Jasper Johns) is an 8 x 12-foot corrugated metal wall painted with red and white stripes to simulate the United States flag. It has been chemically treated so that it also resembles the deteriorated wall dividing Tijuana and San Diego. Ramírez dedicated the piece to Jasper Johns who, in his Flag paintings of the 1950s, divested the American flag of its invincible icon status, freeing it for other uses. For Ramírez, the flag allowed him "to direct a complaint against the arrogant U.S. foreign policy." The wall has been placed diagonally on a 9-foot-square area filled with soil, effectively dividing the "territory" into two separate sections that invoke the exclusionary U.S. control of the border with Mexico. In a second work, Ramírez critiques the Mexican government by revamping the seal on the nation's flag. In the original emblem, adopted in 1823 when Mexico won independence from Spain and became a republic, an eagle devours a serpent, recalling an ancient Aztec myth. Ramírez, noting that Mexico still "writhes to free itself of the claw and the bite of sovereign power," has altered the seal so that the serpent bites the eagle, reversing the fate of the Mexican people.

TOP: Installation view of *Stripes and Fence Forever (Homage to Jasper Johns)* at the Museo de Monterrey, Nuevo León, Mexico, 1997.

Corrugated sheet metal, welded mesh, concrete, clay, and soil, 98 3/8 x 169 x 169 in. (249.9 x 429.3 x 429.3 cm). Quint Contemporary Art, La Jolla, California, and the artist

BOTTOM LEFT: Emblem from the Mexican flag

BOTTOM RIGHT: Digital rendering of *Democracia*, 1999

JENNIFER REEDER

Nevermind is the first segment of a three-part video installation
in which Jennifer Reeder appropriates the music of three popular
and diverse bands and celebrities (Nirvana, U2, and Madonna).
In *Nevermind*, which is also the title of Nirvana's breakthrough
album (a record that single-handedly changed the face of popular
music, bringing grunge rock into the mainstream), Reeder lip-syncs
to "Smells Like Teen Spirit," an anthem for so-called Generation
X-ers. The image is grainy, the color highly saturated, and the speed
is slow motion. Reeder's image in the video, moreover, seldom
occupies the center of the frame.

Reeder's performance of Nirvana's song is, as she puts it,
"a non-narrative post-punk aria...about the manifestation of
gender and rebellion in media culture." She slows down the song
and decenters her own performing image, which sometimes even
drifts partly out of frame, making it harder for the spectator
to fix its iconic value. Through such devices, Reeder both seizes
and critiques the conventionally male-gendered and specifically
phallic power of the rock star, a power whose patriarchal identity
is often camouflaged by its counterculture rebelliousness.

Reeder's performance in *Nevermind* starts and ends with home-
movie footage of Reeder as a little girl, cartwheeling and bowing to
the camera. Especially because she is wearing a dress, this framing
device further points up issues of both gender and performance.
Reeder also repeatedly intercuts the title of the work and her own
name with the childhood images. Not only does this strategy work
against the traditional protocols of bracketing off text from image
(keeping opening and closing credits discrete from the body of
the work), but it also asserts Reeder's right as a female artist to the
same strong identity as male artists such as Nirvana's Kurt Cobain.

Still from *Nevermind*, 1999.
Video, color, sound;
18 minutes

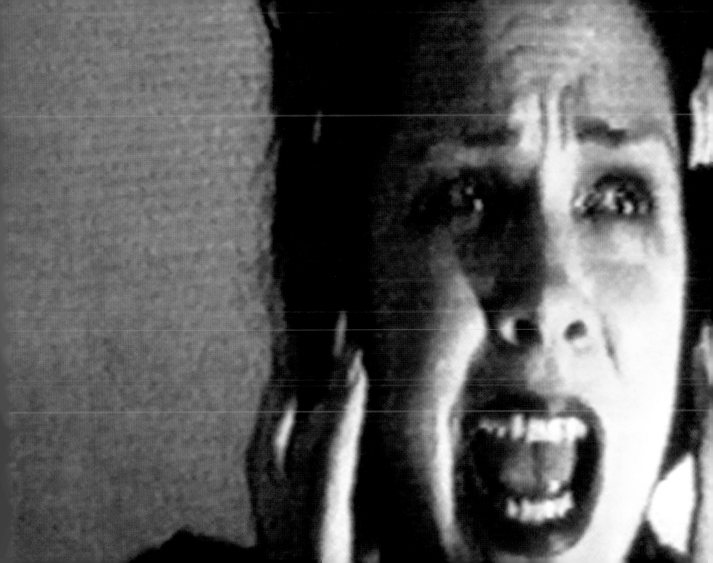

Laurie Reid's monumental watercolors quietly celebrate the relationship between chance and control. Reid began her career painting representational watercolor still lifes, but her interest in recording reality waned when she noticed "how the fruit, as it bruises, was similar to the way pigment settles in on paper…. I started investigating the way the paper acts. Eventually the imagery just dropped away." Traditionally, watercolorists fight the tendency of paper to warp and buckle, but Reid accepts the inherent nature of her materials, in the process encouraging the paintings to assume an almost sculptural quality.

In *Ruby Dew (Pink Melon Joy)*, four large pieces of paper hang vertically, attached directly to the wall with their bottom edges unanchored and loosely curling. A string of brightly colored droplets forms a downward arc that spans the width of the piece. The curve of the accumulated marks, though abstract, is intentionally metaphoric, as the title suggests, and also echoes the unpredictable effects of gravity on the paper itself.

Pink Melon Joy is the title of a play by Gertrude Stein, whose spirited use of language through repetition, simplification, and fragmentation is mirrored in Reid's string of tender drips, which suggests a more delicate incarnation of Jackson Pollock's Action Painting. Reid's watercolors, expanses of paper nearly empty of imagery, have a presence that is saturated with absence, reminiscent of Agnes Martin's subtle meditations on the nature of beauty.

TOP: *Ruby Dew (Pink Melon Joy)*, 1998. Watercolor on paper, 192 x 240 in. (487.7 x 609.6 cm). Stephen Wirtz Gallery, San Francisco, and the artist

BOTTOM: *Ruby Dew (Pink Melon Joy)* (detail)

KAY ROSEN

Kay Rosen's wordplays are sly meditations on meaning.
In paintings, drawings, and, more recently, murals and billboards,
she presents deceptively simple phrases that, upon careful
viewing, deepen our understanding of language. Rosen's works
are visual as well as verbal puns and they frequently exploit
inherent linguistic doublings, such as palindromes. They are
at once highly entertaining and conceptually rigorous, the latter
quality not surprising from an artist who received a graduate
degree in linguistics.

Banner Yet Wave is a series of red-and-white banners that hangs
on the facade of the Whitney Museum. The phrase "banner yet
wave," excerpted from the American national anthem, is divided
into eight banner segments. The placement of the banners
is determined by their correspondence to the anthem's musical
notes—"BA" is G major, "A" is A major, and so on—so that
each banner is placed in the position the note would occupy on
a musical stave. The letters thus function both linguistically
and melodically. The result is an installation in which the image
mimics the subject, as is often the case in Rosen's work. This
piece was commissioned by the Whitney Museum specifically for
the 2000 Biennial and it winks at its own context, heralding the
entrance to a museum dedicated to the exhibition of American art.

Digital mock-up of
Banner Yet Wave, 1999

MICHAL ROVNER

Michal Rovner began her career with still photography rather
than the moving image. Her concerns however, have remained
consistent and are clearly evident in her new video work.
She deals with notions of the border: when and where it enters
as a physical and psychological element and how any trespass
or violation of the border is accompanied by violence.

Rovner uses "nature" to construct these ambiguous zones we
call borders—and perhaps, to protect them. The pulse of insects
across the screen of her recent work evokes the repetitive beat
of artillery fire (and, in previous videotapes, the unaccountable
menace of the wheeling flight of a dense flock of birds). In *Field 1*,
a swarm of small insects clouds the screen, circling soundlessly
in what seems like random motion, repetitive and unnerving.
The soundtrack is a sonorous, near-human electronic hum that
rises and falls rhythmically. Behind the haze of insects, a few dark,
blurry figures become visible, walking with difficulty in a "forced"
migration through a resistant landscape. The layering of disparate
imagery, and its manipulation into a condition of near abstraction,
typifies Rovner's work, which is solidly rooted in her Israeli
upbringing in the midst of conflict. While challenging conventions
that render the natural landscape a source of peace and security,
Rovner nonetheless produces work of great poise and
commanding beauty.

Still from *Field 1*, from
Overhanging, 1999. Video,
color and black-and-white,
sound; 14 minutes.
Collection of the artist

®™ARK

®™ark (pronounced "art-mark") is a multimedia project that
was organized as a for-profit corporation in 1991 to enable the
"creative subversion" of the dominant corporate structure.
The project argues that corporations have been elevated to the
level of individuals, but without the same degree of responsibility.
By using the legal "veil" granted to corporations, ®™ark and
its projects are protected by the same legal loopholes enjoyed
by major corporations. Among ®™ark's past subversions
were funding the exchange of the voice boxes between Barbie
and GI Joe dolls and sponsoring a re-sampling of Beck's music
in *Deconstructing Beck* (1998).

 Bringing IT to YOU! is a 40-minute-long industrial video whose
single purpose is to introduce and promote the corporation.
Its expository voice-over boasts that ®™ark is the "industry leader
in bringing subversive and blacklisted cultural productions
into the marketplace." Paired with the voice-over are computer-
generated visuals and news footage detailing ®™ark's past successes.
The video also includes a Microsoft PowerPoint demonstration for
the "Y2K Corporation," as well as examples of news releases and
reports on ®™ark in the international press. The video conforms
to and subverts corporate visual and aural codes in its ultimate goal:
to promote a corporation that is anti-corporate.

 The core of ®™ark is a database (*rtmark.com*) that lists ideas,
workers, and funding. It is ®™ark's function to pair "donors"
(the investors) with the "workers" who carry out the projects.
®™ark's website is itself a model of corporate subversion, with
a well-designed homepage linked to related ®™ark sites and projects.
The latest funded projects include the marketing of water from
the coolers of Silicon Valley companies (*hq20.org*) and parody
websites on New York mayor Rudolph Giuliani (*yesrudy.com*),
Republican presidential candidate George W. Bush (*gwbush.com*),
and the World Trade Organization (*gatt.org*).

Digital still from
®™*ark*, 1997–present
(*rtmark.com*). Website

Back | Forward | Reload | Home | Search | Guide | Images | Print | Security | Stop

Go To: http://rTMark.com/ads.htm

valuable educated website gwbush responsive

Subscribe | Email | Home

Projects | **History** | **Material** | **World**

Video

Written

Images

Y2K Ads and Posters

Y2K Banner Ads

PowerPoint

Y2K

JOIN ▶ Project CARD: Execution greeting cards

jump to: ▼

Images for print or web | Material / Images / Advertisements

Most images are linked to high-resolution versions.

www.rtmark.com

KATHERINE SHERWOOD

Katherine Sherwood envisions her large-scale paintings as if they were medieval manuscript illuminations seen through a microscope. Her thickly layered surfaces have the brittle, weathered appearance of parchment, and the gestural painted marks suggest vastly enlarged arcane symbols or fragments of ancient script. In fact, these elements do have roots in ancient mysticism: the tracery emblems are based on those in the *Lemegeton, or The Lesser Key of Solomon*, a seventeenth-century handbook of sorcery that is itself a compilation of earlier material. Sherwood juxtaposes these cryptic marks with collaged photolithographs of her own angiograms (X-ray views of blood vessels in the brain). The skeins of blood vessels bear an uncanny resemblance to the fluid lines of the magic emblems, thereby forging a provocative link between a mystical past and the analytic present.

In 1997, Sherwood suffered a cerebral hemorrhage that left the right side of her body partially paralyzed. In these, some of the first works she made after having re-learned to paint, the grand scale speaks to newfound appreciation of the simple miracle of consciousness and being. Although aesthetic decisions remain paramount in the creative process, Sherwood has come to depend on the therapeutic power of "art-making [as] a life-saving device."

Facility of Speech, 1999. Mixed media on canvas, 108 x 84 in. (274.3 x 213.4 cm). Collection of Catherine Klaus Schear and Richard Newman

JOHN F. SIMON, JR.

John F. Simon, Jr.'s *Every Icon* is a Java applet, a small program
that automatically downloads from the Internet and runs on
a computer's hard drive. It generates every possible combination
of black-and-white squares in a grid of 32-by-32, or a total of
1,024 squares. The speed with which the succession progresses
depends on the processing power of the computer in which
it's installed. Starting with an image in which every grid element
is white and moving at the rate of one hundred variations-per-
second on an average home computer, it takes sixteen months to
display all 4.3 billion variations of the first line alone; the second
line would take an exponentially longer 5.85 billion years to
complete. The process concludes when every square is black,
which Simon calculates would take several hundred trillion
years. "Because there's no word for that amount of time, several
hundred trillion years is my way of making you think about
a very, very long time."

Simon has an MA in planetary and earth science from
Washington University in St. Louis and also an MFA from the
School of Visual Arts in New York. He considers programming
a natural extension of the Conceptual practice of artists such
as Sol LeWitt and Lawrence Weiner, whose wall works are
systematically determined by sets of instructions, essentially
qualifying them as software. *Every Icon*'s seriality, modularity,
and lack of specific content invites comparisons to Minimalism.
Yet Simon sees an important, if obvious, distinction between
the Minimalists' grid systems and his own: his predecessors could
see their work through to completion, while his own, in direct
response to the vast capacities of the computer, plays out on
a scale of time that exceeds even our imagination.

Digital stills from
Every Icon, 1997
(*www.numeral.com/everyicon.html*).
Internet project

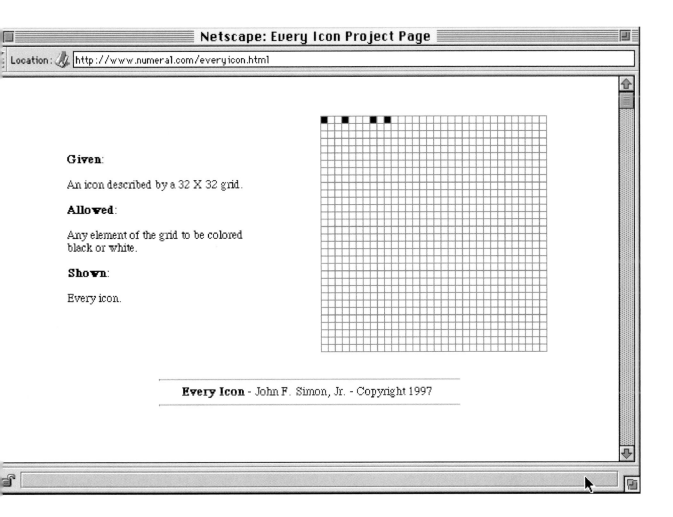

Given:

An icon described by a 32 X 32 grid.

Allowed:

Any element of the grid to be colored black or white.

Shown:

Every icon.

Every Icon - John F. Simon, Jr. - Copyright 1997

Given:
An icon described by a 32 X 32 grid.

Allowed:
Any element of the grid to be colored black or white.

Shown:
Every icon.

Owner:	Stadium
Edition Number:	Web Site Installation
Starting Time:	March 1, 1997, 1:00:00

(c) Copyright 1997 John F. Simon, Jr.

Al Souza began his professional life as an aeronautical engineer,
designing helicopters before becoming an artist in the mid-1960s.
His early hard-edge painterly abstraction gave way to sculptural
photoworks, paintings, assemblages, and collages, most of which
incorporate an overlay of images appropriated from the dustbin
of popular culture—including newspapers, maps, scientific
manuals, and, more recently, jigsaw puzzles. The 18-foot-long
assemblage *The Peaceful Kingdom* consists of thousands of unrelated,
ready-made jigsaw puzzle pieces that Souza collected from thrift
stores and junk shops and then assembled and glued together.
Obsessive in his procedures, Souza once counted around sixty
thousand pieces in one of his much smaller works (he has since
stopped counting). In *The Peaceful Kingdom*, he combines disparate,
fragmented images of New England landscapes, Southwestern
canyons, Austrian mountains, and other banal picturesque views
—the signature and mundane vision of the jigsaw genre—into a
whirligig of rhythm and color fields that juxtapose what the artist
calls "images of geographically and culturally diverse situations."

Souza's title intentionally evokes the famous American
Primitive painting *The Peaceable Kingdom* (1834) by the Quaker artist
Edward Hicks. Souza sees his image, however, as "more secular,"
drawing as it does from popular imagery and mass culture.
His recycling of the cheap and depleted detritus of this culture
aligns his work to that of early Pop artists such as Robert
Rauschenberg and Jasper Johns, while the heroic scale, repetitive
actions, overlaying of images, and reliance on chance evoke
the all-over Abstract Expressionist canvases of Jackson Pollock.

TOP: *The Peaceful Kingdom*,
1998. Puzzle pieces and glue
on wood, 84 x 216 in. (213.4 x
548.6 cm). Moody Gallery,
Houston; Quint Contemporary
Art, La Jolla, California; and
the artist

BOTTOM:
The Peaceful Kingdom (detail)

DARCEY STEINKE

Blindspot is the first web project by writer Darcey Steinke and the last produced by the website *äda 'web*. Steinke is the author of three novels, two of which have been named Notable Books of the Year by *The New York Times*. The *äda 'web* site, active from 1995 to 1998, invited artists to create Internet projects in collaboration with the site's team of designers and programmers. *Blindspot* uses the nonlinear nature of the Internet to produce a new form of fiction. Its inclusion in the 2000 Biennial demonstrates how the traditional distinctions between disciplines —art, literature, and design—are blurred by the emerging medium of the Internet.

Steinke's story spans a single evening, as a young mother named Emma feeds, bathes, and puts her little girl to bed, while waiting for her husband to return home. The central story is linked to nineteen shorter texts, ranging from memories of Emma's parents' marriage to paranoid fears about an intruder in the apartment. The site is presented in stark black-and-white, the only color provided by a yellow bumblebee, a leitmotif of the story. Sounds punctuate the action: a door slams shut, a tub fills with water, a clock ticks. The design employs "frames," an element which subdivides a single webpage into a series of smaller windows. As the story progresses, the imagery multiplies and, as mother and daughter move from room to room, a blueprint of the apartment's floor plan is also slowly revealed. The increasing visual information that glides into the frames mirrors the growing worries—about her husband's absence, the intruder—that preoccupy Emma throughout the narrative.

Digital stills from *Blindspot*, 1999 (*adaweb.walkerart.org/ project/blindspot*). Internet project commissioned by *äda 'web*; Digital Arts Study Collection, Walker Art Center, Minneapolis

ELISABETH SUBRIN

Elisabeth Subrin's film *Shulie* does not merely appropriate the
style, content, and tone of 1960s direct cinema, a type of
documentary in which an explicit narrational framework is
eliminated. Rather, it is a precise shot-for-shot, line-for-line
re-creation of a little-known documentary on Shulamith Firestone
made in 1967, three years before Firestone published her pivotal
feminist text, *The Dialectic of Sex: The Case for Feminist Revolution*.
Subrin's re-creation uses actors as well as almost all of the original
Chicago locations.

Unlike many "mockumentaries," which open with a knowing
wink to the audience, *Shulie* delivers itself "straight," reserving
until the end the fact that it is a re-creation. This permits viewers
to formulate and invest in their own reading of both Firestone
and the film—particularly in response to unexpectedly dramatic
moments such as Firestone's awkward assessment of racial
politics, or her experience with an all-male board of patronizing
art teachers who critique her work. Yet the same deferred
identification intensifies the viewer's responses to the film,
which are forced into radical revision as the closing credits roll.
It is therefore not only the film text itself, but also spectatorial
protocols that become metacritical, examining now familiar
postmodern issues of referentiality and intertextuality, quotation
and appropriation.

History and the form of historical discourse are paramount
issues in *Shulie*, particularly the question of, as Subrin says,
"who and what merits historical consideration." The conventional
but erroneous assumption that both history and documentary
films are constructed of neutral facts dovetails with Subrin's
preoccupation with the notion of originality. Ultimately, it may
be more accurate to say that *Shulie* is less a mock documentary
than a portrait of a documentary.

Still from *Shulie*, 1997.
Super-8 film transferred to
video transferred to 16mm
film, color, sound; 37 minutes

CHRIS SULLIVAN

Chris Sullivan is a performance artist and filmmaker whose performance pieces and animated films are attempts at self-definition, whether in strictly autobiographical or more fictional form. *Consuming Spirits (Part 1)* merges styles, techniques, and stories in an episodic narrative that launches an exploration into the artist's childhood experiences in Pittsburgh with his family's Catholicism, alcoholism, and what he calls "apparent dysfunction." Although the film focuses on two main characters, it also includes many other aural and visual vignettes. Together, they produce an overwhelming atmosphere of loss and a sense of the inevitability of fate.

 Consuming Spirits (Part 1), a work-in-progress, uses three different visual worlds. The present-tense portions are constructed from cutouts that are manipulated frame-by-frame under an animation camera and have an uncanny, puppetlike quality. Memory and flashback sections are created by layered tracing paper cel animation, which has a visual quality suggesting the diffusion and disintegration of memory. The past and present are intertwined with three-dimensional sets animated with moving camera and moving objects, creating an actual physical and emotional space between characters and events and between past and present.

 In *Consuming Spirits (Part 1)*, Sullivan presents a film noir world in which nothing is as it appears. Through the visuals and a soundtrack that mixes silence, dialogue, and bits of talk-radio monologues, we are lulled into the cadences and rhythms of the familiar while being reminded of the dangers lying just under the surface. This tension is encapsulated by a headline that appears halfway through the film: "Consuming Spirits main motivation for bar crowd, followed by loneliness then cable sports."

Still from *Consuming Spirits (Part 1)*, 1997–2000. 16mm film transferred to video, color, sound; 40 minutes

SARAH SZE

Sarah Sze transforms the miscellany of everyday life into
astonishing site-specific installations. Using non-art materials
such as Q-tips, tea bags, pushpins, disposable razors, candy, and
plastic flowers, she creates intricate arrangements of hundreds,
sometimes thousands, of objects. The artist says of her process,
"When I install I move into a space as I might move into a home.
I consider each space in terms of the evidence of its use and
history." She heightens the vernacular atmosphere by using
materials purchased in the vicinity of the exhibition. In the spirit
of Gordon Matta-Clark, Sze often intervenes with the architecture
of a site, as in a 1997 show at P.S.1 Contemporary Art Center
in New York, where she cut into a wall to reveal live wires.

Sze's monumental *Second Means of Egress* was created for the
1998 Berlin Biennale. A fragile tower of Q-tips and matchsticks
sways in the breeze supplied by small electric fans that are part
of the piece. There is an organic quality to the installation,
as if a tangle of vines were creeping toward the huge skylight
looming overhead. Formally, the sculpture resembles a model
of urban sprawl, possibly reflecting the artist's experience living
in New York and Tokyo. Sze's fantastic installations present
a nonhierarchical system in which order teeters on the brink
of chaos. At once poetic and pragmatic, intimate and epic,
they spark a sense of wonder.

Installation view of *Second
Means of Egress* at the 1998
Berlin Biennale. Mixed
media, dimensions variable

TRAN, T. KIM-TRANG

In 1992, *aletheia*, the first in a planned series of eight videos, was released by media artist Tran, T. Kim-Trang. The videos, collectively titled the *Blindness Series*, share a common focus on the theme of visuality and its metaphors.

ocularis: Eye Surrogates, the fourth in the series, is an experimental video that examines the presence and effects of surveillance technology. It is a compilation of visual techniques, including surveillance footage of Tran at home, video footage shot from a moving car, and television footage from the show "Real TV." Accompanying the visuals is a soundtrack that combines theoretical discourses with messages left on an 800 number set up by the artist for callers to discuss their feelings about surveillance. The video's kaleidoscope of sights and sounds brings to light the fear, eroticism, and boredom that accompany interactions with surveillance technology.

ekleipsis takes a more "literal" approach to the subject in its focus on a group of Cambodian women residing in California who form the largest group of hysterically blind people in the world. As with *ocularis*, this latest video in the series combines multiple styles of address, here directed to a dual examination of the history of hysteria and that of the Cambodian civil war. Written text joins still photographs and fiction and nonfiction footage to draw connections between historical events and psychological states. Each of the images is separated by either a white or a black screen, resulting in a "blinking" effect that mimics the act of seeing.

Both films are powerful essays on what and how we see, but they are even more compelling for the questions they raise about what it is we—by choice, by force, or by necessity—do not see.

TOP: Still from *ekleipsis*, 1998. Video, color and black-and-white, sound; 23 minutes

BOTTOM: Still from *ocularis: Eye Surrogates*, 1997. Video, color and black-and-white, sound; 21 minutes

RICHARD TUTTLE

Richard Tuttle has always been engaged in breaking down the
barriers that have traditionally separated a work from its
surrounding space and challenging the conventional distinctions
between drawing, painting, and sculpture. His art has confounded
two- and three-dimensionality and, by extension, the expected
distinctions among art, illusion, and reality. At times mystical
and often highly rational, at times elliptical and often startlingly
direct, Tuttle approaches the conception and realization of
art like a scientist, subjecting an idea to scrutiny through
the art-making process and then observing the resulting work
"out in the world."

Rough Edges is a recent group of works that developed out
of Tuttle's curiosity about the structure of color, which has played
a prominent role in his art. In the 1980s, he began to explore
various facets of the relationship between color and line and
between color and space. With Rough Edges, he specifically set out
to examine what it means for art not just to have color, but to
possess a structure of color. In each work of the series, colors
fill abutting rectangular or square shapes set against each other
in dynamic geometric combinations. The meaning of color
as structure is revealed to the artist as he first makes and then
observes the paintings in their life beyond the studio.

TOP: "Rough Edges, 1", 1999.
Acrylic on plywood, 16 x 16 x
1/2 in. (40.6 x 40.6 x 1.3 cm).
Sperone Westwater, New York

BOTTOM: "Rough Edges, 2",
1999 (half view). Acrylic on
plywood, 16 x 16 x 1/2 in.
(40.6 x 40.6 x 1.3 cm). Sperone
Westwater, New York

AYANNA U'DONGO

Ayanna U'Dongo, self-proclaimed "nanovideo nubiant," has been involved with video and digital and media arts since 1989. Her experimental video works have three common and interrelated areas of investigation: sexuality, origins (what U'Dongo calls "aboriginal association"), and technique. *Aborigitron: Affairs of the Hybrid Heart* borrows from a variety of media to create a polyphony of sounds, voices, and images that are diverse and yet related.

Aborigitron is, at its core, an exploration of the nature and complexities of black love, its roots and its often contemporary manifestation as violence. While a male voice-over reflects on the nature of love and finds nihilism to be prevalent among African-American men, here called "survivalists," we see the infamous videotape of Rodney King's beating and scenes from the 1992 Los Angeles riots that broke out after the police officers who attacked King were acquitted (the beating of Reginald Denny and images of a Korean man shooting into a crowd). These journalistic images are intercut with more formally composed footage from both nonfiction and fiction film. U'Dongo edits image and soundtrack into a symbiotic whole that takes the footage out of its original context and, in the process, reflects on the connections between love and hate and between powerlessness and frustration. Finally, U'Dongo's decision to repeatedly include different images of lovers' embraces enforces the video's challenge to culturally stereotyped views of sex and sexuality and suggests the nature and the power of love.

Still from *Aborigitron: Affairs of the Hybrid Heart*, 2000. Video, color and black-and-white, sound; approximately 30 minutes

CHRIS VERENE

In the photographic tradition of Nan Goldin and his one-time mentor Larry Clark, Chris Verene documents and explores the candid squalor and sometimes lurid psychic underbelly of American subcultures. Over the last ten years, he has created honest, deeply personal, and often sexually charged photographic narratives of the kind of people found in films by John Waters, the American filmmaker with whom Verene is sometimes compared: white trash, drag queens, pansexuals, aspiring starlets and, more recently, amateur photographers take center stage.

For the *Camera Club* series, Verene surreptitiously infiltrated a regional network of amateur photographers who place ads in local newspapers promising an improbable chance at stardom in order to lure teenage girls into posing for boudoir shots. Verene frames the sordid side of this voyeurism, however, by capturing the backs of other photographers, middle-aged men who are awkwardly photographing provocatively posed teens.

Critics tend to situate Verene's work within the framework of feminist discourse about the "male gaze"—the power relations of who is "looking" and who is being "looked upon," and how the very response to this distinction formulates contemporary American identity. Verene's photographs are marked, however, by ambivalence: although they critically expose the voyeurism inherent to photography, they also giddily indulge in its lurid fascination. The calculated unprofessionalism of Verene's photographs—the poorly lit, crudely angled, and cropped shots—contrasts with the slick codes of dominant pornography. Verene's voyeurism mirrors the prurient, basement pornography network now proliferating on cable television and the Internet.

Untitled, 2000, from the *Camera Club* series, 1996–98. Chromogenic color print, 24 x 20 in. (61 x 50.8 cm). Vaknin Schwartz Gallery, Atlanta, and the artist

ANNETTE WEINTRAUB

Annette Weintraub's *Sampling Broadway* is a virtual tour of
five distinct downtown locations along Manhattan's famous
thoroughfare, exploring the relationship between urban
environment and personal mythology. The website equates the
city with media space through a sampling of images, movies,
and animation interspersed with text, voice-over narration,
and sounds of the street. Weintraub's experimental, multilayered
environment examines the power of place to affect perception,
as a series of visual and textual narratives reveal elements of
the real, historical, and imagined Broadway.

A theme intrinsic to the locale is assigned to each of the
five linked virtual environments—Breadth, Antecedents,
Pandemonium, Hegemony, and Respite—and each opens with
a panoramic image of the area which the viewer can navigate.
In the course of moving through the panorama, the viewer
triggers a 5-minute-long narrative which overlaps ambient
sounds and contrasts with the written texts and moving images.
Weintraub is interested in the simultaneous experience of reading,
seeing, and hearing as a metaphor for the dynamics of urban
life. Rather than presenting a frozen, literal view, as is typical
of panoramic photography, she evokes the density and complexity
of city space.

Digital stills from
Sampling Broadway, 1999
(*www.turbulence.org/Works/
broadway/index.html*). Internet
project commissioned by
Turbulence with a grant from the Jerome Foundation,
and supported in part
by a grant from The City
University of New York
PSC-CUNY Research
Award Program; RealAudio narration:
Bill Rice; Second voice:
Annie Shaver-Crandell;
Sound mixing: John Neilson;
Photography assistant:
Reyna DiCiurcio

YVONNE WELBON

Yvonne Welbon's career as a scholar, producer, and film- and videomaker has been devoted to creating a stronger media presence for African-American women. Welbon's films often use autobiography as a starting point for an exploration of the tensions between official history and personal recollection.

In *Living with Pride: Ruth Ellis @ 100*, Welbon combines the personal and the political in a biography of Ruth Ellis, the oldest living African-American lesbian. The film is what Welbon calls a "hybrid documentary," merging archival materials (newspapers, photographs, newsreel footage) with narrative reenactments of "The Gay Spot," the name for the gatherings that Ellis and her lover hosted in their Detroit home from the 1940s on. The Gay Spot was one of the few refuges in Detroit for black gays and lesbians who were denied access to white clubs. The reenactments, shot in Super-8 in order to re-create the look and colors of the past, establish a history that is missing from more official narratives while protecting the identities of those participants who remain closeted.

At the center of the film is Ruth Ellis herself, a lively, talkative centenarian who narrates her own history, thereby determining the structure of the film. In the process, Ellis also narrates a century of American history, stretching from World War I through the civil rights movement to the women's and gay and lesbian liberation movements. *Living with Pride* is an inspirational portrait of an individual who has faced triple oppression, as a lesbian, as an African-American, and as a woman, yet who never presents herself—or is presented—as a victim.

Still from *Living with Pride: Ruth Ellis @ 100*, 1999. Video, color and black-and-white, sound; 60 minutes

KRZYSZTOF WODICZKO

Polish-born artist Krzysztof Wodiczko explores the condition of being alien, silenced, and voiceless by designing interactive devices and by staging large-scale photographic and video projections onto urban monuments. His work extends private predicaments into public spaces, often by way of brief but challenging encounters. Among the best known are *Homeless Vehicle* (1988–89), a mobile self-sufficiency unit for the urban nomad, and *Bunker Hill Monument Projection* (1998), a video projection onto the Revolutionary War memorial in Charlestown, Massachusetts, which gave voice to the traumatic experiences of mothers at the loss of their children to the violence of the local street culture, thus breaking a deadly "code of silence."

The goal of Wodiczko's subversive designs and spectacles is to empower the normally silent and anonymous, an intervention he sees as critical to the democratic process. *Ægis* is part of his *Immigrant Instruments* series, developed with the Interrogative Design Group at MIT, and seeks to redefine and challenge traditional forms of identity (or lack thereof) in today's migratory global order. Named for the *aegis*, the shield or cloak of Athena, which was armed with the protective image of Medusa's head, it consists of a pair of winglike LCD monitors that lie folded on the user's back until activated by voice. The screens then deploy, flanking the user with a mantle of images of his or her own head and spouting preprogrammed responses to such questions as "Where are you from?" To deflect stereotyping, *Ægis* responds with a barrage of disarming counter-questions that become an unruly dialogue—"Who wants to know?" "Where are you from?"—thereby enabling both the user and observers first to proclaim, or "wear," and then to shed some aspects of their mutually held sense of difference. As with all of Wodiczko's work, technology becomes a fundamentally human medium for a new communicative experience.

Ægis: Equipment for a City of Strangers, from the series *Immigrant Instruments*, 1999, during initial testing by Kelly Dobson, Interrogative Design Group, Center for Advanced Visual Studies, Massachusetts Institute of Technology, Cambridge, and Brooklyn Model Works, New York. Two augmented laptop computers, two LCD screens, two loudspeakers, augmented speech recognition software, aluminum structure, electric engine, batteries, and plastic, dimensions variable. Galerie Lelong, New York; Galerie Gabrielle Maubrie, Paris; and the artist

YUKINORI YANAGI

Yukinori Yanagi, a Japanese-born conceptualist living in New York,
has been using insects in his work since he was a student. The
first of his several acclaimed ant farms was made in 1990, when
he filled each of 170 plexiglass boxes with colored sand patterned
after the flag of a different United Nations member state and
connected the boxes with clear plastic tubes. When thousands
of ants were introduced into the assemblage, they tunneled
between the boxes with proverbial industry, transporting sand
from one to the next and eventually blurring the flags' designs
almost beyond recognition. In *Study for American Art—Three Flags*,
created for the 2000 Biennial, Yanagi revisits the American flag,
this time using as his model Jasper Johns' *Three Flags* (1958) in
the Whitney's Permanent Collection. *Three Flags* is one of a series
of Flag paintings by Johns that are now as much icons of postwar
American art as the flag itself is an emblem of national identity.

Like Johns' *Three Flags*, Yanagi's work comprises three
successively smaller representations of the flag, layered one
on top of the other, but in this case rendered in three separate
boxes of sand, plus ants. Riddling the stars and stripes with
unpredictable corridors and tunnels—breaking down discrete
colors, forms, and, ultimately, conventional visual meaning—
the ants enact the corrosive effects of time in a spectacle of
collective purpose that undermines a symbol meant to articulate
social cohesion. But there is also a joyfully anarchic spirit to
Yanagi's *Three Flags*. Indeed, the artist's stated goal is to establish
a "fluctuating perspective" in which stasis and solidarity are
devilishly and effectively subverted.

Digital mock-up of *Study for
American Art—Three Flags*, 1999

LISA YUSKAVAGE

Lisa Yuskavage is well known for lush paintings of disconcertingly sexualized female figures. Her technique relates to that of Venetian High Renaissance painters such as Giorgione, an acknowledged influence. Yuskavage too creates imagery through color rather than line, relying on gradations of light and shadow to define form. Her surreal images also flirt with vulgarity, as the highly stylized subjects flaunt absurdly exaggerated buttocks and breasts. There is something simultaneously powerful and pathetic about Yuskavage's imaginary nymphets. Do these paintings lampoon male sexual fantasy or reveal women's body-obsessed self-deprecation? Are they a celebration of women's sexual power or an indictment of self-subjugation? Like a Rorschach inkblot test, the work is open to a wide range of readings.

Yuskavage came to prominence in the early nineties with a series of monochromatic paintings in a lollipop palette, provocative portraits of preadolescent girls whose figures seemed to merge with the background. In 1996, wanting to expand the use of light in her work, she began to experiment with a method dating back to the sixteenth-century Venetian painter Tintoretto: she fashioned small sculptural models and simulated a variety of lighting conditions—daylight, candlelight, artificial light. She then painted from photographs of the models taken in their varied illuminated environments. Recently, Yuskavage embarked on a series of portraits based on a live model, as in *True Blonde at Home*, though she continues to work from photographs taken during the sittings. This shift from the purely imaginative to the real mirrors the transformation from the strange beauty and extreme artificiality of late Mannerism to the psychological realism of the Baroque.

True Blonde at Home, 1999. Oil on linen, 60 x 72 in. (152.4 x 182.9 cm). Private collection; courtesy greengrassi, London

DENNIS ADAMS

Born in Des Moines, 1948

Studied at Drake University, Des Moines (BFA, 1969); Tyler School of Art, Temple University, Philadelphia (MFA, 1971)

Lives in New York

ONE-ARTIST EXHIBITIONS

1999 Kent Gallery, New York

Galerie Gabrielle Maubrie, Paris

Museum of Contemporary Art, Zagreb, Croatia

1997 Kent Gallery, New York

GROUP EXHIBITIONS

1999 Almeers Centrum Hedendaagse Kunst—De Paviljoens, Almere, The Netherlands, "Private Room/Public Space"

Centraal Museum Utrecht, The Netherlands, "Panorama 2000"

P.S.1 Contemporary Art Center, Long Island City, New York, "The Promise of Photography: Selections from the DG Bank Collection"

1998 Gesellschaft für Aktuelle Kunst, Bremen, Germany, "Do All Oceans Have Walls?"

1997 Neuberger Museum of Art, Purchase College, State University of New York, "Biennial Exhibition of Public Art"

BIBLIOGRAPHY

Dennis Adams: 10 Thru 20 (exhibition catalogue). The Hague: Stroom hcbk, 1995.

Dennis Adams: Trans/Actions (exhibition catalogue). Antwerp: Museum van Hedendaagse Kunst Antwerpen, 1994.

Doroshenko, Peter. *Dennis Adams: Selling History* (exhibition catalogue). Houston: Contemporary Arts Museum, 1994.

Farver, Jane. *Dennis Adams: Ederle* (exhibition catalogue). Flushing, New York: Queens Museum of Art, 1996.

Hentschel, Martin, and Kasper König. *Dennis Adams: Der Müll, () und der Tod* (exhibition catalogue). Frankfurt am Main: Portikus, 1993.

DOUG AITKEN

Born in Redondo Beach, California, 1968

Studied at Marymount College, Palos Verdes, California (1986–87); Art Center College of Design, Pasadena, California (BFA, 1991)

Lives in Los Angeles and New York

ONE-ARTIST EXHIBITIONS

1999 Dallas Museum of Art

Pitti Immagine Discovery, Florence

Victoria Miro Gallery, London

1998 303 Gallery, New York

Taka Ishii Gallery, Tokyo

GROUP EXHIBITIONS

1999 "48th Venice Biennale"

Hirshhorn Museum and Sculpture Garden, Smithsonian Institution, Washington, D.C., "Regarding Beauty in Performance and the Media Arts, 1960–1999"

Zentrum für Kunst und Medientechnologie, Karlsruhe, Germany, "Video Cult/ures und Venedig"

1998 Walker Art Center, Minneapolis, "Unfinished History"

1997 Whitney Museum of American Art, New York, "1997 Biennial Exhibition"

BIBLIOGRAPHY

Anton, Saul. "Doug Aitken's Moment." *Tate*, no. 19 (Winter 1999), pp. 54–58.

Bonami, Francesco. "Doug Aitken: Making Work Without Boundaries." *Flash Art*, 31 (May–June 1998), pp. 80–83.

"Doug Aitken at 303." *Flash Art*, 32 (January–February 1999), p. 40.

Fogle, Douglas. "No Man's Lands." *Frieze*, no. 39 (March–April 1998), pp. 56–61.

Saltz, Jerry. "New Channels." *The Village Voice*, January 12, 1999, p. 113.

GHADA AMER

Born in Cairo, 1963

Studied at Beaux-Arts, Nice (MFA, 1989); Institut des Hautes Études en Art Plastique, Paris (1991)

Lives in New York

ONE-ARTIST EXHIBITIONS

1999 Brownstone, Corréard & Cie, Paris

Centro Andaluz de Arte Contemporáneo, Seville

Deitch Projects, ARCO '99, Madrid

1998 Espace Karim Francis, Cairo

Annina Nosei Gallery, New York

GROUP EXHIBITIONS

1999 "48th Venice Biennale"

SITE Santa Fe, New Mexico, "Third International Biennial: Looking for a Place"

1998 Museum Fridericianum, Kassel, Germany, "Echolot"

Serpentine Gallery, London, "Loose Threads"

1997 Electric Workshop, Johannesburg, "2nd Johannesburg Biennial 1997"

BIBLIOGRAPHY

Breitz, Candice. "Ghada Amer: Critical Strands." In René Block, *Echolot* (exhibition catalogue). Kassel, Germany: Museum Fridericianum, 1998.

———. "Ghada Amer: The Modelling of Desire." *NKA Journal of Contemporary African Art*, 5 (Fall–Winter 1996), pp. 14–16.

Hafez, Khaled. "Throw It in the Nile: Chronology and Show." *Middle East Times*, December 6–12, 1998, p. 24.

Nahas, Dominique. "Ghada Amer." *Review: The Critical State of Visual Art in New York*, May 1, 1998, pp. 8–9.

Zahm, Olivier. "Masculin-Féminin: Ghada Amer." *Omnibus*, no. 4 (October 1992), n.p.

MARK AMERIKA

Born in Miami, 1960

Studied at University of Florida, Gainesville
(BA, 1985); Brown University, Providence,
Rhode Island (MFA, 1997)

Lives in Boulder, Colorado

NEW MEDIA PROJECTS AND EXHIBITIONS

1999 Solomon R. Guggenheim Museum,
New York, "CyberAtlas"
(online exhibition)

 Walker Art Center, Minneapolis,
PHONE:E:ME (Internet project;
*www.walkerart.org/gallery9/amerika/
index.html*)

1998 *Holo-X* (Internet project with Alex Cory,
Jay Dillemuth, and Caroline E. White;
www.holo-x.com)

 Podewil Contemporary Art Centre,
Berlin, "transmediale 98"

 SIGGRAPH 98, Orlando, Florida,
"Touchware"

 Australia, "The Telstra Adelaide
Festival"

 Walker Art Center, Minneapolis,
"Beyond Interface" (online exhibition;
*www.walkerart.org/gallery9/
beyondinterface*)

1997 Linz, Austria, "Ars Electronica 97"

 The School of The Art Institute of
Chicago, "International Symposium
of Electronic Arts"

BIBLIOGRAPHY

Mirapaul, Matthew. "Hypertext Fiction on
the Web: Unbound from Convention."
The New York Times on the Web, June 26, 1997
(*www.nytimes.com/library/cyber/mirapaul/062697m
irapaul.html*).

Shaviro, Steven. "Ten Reflections on Mark
Amerika's PHONE:E:ME.01." In PHONE:E:ME
(Internet project; *www.walkerart.org/
gallery9/amerika/index.html*). Minneapolis:
Walker Art Center, 1999.

Tabbi, Joe. "Amerika, Ink." In PHONE:E:ME
(Internet project; *www.walkerart.org/
gallery9/amerika/index.html*). Minneapolis:
Walker Art Center, 1999.

Williams, Ben. "Amerika Online." *The Village
Voice*, August 26, 1997, p. 33.

LUTZ BACHER

Born in the United States

Lives in Berkeley, California

ONE-ARTIST EXHIBITIONS

1998 Rupert Goldsworthy Gallery, New York

1997 Pat Hearn Gallery, New York

 Bunny Yeager LA

GROUP EXHIBITIONS

1999 The Kent and Vicki Logan Center,
California College of Arts and Crafts,
San Francisco, "Searchlight:
Consciousness at the Millennium"

1998 The Art Gallery, University of
California, Irvine, "Play Mode"
(traveled)

 Kunsthalle Bern, "White Noise"

 The Swiss Institute, New York,
"Where Is Your Rupture?"

 Thread Waxing Space, New York,
"Spectacular Optical"

BIBLIOGRAPHY

Cotter, Holland. "Lutz Bacher." *The New York
Times*, May 8, 1998, p. E33.

Kandel, Susan. "Intimacy and Terror."
Los Angeles Times, March 21, 1997, p. S23.

Kotz, Liz. "Sex with Strangers." *Artforum*, 31
(September 1992), pp. 83–85.

———. "Lutz Bacher's Excruciating Intimacy."
Atlantica, no. 7 (Spring 1994), pp. 157–62.

Rinder, Lawrence. *Lutz Bacher: Matrix/Berkeley
155* (exhibition brochure). Berkeley: University
Art Gallery and Pacific Film Archive,
University of California, Berkeley, 1993.

CRAIG BALDWIN

Born in Oakland, California, 1952

Studied at San Francisco State University
(BA, 1978; MA, 1986)

Lives in San Francisco

SCREENINGS

1999 Blinding Light, Vancouver

 The Film Society of Lincoln Center,
New York, "The New York
Film Festival"

 Museu d'Art Contemporani de
Barcelona, "O.V.N.I."

1998 Künstlerhaus Bethanien, Berlin

 Museum Fridericianum, Kassel,
Germany, "Documenta X"

 Pasadena Armory, California,
"Subliminal Fictions"

1997 Institute of Contemporary Arts,
London, "At the Edge of the World"

 Kansas City Museum of Art, Missouri,
"Electromediascope"

 The Museum of Contemporary Art,
Los Angeles

 The Museum of Modern Art, New York

BIBLIOGRAPHY

Borger, Irene. "Craig Baldwin: Interview."
In *CalArts/Alpert Award in the Arts*. Santa
Monica: California Institute of the Arts,
1999, pp. 186–207.

MacDonald, Scott. *A Critical Cinema*. Vol. 3.
Berkeley: University of California Press, 1998,
pp. 176–80.

Russell, Catherine. *Experimental Ethnography*.
Durham, North Carolina: Duke University
Press, 1999, pp. 238–74.

Tyner, Kathleen. "Pushing the Envelope
with *RocketKitKongoKit*." *Cinematograph* (1991),
pp. 28–33.

LEW BALDWIN

Born in New Brunswick, New Jersey, 1969

Studied at The School of The Art Institute of Chicago (BFA, 1992)

Lives in Los Angeles

NEW MEDIA PROJECTS AND EXHIBITIONS

1999 Robert Berman Gallery, Santa Monica, California, "Window into Hell" (traveled)

Web Bar Gallery, Paris (performance)

1998 *www.hell.com*, "Surface" (online exhibition)

BIBLIOGRAPHY

Brucker-Cohen, Jonah. "Redsmoke.com." *I.D. Magazine*, 45 (March–April 1998), p. 94.

"*Platters*, by Red Smoke." *Metascene*, October 15, 1999 (online; *members.tripod.com/amused_2/archive10.html*).

RINA BANERJEE

Born in Calcutta, 1963

Studied at Case Western Reserve University, Cleveland (BS, 1993); Yale University School of Art, New Haven (MFA, 1995)

Lives in Brooklyn, New York

ONE-ARTIST EXHIBITIONS

1997 The Gallery of the Department of Art and Art History, Colgate University, Hamilton, New York

GROUP EXHIBITIONS

1999 Real Art Ways, Hartford, Connecticut, "Bodies in Resistance" (traveling)

1998 New Museum of Contemporary Art, New York, "Urban Encounters" (traveled)

1997 Arnold and Sheila Aronson Gallery, Parsons School of Design, New York, "Fermented"

Gallery 401, Toronto, "Seeking Beautiful Indian Girls…"

Queens Museum of Art, Flushing, New York, "Out of India: Contemporary Art of the South Asian Diaspora"

BIBLIOGRAPHY

Cotter, Holland. "Many Shows and Many Indias." *The New York Times*, December 26, 1997, p. E43.

————. "Domestic Images from Young Talent." *The New York Times*, January 10, 1997, p. A22.

Kelly, Deirdre. "'Indian Girls' Displays Frame of Mind." *The Globe and Mail* (Toronto), June 12, 1997, p. C2.

McEvilley, Thomas. "Tracking the Indian Diaspora." *Art in America*, 86 (October 1998), pp. 74–79.

Rexer, Lyle. "Midnight's Children: Contemporary Art of the South Asian Diaspora." *Review: The Critical State of Visual Art in New York*, March 1, 1998, pp. 12–15.

REBECCA BARON

Born in Baltimore, 1968

Studied at Brown University, Providence, Rhode Island (BA, 1991); University of California, San Diego (MFA, 1999)

Lives in New York

SCREENINGS

1999 University of California, Berkeley Art Museum and Pacific Film Archive

"42nd San Francisco International Film Festival"

Marseilles, "Festival du Film Documentaire"

Northwest Film Center, Portland Art Museum, Oregon

Rotterdam, "28th International Film Festival"

Vienna, "Viennale"

1998 San Diego Museum of Photographic Arts

1997 The Film Society of Lincoln Center, New York, "The New York Film Festival"

BIBLIOGRAPHY

Camper, Fred. "Critic's Choice: Onion City Film Festival." *Chicago Reader*, May 3, 1996, p. 8.

McNeal, Laura. "Okay. Bye-Bye, Cambodia." *San Diego Weekly Reader*, September 17, 1998, p. 61.

Wilkinson, Kathleen. "Found Footage, Lost Memories: Rebecca Baron Remembers the Cambodian Holocaust in *okay bye bye*." *Release Print* (July–August 1999), pp. 33, 41–42.

VANESSA BEECROFT

Born in Genoa, 1969

Studied at Accademia Ligustica di Belle Arti, Genoa (1987–88); Accademia di Belle Arti di Brera, Milan (1988–93)

Lives in New York

ONE-ARTIST EXHIBITIONS

1999 Museum of Contemporary Art, San Diego

Museum of Contemporary Art, Sydney

Wacoal Art Center, Tokyo

1998 Moderna Museet, Stockholm

Solomon R. Guggenheim Museum, New York

GROUP EXHIBITIONS

1999 Hirshhorn Museum and Sculpture Garden, Smithsonian Institution, Washington, D.C., "Regarding Beauty in Performance and the Media Arts, 1960–1999"

Museum of Contemporary Art, Chicago, "Examining Pictures: Exhibiting Paintings"

1997 "47th Venice Biennale"

The Museum of Modern Art, New York, "Young and Restless"

SITE Santa Fe, New Mexico, "Truce: Echoes of Art in an Age of Endless Conclusions"

BIBLIOGRAPHY

Avgikos, Jan. "Let the Picture Do the Talking." *Parkett*, no. 56 (1999), pp. 106–19.

Bryson, Norman. "US Navy Seals." *Parkett*, no. 56 (1999), pp. 78–87.

Koestenbaum, Wayne. "Bikini Brief." *Artforum*, 36 (Summer 1998), pp. 23–24.

Smith, Roberta. "Standing and Staring, Yet Aiming for Empowerment." *The New York Times*, May 6, 1998, p. E2.

Tazzi, Pier Luigi. "Parades." *Parkett*, no. 56 (1999), pp. 94–97.

ROLF BELGUM

Born in Minneapolis, 1965

Studied at University of Minnesota, Twin Cities (BA, 1987); University of California, San Diego (MFA, 1992)

Lives in Minneapolis

SCREENINGS

1999 University of California, Berkeley Art Museum and Pacific Film Archive

Cleveland Cinematheque

Durham, North Carolina, "The *DoubleTake* Documentary Film Festival"

KTCA Minnesota Public Television, Minneapolis

"Seattle Underground Film Festival"

Wexner Center for the Arts, Columbus, Ohio

1998 Independent Film Channel, "Split Screen"

"Minneapolis/St. Paul International Film Festival"

University Film Society, Minneapolis

Washington, "Olympia Film Festival"

BIBLIOGRAPHY

Gabrenya, Frank. "Documentary Follows Courier Chasing His Star." *The Columbus Dispatch*, February 18, 1999, p. 4.

Kallberg, Ryan. "Drive-by Shooting." *The Minnesota Daily*, May 28, 1998, p. 4.

Lindamood, Brian. "Disorder: The Dark Horse Basement Tapes." *Columbus Alive*, February 18, 1999, p. 14.

Marshall, Rogan. "*Driver 23*." *Alternative Cinema*, no. 16 (Spring–Summer 1999), p. 53.

Nelson, Rob. "Beautiful Losers." *City Pages* (Minneapolis-St. Paul), July 15, 1998, p. 30.

BEN BENJAMIN

Born in Indianapolis, 1970

Studied at Earlham College, Richmond, Indiana (BA, 1993)

Lives in San Francisco

BIBLIOGRAPHY

Mirapaul, Matthew. "It's Better than Good— It's Superbad." *The New York Times on the Web*, July 31, 1997 (*www.nytimes.com/library/cyber/ mirapaul/073197mirapaul.html*).

SADIE BENNING

Born in Milwaukee, 1973

Studied at Milton Avery Graduate School of the Arts, Bard College, Annandale-on-Hudson, New York (MFA, 1997)

Lives in Chicago

SCREENINGS

1999 "Dallas Video Festival"

Filmforum, Los Angeles

"Melbourne International Film Festival"

New Zealand, "28th Wellington Film Festival"

San Francisco Cinematheque

"13th London Lesbian & Gay Film Festival"

Wexner Center for the Arts, Columbus, Ohio

1998 The Film Society of Lincoln Center, New York, "The New York Video Festival"

Rotterdam, "27th International Film Festival"

Walker Art Center, Minneapolis

BIBLIOGRAPHY

Adams, Kathleen Pirrie. "Tomboy on the Bridge: Recent Videos by Sadie Benning." *Mix*, 24 (Winter 1998), pp. 38–41.

Chang, Chris. "Up in Sadie's Room." *Film Comment*, 29 (March–April 1993), pp. 7–8.

Horrigan, Bill. "Sadie Benning or the Secret Annex." *Art Journal*, 54 (Winter 1995), pp. 26–29.

Huston, Johnny Ray. "Where the Art Is." *The San Francisco Bay Guardian*, January 27–February 2, 1999, pp. 42–43.

Smyth, Cherry. "Girls, Videos, and Everything (after Sarah Schulman): The Work of Sadie Benning." *Frieze* (January–February 1993), pp. 21–23.

ROBIN BERNAT

Born in Monroe, Louisiana, 1965

Studied at University of Georgia, Athens (BA, 1987); Emory University, Atlanta; Atlanta College of Art (BFA, 1992)

Lives in Chicago

ARTIST BOOKS

Blue: Twenty Love Poems and a Song of Despair. Atlanta: Circle B Press, 1999.

Sentinel Views: Stories and Images of Phyllis Alterman Franco. Text by Judy Henson. Atlanta: Circle B Press, 1997.

Treading Water; and a Discovery About Duration. Atlanta: Circle B Press, 1997.

Waiting: Eleven Poems of Love and Anticipation. Atlanta: Circle B Press, 1997.

EXHIBITIONS

1998 Solomon Projects, Atlanta

Nexus Contemporary Art Center, Atlanta, "Union/Reunion"

1997 Nancy Solomon Gallery, Atlanta

BIBLIOGRAPHY

Cullum, Jerry. "A Closer Look Reveals Commonalities of Artwork." *The Atlanta Journal-Constitution*, February 28, 1997.

———. "Notes on the Art of Robin Bernat." *Art Papers Magazine*, 21 (November–December 1997), pp. 36–37.

Feaster, Felicia. "Reviews: Atlanta." *Art Papers Magazine*, 23 (November–December 1999), pp. 41–42.

Forrest, Jason A. "Video Creates 'effortless' Emotion in Mixed-media Show." *The Atlanta Journal-Constitution*, November 20, 1998, p. Q8.

Fox, Catherine. "'Woman's Place' Is in a Brewery." *The Atlanta Journal-Constitution*, June 11, 1999, p. Q8.

LINDA BESEMER

Born in South Bend, Indiana, 1957

Studied at Skowhegan School of Painting and Sculpture, Maine (1981); Indiana University, Bloomington (BFA, 1981); Tyler School of Art, Temple University, Philadelphia (MFA, 1983)

Lives in Los Angeles

ONE-ARTIST EXHIBITIONS

1999 Angles Gallery, Santa Monica, California

1998 POST, Los Angeles

GROUP EXHIBITIONS

1999 Museo de la Ciudad de México, Mexico City, "Five Continents and a City"

Oliver Art Center, California College of Arts and Crafts, Oakland, "Twistfoldlayerflake"

SITE Santa Fe, New Mexico, "POSTMARK: An Abstract Effect"

1998 Luckman Fine Arts Gallery, California State University, Los Angeles, "Color Fields"

1997 Grand Arts, Kansas City, Missouri, "Spot Making Sense"

BIBLIOGRAPHY

Cutejar, Mario. "Linda Besemer." *Art + Text*, no. 54 (May 1996), pp. 77–78.

Duncan, Michael. "Testing the Fabric of the New Color Field." *D'Art International*, 2 (Winter 1999), pp. 16–18.

Gilbert-Rolfe, Jeremy. "Linda Besemer." *Art Papers Magazine*, 22 (July–August 1998), p. 29.

———. "Notes on Being Framed by a Surface." *Art + Text*, no. 62 (Summer 1998), pp. 42–45.

Pagel, David. "Wet Paint." *Los Angeles Times*, March 14, 1996, p. F2.

DAWOUD BEY

Born in Queens, New York, 1953

Studied at Empire State College, State University of New York, Saratoga Springs (BA, 1990); Yale University School of Art, New Haven (MFA, 1993)

Lives in Chicago

ONE-ARTIST EXHIBITIONS

1999 The Parrish Art Museum, Southampton, New York

1998 Queens Museum of Art, Flushing, New York

1997 Addison Gallery of American Art, Andover, Massachusetts

Rhona Hoffman Gallery, Chicago

Wadsworth Atheneum, Hartford, Connecticut

GROUP EXHIBITIONS

1998 The Museum of Contemporary Photography of Columbia College Chicago, "Photography's Multiple Roles: Art, Document, Market, Science"

Royal Scottish Academy, Edinburgh, "Transatlantic Connections"

Yale University Art Gallery, New Haven, "Then and Now and Later: Art Since 1945 at Yale"

1997 P.S.1 Contemporary Art Center, Long Island City, New York, "Heaven: Public View, Private View"

Whitney Museum of American Art, New York, "Heart, Mind, Body, Soul"

BIBLIOGRAPHY

Farver, Jane. *Dawoud Bey* (exhibition brochure). Flushing, New York: Queens Museum of Art, 1998.

Johnson, Ken. "Enigmatic Portraits of Teen-Agers Free of All Context." *The New York Times*, August 21, 1998, p. B38.

Miller-Keller, Andrea. *Dawoud Bey: Hartford Portraits '96* (exhibition brochure). Hartford, Connecticut: Wadsworth Atheneum, 1997.

Sancho, Victoria A-T. "Respect and Representation: Dawoud Bey's Portraits of Individual Identity." *Third Text: Third World Perspectives on Contemporary Art and Culture*, no. 44 (Autumn 1998), pp. 55–68.

JEREMY BLAKE

Born in Ft. Sill, Oklahoma, 1971

Studied at The School of The Art Institute of Chicago (BFA, 1993); California Institute of the Arts, Valencia (MFA, 1995)

Lives in New York

EXHIBITIONS

1999 Jacob Fabricius/Nicolai Wallner, Copenhagen

Feigen Contemporary, New York

Grinnell College Art Gallery, Bucksbaum Center for the Arts, Iowa, "Re-structure"

Works on Paper, Inc., Los Angeles

1998 Thread Waxing Space, New York, "Spectacular Optical"

SCREENINGS (WITH THERESA DUNCAN)

1999 University of California, Berkeley Art Museum and Pacific Film Archive

The Film Society of Lincoln Center, New York, "The New York Video Festival"

Rotterdam, "28th International Film Festival"

"Tokyo International Film Festival"

1998 Bronwyn Keenan, New York

Gavin Brown's Experience, New York, "Oriental Nights"

Works on Paper, Inc., Los Angeles

BIBLIOGRAPHY

Blake, Jeremy, et al. "Power Ballads in the Form of a Gel Cap" (interview). *Purple*, no. 4 (Winter 1999–2000), pp. 285–87.

Blake, Jeremy, and Theresa Duncan. "The Red Eye." *Art/Text*, no. 67 (November 1999–January 2000), pp. 52–57.

Griffin, Tim. "Jeremy Blake at Feigen Contemporary." *Art in America*, 87 (November 1999), p. 144.

Johnson, Ken. "Jeremy Blake." *The New York Times*, April 2, 1999, p. E39.

Perchuk, Andrew. "Jeremy Blake." *Artforum*, 37 (Summer 1999), pp. 156–57.

CHAKAIA BOOKER

Born in Newark, New Jersey, 1953

Studied at Rutgers, The State University of New Jersey, New Brunswick (BA, 1976); City College, The City University of New York (MFA, 1993)

Lives in New York

ONE-ARTIST EXHIBITIONS

1999 Laumeier Sculpture Park & Museum, St. Louis

1998 June Kelly Gallery, New York

1997 Neuberger Museum of Art, Purchase College, State University of New York

GROUP EXHIBITIONS

1999 Artrain: America's Museum in Motion, Ann Arbor, Michigan, "Artistry of Space" (traveling)

New Museum of Contemporary Art, New York, "The Time of Our Lives"

1998 Public Art Fund, MetroTech Center, Brooklyn, New York, "Beyond the Monument"

Robert Miller Gallery, New York, "Rubber"

1997 Socrates Sculpture Park, Long Island City, New York, "Socrates Sculpture Park International 97"

BIBLIOGRAPHY

Bear, Liza. "Chakaia Booker at Max Protetch." *Art in America*, 85 (May 1997), pp. 131–32.

Cotter, Holland. "Chakaia Booker: 'Not That Daughter.'" *The New York Times*, July 10, 1998, p. E38.

Farver, Jane. *Chakaia Booker* (exhibition brochure). Flushing, New York: Queens Museum of Art at Bulova Corporate Center, 1996.

Glueck, Grace. "The Antithesis of Minimalism's Cool Geometry: Fleshy Rubber." *The New York Times*, February 13, 1998, p. E40.

Veneciano, J. Daniel. *From the Studio: Artists-In-Residence 1995–1996, "…To Carry Me Home"* (exhibition brochure). New York: The Studio Museum in Harlem, 1996.

M.W. BURNS

Born in Stamford, Connecticut, 1958

Studied at Philadelphia College of Art (1977–82); The University of the Arts, Philadelphia (BFA, 1989); The School of The Art Institute of Chicago (MFA, 1990)

Lives in Chicago

ONE-ARTIST EXHIBITIONS

1998 TBA Exhibition Space, Chicago

1997 Northern Illinois University Art Museum, DeKalb

Tough, Chicago

GROUP EXHIBITIONS

1999 Donald Young Gallery, Chicago, "Invitational"

Museum of Contemporary Art, Chicago, "Trans23"

BIBLIOGRAPHY

Cobb, LCD. "New Spaces." *New Art Examiner*, 19 (February–March 1992), pp. 40–41.

Grabner, Michelle. "M.W. Burns." *Frieze*, no. 34 (May 1997), p. 80.

Hixson, Kathryn. "...and the Object Is the Body." *New Art Examiner*, 19 (October 1991), pp. 20–24.

Lueck, Brock. "M.W. Burns." *New Art Examiner*, 22 (December 1994), pp. 39–40.

Snodgrass, Susan. "M.W. Burns at N.A.M.E." *Art in America*, 83 (January 1995), pp. 108–09.

CAI GUO-QIANG

Born in Quanzhou City, Fujian Province, China, 1957

Studied at Shanghai Drama Institute (1981–85)

Lives in New York

ONE-ARTIST EXHIBITIONS

1999 Kunsthalle Wien, Vienna

1998 Cherng Piin Gallery, Taipei

Taiwan Museum of Art, Taichung

1997 Louisiana Museum of Modern Art, Humlebaek, Denmark

Queens Museum of Art, Flushing, New York

GROUP EXHIBITIONS

1999 Queensland Art Gallery, Brisbane, Australia, "Beyond the Future: The Third Asia-Pacific Triennial of Contemporary Art"

"48th Venice Biennale"

1998 Moderna Museet, Stockholm, "Wounds Between Democracy and Redemption in Contemporary Art"

1997 "5th International Istanbul Biennial: On Life, Beauty, Translations, and Other Difficulties, or Finding Angels in Istanbul"

Museum of Contemporary Art, Chicago, "Performance Anxiety" (traveled)

BIBLIOGRAPHY

Cotter, Holland. "Playing to Whoever in Distant Galaxies." *The New York Times*, August 15, 1997.

Farver, Jane, and Reiko Tomii. *Cultural Melting Bath: Projects for the 20th Century* (exhibition catalogue). Flushing, New York: Queens Museum of Art, 1997.

Jolles, Claudia. "Cai Guo-Qiang: Künstler sind wie Kung-Fu-Kämpfer." *Das Kunst-Bulletin*, no. 4 (April 1997), pp. 12–17.

Lutfy, Carol. "Flame and Fortune." *Art News*, 96 (December 1997), pp. 144–47.

Schwabsky, Barry. "Tao and Physics: The Art of Cai Guo-Qiang." *Artforum*, 35 (Summer 1997), pp. 118–21, 155.

INGRID CALAME

Born in New York, 1965

Studied at Tyler School of Art, Rome (1986); Purchase College, State University of New York (BFA, 1987); Skowhegan School of Painting and Sculpture, Maine (1995); California Institute of the Arts, Valencia (MFA, 1996)

Lives in Los Angeles

ONE-ARTIST EXHIBITIONS

1999 Karyn Lovegrove Gallery, Los Angeles

1998 Galerie Rolf Ricke, Cologne

Rosamund Felsen Gallery, Project Wall, Los Angeles

1997 Four Walls, San Francisco

POST, Los Angeles

GROUP EXHIBITIONS

1999 Kunsthallen Brandts Klædefabrik, Odense, Denmark, "Color Volume"

SITE Santa Fe, New Mexico, "POSTMARK: An Abstract Effect"

Württembergischer Kunstverein Stuttgart, "Colour Me Blind!"

1998 Contemporary Arts Museum, Houston, "Abstract Painting Once Removed"

The Drawing Center, New York, "Selections Winter '98"

BIBLIOGRAPHY

Knight, Christopher. "The Case for Painting." *Los Angeles Times*, April 4, 1999, pp. 4–6, 80.

Pagel, David. "Editor's Choice: Art." *Bomb*, 17 (Spring 1997), p. 17.

Relyea, Lane. "Virtually Formal." *Artforum*, 37 (September 1998), pp. 126–33, 173.

Rinder, Lawrence. *Twistfoldlayerflake* (exhibition catalogue). Oakland: California College of Arts and Crafts, 1999.

Schjeldahl, Peter. "Ultraloungerie." *The Village Voice*, June 23, 1998, p. 153.

LUIS CAMNITZER

Born in Lübeck, Germany, 1937

Studied at Akademie der Bildende Künste, Munich (1957–58); Universidad del Uruguay, Montevideo (graduated 1959)

Lives in Great Neck, New York

ONE-ARTIST EXHIBITIONS

1997 Galerie Basta, Hamburg

GROUP EXHIBITIONS

1999 The Liverpool Biennial of Contemporary Art, "TRACE: The Liverpool International Exhibition"

1997 Kwangju, South Korea, "2nd Kwangju Biennale"

Carla Stellweg Gallery, ARCO '97, Madrid

Fundação Bienal de Artes Visuais do Mercosul, Porto Alegre, Brazil, "1 Bienal de Artes Visuais do Mercosul"

Galerie Basta, Cologne, "Art Cologne 1997"

BIBLIOGRAPHY

Borum, Jenifer P. "Luis Camnitzer." *Artforum*, 29 (Summer 1991), pp. 114–15.

Farver, Jane. *Luis Camnitzer: Retrospective Exhibition 1966–1990* (exhibition catalogue). The Bronx, New York: Lehman College Art Gallery, 1991.

Linari, Gabriel Peluffo. "The Instrumental Art of Luis Camnitzer." In *America, Bride of the Sun* (exhibition catalogue). Antwerp: Koninklijk Museum voor Schone Kunsten, 1992, pp. 277–78.

Lippard, Lucy R. *Six Years: The Dematerialization of the Art Object from 1966 to 1972* (1973). Reprt. Berkeley: University of California Press, 1997, pp. 168–69.

Ramírez, Mari Carmen and Beverly Adams. *Encounters/Displacements: Luis Camnitzer, Alfredo Jaar, Cildo Meireles* (exhibition catalogue). Austin, Texas: Archer M. Huntington Art Gallery, College of Fine Arts, The University of Texas at Austin, 1992.

JEM COHEN

Born in Kabul, Afghanistan, 1962

Studied at Wesleyan University, Middletown, Connecticut (BA, 1984)

Lives in Brooklyn, New York

SCREENINGS

1999 Florence, "Festival dei Popoli"

Rotterdam, "28th International Film Festival"

Switzerland, "The Locarno International Film Festival"

1997 Bonn, "Videonale Festival"

Brooklyn Museum of Art, New York

The Film Society of Lincoln Center, New York, "Image Innovators"

Graz, Austria, "3. International Biennial film+arc.graz"

The Museum of Modern Art, New York

BIBLIOGRAPHY

Brace, Eric. "Fugazi's Big Screen Jam." *The Washington Post*, May 7, 1999, pp. 15–16.

Dubler, Linda. *Art at the Edge: Jem Cohen* (exhibition brochure). Atlanta: High Museum of Art, 1995.

Gee, Grant. "Wish You Were Here" (interview). *Filmmaker*, 7 (Spring 1999), pp. 52–55, 92–95.

Harrington, Richard. "Keeping It Reel: Film as a Backstage Pass." *The Washington Post*, June 13, 1999, p. 64.

Plante, Mike. "Glass Is a Liquid: Interview with Filmmaker Jem Cohen." *Cinemad*, no. 2 (Fall 1999), pp. 4–13.

JOHN COPLANS

Born in London, 1920

Lives in New York

ONE-ARTIST EXHIBITIONS

1999 The Dean Gallery, Scottish National Gallery of Modern Art, Edinburgh

Galleria Massimo De Carlo, Milan

Galerie Peter Kilchmann, Zurich

1997 Andrea Rosen Gallery, New York

P.S.1 Contemporary Art Center, Long Island City, New York

GROUP EXHIBITIONS

1999 The Aldrich Museum of Contemporary Art, Ridgefield, Connecticut, "The Nude in Contemporary Art"

Galerie Lelong, New York, "Alter/Body"

1998 Magasin 3 Stockholm Konsthall, "Spatiotemporal Verk ur Samlingen 1988–1998"

Nina Freudenheim Gallery, Buffalo, New York, "Art That Happens To Be Photography"

1997 Milwaukee Art Museum, "Identity Crisis: Self-Portraiture at the End of the Century"

BIBLIOGRAPHY

Boxer, Sarah. "The Anatomy of a Photographer." *The New York Times*, October 31, 1997, p. E31.

Chevrier, Jean-François. *A Self-Portrait: John Coplans 1984–1987* (exhibition catalogue). Long Island City, New York: P.S.1 Contemporary Art Center, 1997.

Miller-Keller, Andrea. *John Coplans/Matrix 113* (exhibition brochure). Hartford, Connecticut: Wadsworth Atheneum, 1991.

Schjeldahl, Peter. "The Old Guy." *The Village Voice*, November 25, 1997, p. 107.

Schwabsky, Barry. "John Coplans." *Artforum*, 36 (March 1998), p. 97.

PETAH COYNE

Born in Oklahoma City, 1953

Studied at Kent State University, Ohio (1972–73); Art Academy of Cincinnati (1977)

Lives in New York

ONE-ARTIST EXHIBITIONS

1999 The Butler Gallery, The Castle, Kilkenny, Ireland

1998 Galerie Lelong, New York

1997 The Corcoran Gallery of Art, Washington, D.C. (traveled)

Weatherspoon Art Gallery, University of North Carolina, Greensboro

GROUP EXHIBITIONS

1999 The Aldrich Museum of Contemporary Art, Ridgefield, Connecticut, "Best of the Season: Selected Work from the 1998–99 Manhattan Exhibition Season"

San Jose Museum of Art, California, "Surroundings: Responses to the American Landscape," organized by the Whitney Museum of American Art, New York

Heckscher Museum of Art, Huntington, New York, "Millennium Messages" (traveling)

1997 The Museum of Modern Art, New York, "Selections from the Collection"

Museum of Contemporary Art, San Diego, "Selections from the Permanent Collection"

BIBLIOGRAPHY

Dobrzynski, Judith H. "Steadily Weaving Toward Her Goal." *The New York Times*, October 6, 1998, pp. E1, E3.

Macadam, Barbara A. "Girl Talk." *Art News*, 95 (September 1996), pp. 104–07.

Koplos, Janet. "Blankets of Darkness." *Art in America*, 87 (September 1999), pp. 116–19.

Princenthal, Nancy. In *Petah Coyne: Fairy Tales* (exhibition catalogue). Kilkenny, Ireland: The Butler Gallery, 1999, pp. 4–8.

Smith, Roberta. "The World Through Women's Lenses." *The New York Times*, December 13, 1996, p. C28.

JOHN CURRIN

Born in Boulder, Colorado, 1962

Studied at Carnegie Mellon University, Pittsburgh (BFA, 1984); Yale University School of Art, New Haven (MFA, 1986)

Lives in New York

ONE-ARTIST EXHIBITIONS

1999 Regen Projects, Los Angeles

Andrea Rosen Gallery, New York

1997 Andrea Rosen Gallery, New York

Sadie Coles HQ, London

GROUP EXHIBITIONS

1999 Carnegie Museum of Art, Pittsburgh, "1999 Carnegie International"

Carpenter Center for the Visual Arts, Harvard University, Cambridge, Massachusetts, "John Currin and Elizabeth Peyton"

Whitechapel Art Gallery, London, "Examining Pictures: Exhibiting Paintings" (traveling)

1998 The Saatchi Gallery, London, "Young Americans 2: New American Art at The Saatchi Gallery"

1997 The Museum of Modern Art, New York, "Projects 60: John Currin, Elizabeth Peyton, Luc Tuymans"

BIBLIOGRAPHY

"Cherchez la Femme Peintre!—A Parkett Inquiry." *Parkett*, no. 37 (1993), pp. 138–47.

John Currin: Oeuvres/Works 1989–1995 (exhibition catalogue). Limoges, France: Fonds Régional d'Art Contemporain Limousin, 1995.

Fox, Marisa. "High-Art/Low-Lifes." *World Art*, no. 19 (1998), pp. 72–73.

Schjeldahl, Peter. "The Elegant Scavenger." *The New Yorker*, February 22 and March 1, 1999, pp. 174–75.

Van der Walle, Mark. "Contract with a Coldhearted Muse." *Parkett*, nos. 50–51 (1997), pp. 240–48.

E.V. DAY

Born in New York, 1967

Studied at Hampshire College, Amherst, Massachusetts (BA, 1991); Yale University School of Art, New Haven (MFA, 1995)

Lives in Brooklyn, New York

GROUP EXHIBITIONS

1999 Track 16 Gallery, Santa Monica, California, "At the Curve of the World"

Henry Urbach Architecture, New York, "Luster"

1997 Sandra Gering Gallery, New York, "Julia Wachtel, E.V. Day, Lindsay Brant, and Janine Cirincione and Michael Ferraro"

Andrew Kreps Gallery, New York, "Perfect Day"

Real Art Ways, Hartford, Connecticut, "Twister"

BIBLIOGRAPHY

Avgikos, Jan. "A Delightful Horror, A Terrible Joy: An Essay Mainly About E.V. Day's Exploded Dresses and Dissected Wetsuits." In Pilar Perez, ed. *At the Curve of the World* (exhibition catalogue). Santa Monica, California: Smart Art Press, 1999.

Day, E.V. "Double-D Disaster." *The Nose* (1992), pp. 46–47.

González, Rita. "E.V. Day." *Poliester*, 8 (Fall 1999), pp. 46–49.

Pandiscio, Richard. "She Blows Up Fashion." *Interview*, 29 (September 1999), p. 106.

Yoe, Craig, ed. *The Art of Barbie: Artists Celebrate the World's Favorite Doll*. San Francisco: Workman Publishing Company, 1994, p. 110.

WILLIAM DE LOTTIE

Born in New Britain, Connecticut, 1942

Studied at University of Connecticut, Storrs (BFA, 1968)

Lives in Eastford, Connecticut

ONE-ARTIST EXHIBITIONS

1999 Derek Eller Gallery, New York

GROUP EXHIBITIONS

1997 Hartford, Connecticut, "Qua Qua Qua"

BIBLIOGRAPHY

Rosoff, Patricia. "Take the Real Art Ways Plunge." *Hartford Advocate*, April 6, 1995, p. 25.

Schnaidt, Dan. "Unsettling Works in the Rough Interiors of a RAW Industrial Space." *The Hartford Courant*, April 21, 1995, p. E3.

Schwendenwien, Jude. "De Lottie, Scavotto-Earley, Raymond, LeWitt Shined This Year." *The Hartford Courant*, December 31, 1995, p. G4.

————. "William De Lottie." *Sculpture*, 15 (May–June 1996), p. 76.

ROMAN DE SALVO

Born in San Francisco, 1965

Studied at California College of Arts and Crafts, Oakland (BFA, 1990); University of California, San Diego (MFA, 1995)

Lives in San Diego

ONE-ARTIST EXHIBITIONS

1999 Quint Contemporary Art, La Jolla, California

1998 Museum of Contemporary Art, San Diego

1997 Founders Gallery, Department of Fine Arts, University of San Diego

GROUP EXHIBITIONS

1999 The Hudson River Museum of Westchester, Yonkers, New York, "Drip, Blow, Burn: Forces of Nature in Contemporary Art"

1997 Children's Museum/Museo de los Niños, San Diego, "¡Pop! Goes the Museum/En El Museo"

University Art Gallery, University of California, San Diego, "Presence: Eighteen Area Sculptors"

BIBLIOGRAPHY

Pincus, Robert L. "Contraptions and Canvases: Roman de Salvo Revels in Fractured Wit; Doris Bittar Cloaks Her History in Patterns." *The San Diego Union-Tribune*, February 11, 1999, p. 53.

————. "Pop of Ages." *The San Diego Union-Tribune*, May 4, 1997, pp. E1, E4.

————. "Witty Inventiveness Spawns a 'Presence' of Mind." *The San Diego Union-Tribune*, July 10, 1997, p. 15.

THORNTON DIAL

Born in Emelle, Alabama, 1928

Lives in McCalla, Alabama

ONE-ARTIST EXHIBITIONS

1998 Ricco/Maresca Gallery, New York

1997 Artspace, Richmond, Virginia

GROUP EXHIBITIONS

1998 Museum of American Folk Art,
–99 New York, "Self-Taught Artists of the 20th Century: An American Anthology" (traveled)

1997 Hirshhorn Museum and Sculpture Garden, Smithsonian Institution, Washington, D.C., "The Hirshhorn Collects: Recent Acquisitions 1992–1996"

Milwaukee Art Museum, "Since Hall: New Acquisitions of Folk and Self-Taught Art"

Schomburg Center for Research in Black Culture, The New York Public Library, "Bearing Witness: African-American Vernacular Art of the South"

Spoleto Festival USA, Charleston, South Carolina, "Human/Nature: Art and Landscape in Charleston and the Low Country"

BIBLIOGRAPHY

Beardsley, John. *Art and Landscape in Charleston and the Low Country* (exhibition catalogue). Charleston, South Carolina: Spoleto Festival USA, 1998.

McEvilley, Thomas. "The Missing Tradition." *Art in America*, 85 (May 1997), pp. 78–85, 137.

McEvilley, Thomas, and Amiri Baraka. *Thornton Dial: Image of the Tiger* (exhibition catalogue). New York: Museum of American Folk Art; Paris: The American Center, 1993.

Smith, Dinitia. "Bits and Pieces and an Artist's Drive." *The New York Times*, February 5, 1997, p. B1–B2.

Wallach, Amei. "The Eye of the Tiger." *New York Newsday*, November 21, 1993, p. 19.

KIM DINGLE

Born in Pomona, California, 1951

Studied at California State University, Los Angeles (BFA, 1988); Claremont Graduate School, California (MFA, 1990)

Lives in Los Angeles

ONE-ARTIST EXHIBITIONS

1998 Gian Enzo Sperone, Rome

Sperone Westwater, New York

1997 Blum & Poe, Santa Monica, California

GROUP EXHIBITIONS

1999 Des Moines Art Center, Iowa, "Almost Warm and Fuzzy"

1998 Anderson Gallery, School of Arts, Virginia Commonwealth University, Richmond, "Presumed Innocence"

The Museum of Contemporary Art, Los Angeles, "Family Viewing: Selections from the Permanent Collection"

1997 Louisiana Museum of Modern Art, Humlebaek, Denmark, "Sunshine & Noir: Art in L.A., 1960–1997"

Museum of Contemporary Art, Chicago, "My Little Pretty: Images of Girls by Contemporary Women Artists"

BIBLIOGRAPHY

Greenstein, M.A. "A Conversation with Kim Dingle, Artist." *Artweek*, 27 (January 1996), pp. 23–24.

Knode, Marilu. "My Struggle with Dingle." In *Kim Dingle* (exhibition catalogue). Los Angeles: Otis Gallery, Otis College of Art and Design, 1995.

Schjeldahl, Peter. "The Dingle Flap." *The Village Voice*, January 30, 1996, p. 73.

Wallach, Amei. "Malevolent Babies Busting Up Walls, Sharpening Darts." *The New York Times*, November 1, 1998, pp. 47–48.

Willette, Jeanne S.M. "Kim Dingle and Cohorts: The Writer, the Bad Girl and the Seamstress." *Artweek*, 29 (November 1998), pp. 15–16.

ANTHONY DISCENZA

Born in New Brunswick, New Jersey, 1967

Studied at Wesleyan University, Middletown, Connecticut (BA, 1990); California College of Arts and Crafts, Oakland (1998–present)

Lives in Oakland, California

GROUP EXHIBITIONS

1999 jennjoygallery, San Francisco, "Static Theory"

WRO 99 7th International Media Art Biennale, Wroclaw, Poland

1998 jennjoygallery, San Francisco, "HalfLifers: BarnLanders"

London Electronic Arts, "Pandæmonium: The London Festival of Moving Images 1998"

Utrecht, The Netherlands, "Impakt Festival '98"

BIBLIOGRAPHY

Baker, Kenneth. "What's Wrong with This Picture?" *San Francisco Chronicle*, July 24, 1999, pp. B1, B10.

Supanick, Jim. "Quest for What." *Film Comment*, 35 (September–October 1999), pp. 52–53.

Van Proyen, Mark. "HalfLifers at jennjoygallery." *Artweek*, 29 (June 1998), p. 20.

TARA DONOVAN

Born in New York, 1969

Studied at School of Visual Arts, New York (1987–88); The Corcoran College of Art and Design, Washington, D.C. (BFA, 1991); Virginia Commonwealth University, Richmond (MFA, 1999)

Lives in Richmond, Virginia

ONE-ARTIST EXHIBITIONS

1999 The Corcoran Gallery of Art, Washington, D.C.

1998 Reynolds Gallery, Richmond, Virginia

Hemphill Fine Arts, Washington, D.C.

GROUP EXHIBITIONS

1999 Anderson Gallery, School of the Arts, Virginia Commonwealth University, "MFA Thesis Exhibition"

Kim Foster Gallery, New York, "Fresh Meat"

1998 Numark Gallery, Washington, D.C., "Simple Matter"

1997 Baumgartner Galleries, Washington, D.C., "What's Hot"

projectspace, Washington, D.C., "Options 1997," organized by the Washington Project for the Arts/Corcoran

BIBLIOGRAPHY

Fleming, Tyler. "Originality Plus." *Style Weekly* (Richmond, Virginia), April 7, 1998, p. 32.

Greenwell, Stuart. "Tara Donovan: Resonances." *Articulate*, 27 (March–April 1998), pp. 7–8.

Howell, George. "Tara Donovan." *Sculpture*, 17 (May–June 1998), pp. 80–81.

Protzman, Ferdinand. "Industrial-Strength Sculpture." *The Washington Post*, January 22, 1998, p. C7.

NATHANIEL DORSKY

Born in New York, 1943

Studied at Antioch College, Yellow Springs, Ohio (BA, 1961); New York University

Lives in San Francisco

SCREENINGS

1999 Archives du Film Experimental d'Avignon, France

Filmforum, Hollywood, California

Rotterdam, "28th International Film Festival"

San Francisco Museum of Modern Art

Vienna, "Viennale"

Wellington, "The New Zealand Film Festival"

1998 University of California, Berkeley Art Museum and Pacific Film Archive

The Film Society of Lincoln Center, New York, "The New York Film Festival"

The Museum of Modern Art, New York

San Francisco Cinematheque

Scratch Projection, Paris

BIBLIOGRAPHY

Arthur, Paul. "The Avant-Garde in '98." *Film Comment*, 35 (January–February 1999), pp. 38–39.

Delabre, Patrick. "Acting/Being on the Surface of Film: Conversation with Nathaniel Dorsky." *Cinematograph*, 1 (1985), pp. 96–100.

Dixon, Wheeler Winston. *The Exploding Eye: A Re-visionary History of 1960s American Experimental Cinema*. Albany, New York: State University of New York Press, 1997, pp. 56–62.

Kleinhans, Chuck. "Margin Notes." *Afterimage*, 15 (February 1988), p. 21.

Powers, Thomas. "A Film Is Like a Panther" (interview). *Release Print* (October 1996), pp. 26–28.

JAMES DRAKE

Born in Lubbock, Texas, 1946

Studied at Art Center College of Design, Los Angeles (BFA, 1969; MFA, 1970)

Lives in El Paso, Texas; Santa Fe, New Mexico; and New York

ONE-ARTIST EXHIBITIONS

1999 Australian Centre for Photography, Sydney

Grand Arts, Kansas City, Missouri

1998 ArtPace, A Foundation for Contemporary Art, San Antonio, Texas

Pamela Auchincloss, New York

1997 Rhona Hoffman Gallery, Chicago

GROUP EXHIBITIONS

1999 Contemporary Arts Museum, Houston, "Texas Draws"

DePaul University Art Gallery, Chicago, "Crossing Zones"

1998 Museum of Fine Arts, Boston, "PhotoImage: Printmaking 60s to 90s"

National Museum of American Art, Smithsonian Institution, Washington, D.C., "Recent Acquisitions: Contemporary Prints"

New Orleans Museum of Art, "1998 New Orleans Triennial"

BIBLIOGRAPHY

Brooks, Rosetta. "Hot Rod Snake Charmer." *World Art*, no. 3 (September 1995), pp. 48–52.

———. "James Drake." *Artforum*, 37 (November 1998), pp. 118–19.

Colpitt, Frances. "Terry Allen and James Drake at Blue Star Art Space." *Art in America*, 82 (October 1994), p. 144.

Ferguson, Bruce W. "James Drake." *Flash Art*, 30 (March–April 1997), p. 109.

Plante, Michael. "Southern Discomfort." *Art in America*, 87 (March 1999), pp. 67–71.

THERESA DUNCAN

Born in Detroit, 1968

Studied at University of Michigan, Ann Arbor

Lives in Los Angeles and New York

SCREENINGS (WITH JEREMY BLAKE)

1999 University of California, Berkeley Art Museum and Pacific Film Archive

The Film Society of Lincoln Center, New York, "The New York Video Festival"

Rotterdam, "28th International Film Festival"

"Tokyo International Film Festival"

1998 Bronwyn Keenan, New York

Gavin Brown's Experience, New York, "Oriental Nights"

Works on Paper, Inc., Los Angeles

BIBLIOGRAPHY

Glos, Jennifer, and Shari Goldin. In Justine Cassell and Henry Jenkins, eds., *From Barbie® to Mortal Kombat: Gender and Computer Games*. Chapter 8, "Interviews with Theresa Duncan and Monica Gesue (Chop Suey)." Cambridge, Massachusetts: The MIT Press, 1998, pp. 172–86.

Harlan, Megan. "Game Girl: Interactive Satire from Whiz Kid Theresa Duncan." *Elle*, 13 (August 1998), p. 62.

Holden, Stephen. "A Thematic Feast of Avante-Garde Videos." *The New York Times*, July 16, 1999, pp. 1, 27.

Rimanelli, David. "Whirl Weary." *Artforum*, 37 (November 1998), p. 30.

Subotnick, Ali. "Living Doll." *Art News*, 97 (October 1998), p. 34.

LEANDRO ERLICH

Born in Buenos Aires, 1973

Studied at Universidad de Buenos Aires (1991–93)

Lives in Houston

ONE-ARTIST EXHIBITIONS

1999 Kent Gallery, New York

Moody Gallery, Houston

Ruth Benzacar Gallery, Buenos Aires

1997 Consulate General of Argentina in New York

GROUP EXHIBITIONS

1999 Fondo Nacional de las Artes, ARCO '99, Madrid, "Paralelos, Paralelas"

The Glassell School of Art, Museum of Fine Arts, Houston, "Core 1999"

1998 The Glassell School of Art, Museum of Fine Arts, Houston, "Core 1998"

1997 Fundação Bienal de Artes Visuais do Mercosul, Porto Alegre, Brazil, "1 Bienal de Artes Visuais do Mercosul"

BIBLIOGRAPHY

Dewan, Shaila. "Remaining Calm." *Houston Press*, April 8–14, 1999, pp. 61–62.

Johnson, Patricia C. "Esprit de Core." *Houston Chronicle*, March 21, 1999, pp. 8–9.

———. "Gallery Shows Full of Surprises." *Houston Chronicle*, July 15, 1999, pp. D1, D3.

Szatmary, Peter. "Essay in Reach." In *Core 1999* (exhibition catalogue). Houston: The Glassell School of Art, Museum of Fine Arts, Houston, 1999, pp. 11–17.

FAKESHOP

Organized in 1995

Based in Brooklyn, New York

CORE MEMBERS

JEFF GOMPERTZ

Born in New York, 1959

Studied at The Cooper Union for the Advancement of Science and Art, New York (BFA, 1981)

PREMA MURTHY

Born in Seattle, 1969

Studied at the University of Texas at Austin (BA, 1993)

EUGENE THACKER

Born in Seattle, 1971

Studied at University of Washington, Seattle (BA, 1994); Rutgers, The State University of New Jersey, New Brunswick (MA, 1997)

NEW MEDIA PROJECTS AND EXHIBITIONS

1999 Linz, Austria, "Ars Electronica 99"

Amsterdam, "The Next 5 Minutes 3 Conference"

1998 *Artificial Constructions* (audio project with WKCR Radio, New York)

Multiple Dwelling (performative installation and website; www.fakeshop.com/multiple_dwelling)

1997 Brooklyn, New York, *451 Test*

Channel 16, New York, "CU-SeeMeTV"

BIBLIOGRAPHY

"Artificial Construction." *Acoustic.Space*, no. 2 (Fall 1999), pp. 132–38.

Bosma, Josephine. "(Xchange) Net, 'Radio' and Physical Space: FAKESHOP." *Xchange Network* (online; xchange.re-lab.net/a/msg00035.html).

Chalmers, Jessica. "The Screens: All the World's a Cyber Stage—The State of Online Theater." *The Village Voice*, December 2–8, 1998.

Dominguez, Ricardo. "Diogenes On-line: Gestures Against the Virtual Republic." *Switch*, 4 (online; switch.sjsu.edu/web/v4n2/contents.html).

Thacker, Eugene. "The net.art of Technoscience: Tactics for Anatomizing the Web." (Online article; gsa.rutgers.edu/maldoror/theory/netart_techsci/netart_techsci.html).

VERNON FISHER

Born in Fort Worth, Texas, 1943

Studied at Hardin-Simmons University, Abilene, Texas (BA, 1967); University of Illinois at Urbana-Champaign (MFA, 1969)

Lives in Fort Worth, Texas

ONE-ARTIST EXHIBITIONS

1999 Devin Borden Hiram Butler Gallery, Houston

1998 Charles Cowles Gallery, New York

Mark Moore Gallery, Santa Monica, California

Zolla/Lieberman Gallery, Chicago

1997 Modern Art Museum of Fort Worth, Texas

GROUP EXHIBITIONS

1999 Contemporary Arts Museum, Houston, "Texas Draws"

1998 Miami Art Museum, "Words & Images"

1997 Arizona State University Art Museum, Tempe, "Dis/Functional"

The Museum of Modern Art, New York, "A Singular Vision: Prints from Landfall Press"

Gerald Peters Gallery, Dallas, "Link"

BIBLIOGRAPHY

Davies, Hugh M., and Ronald J. Onorato. *Blurring the Boundaries: Installation Art 1969–1996*. San Diego: Museum of Contemporary Art, San Diego, 1997.

Davies, Hugh M., and Madeleine Grynsztejn. *Vernon Fisher* (exhibition catalogue). La Jolla, California: La Jolla Museum of Contemporary Art, 1989.

Swimming Lesions (exhibition catalogue). San Antonio, Texas: Blue Star Art Space, 1994.

Vernon Fisher (exhibition catalogue). Dallas: Gerald Peters Gallery, 1997.

Vernon Fisher (exhibition catalogue). Champaign: Krannert Art Museum and Kinkead Pavilion, University of Illinois at Urbana-Champaign, 1994.

SUZAN FRECON

Born in Mexico, Pennsylvania, 1941

Studied at The Pennsylvania State University, State College

Lives in New York

ONE-ARTIST EXHIBITIONS

1999 Galerie Franck + Schulte, Berlin

Lawrence Markey Gallery, New York

1998 Galerij S65, Aalst, Belgium

Häusler Kunst Projekte, Munich

GROUP EXHIBITIONS

1998 Diözesanmuseum Freising, Germany, "Geistes Gegenwart"

Oliver Art Center, California College of Arts and Crafts, Oakland, "Undercurrents and Overtones: Contemporary Abstract Painting"

Stephen Wirtz Gallery, San Francisco, "Paper Thin"

Turner & Runyon Gallery, Dallas, "Suzan Frecon, Rachel Harrison, Thomas Nozkowski"

BIBLIOGRAPHY

Caramelle, Ernst. *Suzan Frecon: Works Relating to Painting 1988–1994* (exhibition catalogue). Vienna: Wiener Secession; Berkeley: University Art Museum and Pacific Film Archive, University of California, Berkeley, 1994.

Mitchell, Charles Dee. "Suzan Frecon at Lawrence Markey and Hirschl & Adler Modern." *Art in America*, 85 (March 1997), p. 102.

Rinder, Lawrence. *Suzan Frecon: Watercolors and Small Paintings* (exhibition brochure). Berkeley: University Art Museum and Pacific Film Archive, University of California, Berkeley, 1995.

Westfall, Stephen. "Suzan Frecon at Lawrence Markey." *Art in America*, 81 (February 1993), p. 112.

Yau, John. *Suzan Frecon: Paintings* (exhibition catalogue). Munich: Häusler Kunst Projekte, 1999.

BRIAN FRIDGE

Born in Fort Worth, Texas, 1969

Studied at University of North Texas, Denton (BFA, 1994)

Lives in Fort Worth, Texas

ONE-ARTIST EXHIBITIONS

1999 Conduit Gallery Annex, Dallas

1998 Good/Bad Art Collective, Denton, Texas

GROUP EXHIBITIONS

1999 Amarillo Museum of Art, Texas, "Black and White/Gray Permitted"

The McKinney Avenue Contemporary and Dallas Video Festival, "Wired for Living"

1998 Main Gallery, Visual Arts, University of Texas at Dallas, Richardson, "Blurring the Lines"

1997 ArtPace, A Foundation for Contemporary Art, San Antonio, Texas, "Fort Worth Hot Shots: Nine Artists"

Hohenthal und Bergen, Cologne, "Video Flash"

BIBLIOGRAPHY

Kutner, Janet. "Show Covers the Whole Wired World." *The Dallas Morning News*, March 14, 1999, pp. 1C, 8C.

Palmer, Rachel. "The Weather Channel." *Denton Record Chronicle*, May 21, 1998, pp. 3, 14.

Rees, Christina. "Meteor Man." *Dallas Observer*, July 15–21, 1999, p. 71.

Wilson, Wade. "Fort Worth Hotshots: Nine Artists." *Flash Art*, 30 (October 1997), p. 76.

DARA FRIEDMAN

Born in Bad Kreuznach, Germany, 1968

Studied at Vassar College, Poughkeepsie, New York (BA, 1990); Staatliche Hochschule für Bildende Künste, Städelschule, Frankfurt (1989–91); The Slade School of Fine Art, University College London (1991–92); University of Miami (MFA, 1994)

Lives in Miami

ONE-ARTIST EXHIBITIONS

1998 Gavin Brown's Enterprise, New York (with Mark Handforth)

Miami Art Museum

Museum of Contemporary Art, Chicago

GROUP EXHIBITIONS

1999 Museum of Contemporary Art, North Miami, "Heads Up"

Nature Morte, New Delhi, "Leftover Festivities"

1998 Museum of Contemporary Art, North Miami, "New Art: South Florida"

The Swiss Institute, New York, "Independing Loop"

1997 Thread Waxing Space, New York, "Celluloid Cave"

BIBLIOGRAPHY

Brackman, Yvette. "Dara Friedman + Mark Handforth." *Time Out New York*, February 12–19, 1998, p. 49.

Dellinger, Jade. "Mark Handforth and Dara Friedman." *Flash Art*, 31 (March–April 1998), p. 72.

Friedman, Dara, and Lisa Jaye Young. *Celluloid Cave* (exhibition brochure). New York: Thread Waxing Space, 1997.

Johnson, Ken. "Dara Friedman and Mark Handforth." *The New York Times*, February 6, 1998, p. E36.

Molon, Dominic. *Dara Friedman: Creator/Destroyer* (exhibition brochure). Chicago: Museum of Contemporary Art, 1998.

JOE GIBBONS

Born in Providence, Rhode Island, 1953

Studied at Antioch College, Yellow Springs, Ohio (BA, 1976); Bard College, Annandale-on-Hudson, New York (MFA, 1991)

Lives in New York

SCREENINGS

1999 Geneva, "7e Semaine Internationale de Vidéo (Biennale de l'Image en Mouvement)"

The Museum of Modern Art, New York, "Big as Life: An American History of 8mm Films"

Osnabrück, Germany, "European Media Art Festival"

Rotterdam, "28th International Film Festival"

San Francisco Cinematheque

1998 The Film Society of Lincoln Center, New York, "The New York Video Festival"

"Melbourne International Film Festival"

Pleasure Dome, Toronto, "American Psycho(drama): Sigmund Freud vs Henry Ford"

Utrecht, The Netherlands, "Impakt Festival '98"

1997 IVAM Centre Julio González, Valencia, Spain

BIBLIOGRAPHY

Gibbons, Joe, Richard Pontius, and Holladay Weiss. "'and THEN what happened???': An Interview with Joe Gibbons." *Motion Picture*, 4 (Summer 1991), pp. 31–35.

Hoberman, J. "Acting Out." *The Village Voice*, October 16, 1984, p. 55.

Holden, Stephen. "Galleries and Greed in an Art-World Satire." *The New York Times*, April 2, 1993, p. C34.

Pruitt, John. "Joe Gibbons' *Living in the World*." *Motion Picture*, no. 1 (Spring–Summer 1986), pp. 14–15.

Szwed, John F. "Childhood's Ends." *The Village Voice*, April 23, 1985, p. 96.

ROBERT GOBER

Born in Wallingford, Connecticut, 1954

Studied at Tyler School of Art, Rome (1973–74); Middlebury College, Vermont (BA, 1976)

Lives in New York

ONE-ARTIST EXHIBITIONS

1999 Walker Art Center, Minneapolis (traveling)

1998 The Aldrich Museum of Contemporary Art, Ridgefield, Connecticut

1997 The Museum of Contemporary Art and The Geffen Contemporary, Los Angeles

Paula Cooper Gallery, New York

GROUP EXHIBITIONS

1999 The Ian Potter Museum of Art, The University of Melbourne, Australia, "Signs of Life: Melbourne International Biennial 1999"

Institute of Contemporary Art, Philadelphia, "Three Stanzas: Miroslaw Balka, Robert Gober, and Seamus Heaney"

1997 Institute of Contemporary Art, Boston, "Gothic" (traveled)

The Museum of Modern Art, New York, "Objects of Desire: The Modern Still Life" (traveled)

Setagaya Art Museum, Tokyo, "De-Genderism"

BIBLIOGRAPHY

David, Catherine. In *Robert Gober* (exhibition catalogue). Paris: Galerie Nationale du Jeu de Paume, 1991.

Flood, Richard, Gary Garrels, and Ann Temkin. *Robert Gober: Sculpture + Drawing* (exhibition catalogue). Minneapolis: Walker Art Center, 1999.

Robert Gober (exhibition catalogue). New York: Dia Center for the Arts, 1993.

Robert Gober (exhibition catalogue). Rotterdam: Museum Boymans-van Beuningen; Bern: Kunsthalle Bern, 1990.

Schimmel, Paul. *Robert Gober* (exhibition catalogue). Los Angeles: The Museum of Contemporary Art, 1997.

JILL GODMILOW

Born in Philadelphia, 1943

Studied at University of Wisconsin, Madison (BA, 1965)

Lives in South Bend, Indiana

SCREENINGS

1999 The Center for Media, Culture, and History, New York University

"The 23rd Hong Kong International Film Festival"

Walker Art Center, Minneapolis

1998 Cinema Münster, Munich

The Film Center, The School of The Art Institute of Chicago

"L'Immagine Leggera: Palermo International Videoart + Film + Media Festival"

Oberhausen, Germany, "44. Internationale Kurzfilmtage"

Rotterdam, "27th International Film Festival"

"Toronto International Film Festival"

1997 Cinema 21, Portland, Oregon

BIBLIOGRAPHY

"Jill Godmilow: 'Don't tell lies, don't tell the truth, tell stories'" (interview). *American Film*, 15 (June 1989), pp. 20–24.

Miller, Lynn C. "[Un]documenting History: An Interview with Filmmaker Jill Godmilow." *Text and Performance Quarterly*, 17 (July 1997), pp. 273–87.

Rabinowitz, Paula. *They Must Be Represented: The Politics of Documentary*. Chapter 4, "National Bodies: Gender, Sexuality, and Terror in Feminist Counter-documentaries." London: Verso, 1994.

Rosenstone, Robert A. *Visions of the Past: The Challenge of Film to Our Idea of History*. Cambridge, Massachusetts: Harvard University Press, 1995, pp. 38–39, 208–10.

Shapiro, Ann-Louise. "How Real Is the Reality in Documentary Film?" (interview). *History and Theory: Studies in the Philosophy of History. Producing the Past: Making Histories Inside and Outside the Academy*, no. 36 (December 1997), pp. 80–101.

KEN GOLDBERG

Born in Ibadan, Nigeria, 1961

Studied at University of Pennsylvania, Philadelphia (BS, 1984); Carnegie-Mellon University, Pittsburgh (MS, 1987; PhD, 1990)

Lives in San Francisco

NEW MEDIA PROJECTS AND EXHIBITIONS

1999 *Mori: An Interface to the Earth* (Internet project with Randall Packer, Wojceich Matusik, and Gregory Kuhn; *memento.ieor.berkeley.edu*)

NTT InterCommunication Center, Tokyo, "ICC Biennale '99"

www.rhizome.org, "Rhizome Artbase"

Zentrum für Kunst und Medientechnologie, Karlsruhe, Germany, "Net_Condition"

1998 Catharine Clark Gallery, San Francisco International Art Expo, "Interiors"

Dislocation of Intimacy (Internet project with Bobak Farzin; *www.ieor.berkeley.edu/ ~goldberg/art/doi.html*)

Duke University Museum of Art, Durham, North Carolina, "Interface: Art + Tech in the Bay Area"

Walker Art Center, Minneapolis, "Beyond Interface" (online exhibition; *www.walkerart.org/gallery9/beyondinterface*)

Walker Art Center, Minneapolis, "Shock of the View" (online exhibition; *www.walkerart.org/salons/shockoftheview*)

BIBLIOGRAPHY

Jana, Reena. "Ken Goldberg: Keeping Technology Grounded." *Artbyte*, 2 (November–December 1999), pp. 34–37.

———. "Fault Vault." *Artforum*, 38 (October 1999), p. 35.

Mirapaul, Matthew. "Made in the Shade." *The New York Times on the Web*, October 30, 1999 (*www.nytimes.com/library/cyber/mirapaul/103097 mirapaul.html*).

Pescovitz, David. "Be There Now: Telepresence Art Online." *Flash Art*, 32 (March–April 1999), pp. 51–52.

KOJO GRIFFIN

Born in Farmville, Virginia, 1971

Studied at Morehouse College, Atlanta (BA, 1995)

Lives in Atlanta

ONE-ARTIST EXHIBITIONS

1999 Mint Museum of Art, Charlotte, North Carolina

Vaknin Schwartz Gallery, Atlanta

GROUP EXHIBITIONS

1998 Ballroom Studios, Atlanta, "The Blue Dress Project"

City Gallery East, Atlanta, "When Tears Come Down Like Falling Rain"

Vaknin Schwartz Gallery, Atlanta, "Two Thumbs Up: Must See Picks of Vaknin & Schwartz"

1997 Nexus Contemporary Art Center, Atlanta, "1997 Atlanta Biennial"

Youth Art Connection, Atlanta, "Present & Unaccounted For"

BIBLIOGRAPHY

Cochran, Rebecca Dimling. "Kojo Griffin." *Art Papers Magazine*, 23 (July–August 1999), pp. 14–15.

Cullum, Jerry. "Mixing of Cultures." *The Atlanta Journal-Constitution*, April 16, 1999, p. Q8.

Henry, Lindsey. "Parables in Paint." *The Charlotte Observer*, August 20, 1999, p. E20.

Lucas, Scott. "In Vitro Epiphanies." *Creative Loafing*, September 4, 1999, pp. 38–39.

Smith, Todd. *New Frontiers 2: Kojo Griffin* (exhibition catalogue). Charlotte, North Carolina: Mint Museum of Art, 1999.

JOSEPH GRIGELY

Born in Springfield, Massachusetts, 1956

Studied at National Technical Institute for the Deaf, Rochester Institute of Technology, New York (1974–75); New England College, Arundel, England (1976–77); Oxford University, England (D.Phil., 1983)

Lives in Jersey City, New Jersey, and Ann Arbor, Michigan

ONE-ARTIST EXHIBITIONS

1999 Galerie Air de Paris, Paris

1998 The Barbican Centre, London

Douglas Hyde Gallery, Trinity College, Dublin

Galerie Francesca Pia, Bern

Masataka Hayakawa Gallery, Tokyo

GROUP EXHIBITIONS

1999 New Museum of Contemporary Art, New York, "The Time of Our Lives"

Provinciaal Museum voor Fotografie, Antwerp, "Laboratorium"

1998 Matthew Marks Gallery, New York, "The Tree-Trimming Party"

"The 11th Biennale of Sydney: Every Day"

Kunsthaus Zürich, "Freie Sicht aufs Mittelmeer: Junge Schweizer Kunst"

BIBLIOGRAPHY

Bush, Kate. "Small Talk." *Frieze*, no. 27 (March–April 1996), pp. 64–65.

Cabidoche, Laurence. "Histoires Sans Parole." *Les Inrockuptibles*, no. 153 (May 1998), p. 66.

Cameron, Dan. "Joseph Grigely." In *Cream: Contemporary Art in Culture*. London: Phaidon Press Limited, 1998, pp. 156–59.

Grigely, Joseph. *Conversation Pieces*. Kitakyushu, Japan: Center for Contemporary Art, 1998.

Rubinstein, Raphael. "Visual Voices." *Art in America*, 84 (April 1996), pp. 94–100, 133.

HANS HAACKE

Born in Cologne, 1936

Studied at Staatliche Werkakademie, Kassel, Germany (MFA equivalent, 1960)

Lives in New York

GROUP EXHIBITIONS

1999 The Museum of Modern Art, New York, "The Museum as Muse: Artists Reflect"

Whitney Museum of American Art, New York, "The American Century: Art & Culture 1900–2000"

1997 Electric Workshop, Johannesburg, "2nd Johannesburg Biennial 1997: Alternating Currents"

Museum Fridericianum, Kassel, Germany, "Documenta X"

"Sculpture: Projects in Münster 1997"

BIBLIOGRAPHY

Bourdieu, Pierre, and Hans Haacke. *Free Exchange.* Stanford, California: Stanford University Press, 1995.

Haacke, Hans. *AnsichtsSachen = ViewingMatters.* Düsseldorf: Richter Verlag, 1999.

———. *"Obra Social"* (exhibition catalogue). Barcelona: Fundació Antoni Tàpies, 1995.

Haacke, Hans, Klaus Bussmann, and Florian Matzner. *Hans Haacke, Bodenlos: Biennale Venedig 1993, Deutscher Pavillon* (exhibition catalogue). Stuttgart: Edition Cantz, 1993.

Wallis, Brian, ed. *Hans Haacke: Unfinished Business* (exhibition catalogue). New York: The New Museum of Contemporary Art, 1986.

TRENTON DOYLE HANCOCK

Born in Oklahoma City, 1974

Studied at Paris Junior College, Texas (AS, 1994); Texas A&M University, Commerce (BFA, 1997); Tyler School of Art, Temple University, Philadelphia (1998–present)

Lives in Paris, Texas

ONE-ARTIST EXHIBITIONS

1998 Gerald Peters Gallery, Dallas

1997 University Gallery, Texas A&M University, Commerce

GROUP EXHIBITIONS

1998 Blue Star Art Space, San Antonio, Texas, "Texas Dialogues: Parallels"

Gerald Peters Gallery, Dallas, "Link"

1997 Gerald Peters Gallery, Dallas, "Link"

Gerald Peters Gallery, Dallas, "New Views: Eight Emerging Texas Artists"

BIBLIOGRAPHY

Daniel, Mike. "Young Artist Comes into His Own." *The Dallas Morning News,* May 29, 1998, p. 52.

Kutner, Janet. "Gallery Gourmet." *The Dallas Morning News,* July 4, 1998, p. 8C.

Mitchell, Charles Dee. "Trenton Doyle Hancock at Gerald Peters." *Art in America,* 86 (November 1998), p. 138.

Rees, Christina. "Guts 'R' Us." *Dallas Observer,* June 18–24, 1998, p. 64.

JOSEPH HAVEL

Born in Minneapolis, 1954

Studied at University of Minnesota, Minneapolis (BFA, 1976); The Pennsylvania State University, University Park (MFA, 1979)

Lives in Houston

ONE-ARTIST EXHIBITIONS

1999 Galveston Arts Center, Texas

1998 Devin Borden Hiram Butler Gallery, Houston

1997 Center for Curatorial Studies, Bard College, Annandale-on-Hudson, New York

Galerie Gabrielle Maubrie, Paris

Institute of Visual Arts, University of Wisconsin-Milwaukee

GROUP EXHIBITIONS

1999 Contemporary Arts Museum, Houston, "Texas Draws"

DeCordova Museum and Sculpture Park, Lincoln, Massachusetts, "On the Ball: The Sphere in Contemporary Sculpture"

Galerie Rottloff, Karlsruhe, Germany, "Arbeiten auf Papier"

Modern Art Museum of Fort Worth, Texas, "House of Sculpture" (traveled)

Project Row Houses, Houston, "Street Life"

BIBLIOGRAPHY

Doroshenko, Peter, and David Pagel. *Joseph Havel* (exhibition catalogue). Huntington Beach, California: Huntington Beach Art Center, 1996.

———. *Joseph Havel: Weather* (exhibition brochure). Dallas: Barry Whistler Gallery, 1997.

Lightman, Victoria Hodge. "Joe Havel." *Sculpture,* 16 (September 1997), pp. 80–82.

Sans, Jérôme. "White Bodies." In *Commun* (exhibition catalogue). Paris: Galerie Gabrielle Maubrie, 1997, pp. [4–5].

Youngs, Christopher. *Interactions: Joseph Havel* (exhibition brochure). Reading, Pennsylvania: Freedman Gallery, Center for the Arts, Albright College, 1996.

SALOMÓN HUERTA

Born in Tijuana, 1965

Studied at Art Center College of Design, Pasadena, California (BFA, 1991); University of California, Los Angeles (MFA, 1998)

Lives in Los Angeles

ONE-ARTIST EXHIBITIONS

1998 Patricia Faure Gallery, Santa Monica, California

GROUP EXHIBITIONS

1999 Armory Center for the Arts, Pasadena, California, "Portraiture: Front, Back & In-between"

Museo de la Ciudad de México, Mexico City, "Five Continents and a City"

1997 Academy of Fine Arts Gallery, Munich, "In the Red"

Fisher Gallery, University of Southern California, Los Angeles, "Intersecting Identities"

Patricia Faure Gallery, Santa Monica, California, "Some Lust"

BIBLIOGRAPHY

Carotenuto, Gianna. "Salomón Huerta." *Art Issues*, no. 56 (January–February 1999), p. 42.

González, Rita. "Post-Chicano." *Poliester*, 7 (Spring–Summer 1999), pp. 40–47.

Miles, Christopher. "Salomón Huerta." *Art Papers Magazine*, 23 (March–April 1999), p. 41.

Pagel, David. "The Enduring Puzzlement of Huerta's People." *Los Angeles Times*, November 13, 1998, p. F27.

Zellen, Jody. "Salomón Huerta at Patricia Faure." *D'Art International*, 2 (Winter 1999), p. 27.

ARTHUR JAFA

Born in Tupelo, Mississippi, 1960

Studied at Howard University, Washington D.C. (1979–83)

Lives in New York

GROUP EXHIBITIONS

1999 Artists Space, New York, "Dexter Buell, Arthur Jafa, Judy Stevens"

BildMuseet, University of Umeå, Sweden, "Mirror's Edge"

BIBLIOGRAPHY

Jafa, Arthur. "69." In Michele Wallace, *Black Popular Culture*, edited by Gina Dent. Dia Center for the Arts, Discussions in Contemporary Culture, Number 8. Seattle: Bay Press, 1992, pp. 249–54.

Jafa, Arthur. "Like Rashomon but Different: The New Black Cinema." *Artforum*, 31 (Summer 1993), pp. 10–11.

Tate, Greg, and Arthur Jafa. "La Vénus Nègre." *Artforum*, 30 (January 1992), pp. 90–93.

MICHAEL JOO

Born in Ithaca, New York, 1966

Studied at Wesleyan University, Middletown, Connecticut (1984–86); Washington University, St. Louis (BFA, 1989); Yale University School of Art, New Haven (MFA, 1991)

Lives in New York

ONE-ARTIST EXHIBITIONS

1999 Anton Kern Gallery, New York

1998 White Cube, London

1997 Anton Kern Gallery, New York

GROUP EXHIBITIONS

1998 P.S.1 Contemporary Art Center, Long Island City, New York, "Matthew McCaslin, Susan Etkin, Michael Joo"

The Wanås Foundation, Knislinge, Sweden, "Nine International Artists at Wanås 1998"

1997 Brooklyn Bridge Anchorage, New York, "Art in the Anchorage 1997"

The Cooper Union for the Advancement of Science and Art, School of Art, New York, "Techno-Seduction"

MuseuMAfricA, Johannesburg, "2nd Johannesburg Bienniale 1997"

BIBLIOGRAPHY

"Exchange/Expansion/Expenditure: A Discussion Between Roddy Bogawa and Michael Joo." *Documents* (Spring 1993), pp. 36–47.

Jones, Ronald. "Michael Joo." *Frieze*, no. 49 (November–December 1999), p. 106.

Ritchie, Matthew. "Michael Joo." *Flash Art International*, 27 (December 1994), pp. 69–70.

Schwarzman, Carol. "Michael Joo." *New Art Examiner*, 27 (September 1999), pp. 55–56.

Yang, Alice. "MSG: The Processed Art of Michael Joo." In Yang, *Why Asia?: Contemporary Asian and Asian American Art*, edited by Jonathan Hay and Mimi Young. New York: New York University Press, 1998.

KURT KAUPER

Born in Indianapolis, 1966

Studied at Boston University (BFA, 1988); University of California, Los Angeles (MFA, 1995)

Lives in Brooklyn, New York

ONE-ARTIST EXHIBITIONS

1999 ACME., Los Angeles

1997 ACME., Santa Monica, California

Jay Gorney Modern Art, New York (with Judie Bamber)

GROUP EXHIBITIONS

1999 New Langton Arts, San Francisco, "In Your Face"

1998 Deitch Projects, New York, "Painting from Another Planet"

The Institute of Contemporary Art, Boston, "Transience and Sentimentality"

BIBLIOGRAPHY

Cotter, Holland. "Painting from Another Planet." *The New York Times*, July 24, 1998, p. F26.

Knight, Christopher. "Kurt Kauper at ACME." *Art Issues*, no. 49 (September–October 1997), p. 36.

Miles, Christopher. "Kurt Kauper." *Artforum*, 37 (May 1999), p. 183.

Pagel, David. "These Grand Divas Are Truly Larger Than Life." *Los Angeles Times*, February 26, 1999, p. F26.

Schjeldahl, Peter. "Ultraloungerie." *The Village Voice*, June 23, 1998, p. 153.

SILVIA KOLBOWSKI

Born in Buenos Aires, 1953

Studied at Hunter College, The City University of New York (BS, 1978)

Lives in New York

ONE-ARTIST EXHIBITIONS

1999 American Fine Arts, New York

1997 Postmasters Gallery, New York

BIBLIOGRAPHY

Lamoureux, Johanne. "Underlining the Legend of the Gallery Space." *October*, no. 65 (Summer 1993), pp. 21–28.

———. "The Open Window Case: New Displays for an Old Western Paradigm." In *Silvia Kolbowski: XI Projects*. New York: Border Editions, 1992, pp. 6–15.

Martin, Reinhold. "Soho oder Chelsea: Silvia Kolbowski bei Postmasters." *Texte zur Kunst*, no. 28 (November 1997), pp. 128–32.

Quéloz, Catherine. "Architectures of Display." *Faces*, no. 39 (Autumn 1996), pp. 58–61.

Smith, Roberta. "The Gallery Is the Message." *The New York Times*, October 4, 1992, p. 35.

HARMONY KORINE

Born in Bolinas, California, 1974

Studied at New York University

Lives in New York

SCREENINGS

1999 The Film Society of Lincoln Center, New York, "The New York Film Festival"

BIBLIOGRAPHY

Black, Shane, and Harmony Korine, with Lynn Hirschberg. "Shane Black and Harmony Korine" (dialogue). *The New York Times Magazine*, November 16, 1997, pp. 136–38.

Freidson, Michael. "*Gummo*." *Time Out New York*, October 16–23, 1997, p. 71.

Musetto, V.A. "*Gummo*: Paws for Reflection." *New York Post*, October 17, 1997, p. 48.

Shapiro, Dana. "Liar, Liar" (interview). *Icon ThoughtStyle Magazine*, 1 (November–December 1997), pp. 72–75.

Taubin, Amy. "Scrap Happy." *The Village Voice*, October 21, 1997, p. 96.

LOUISE LAWLER

Born in Bronxville, New York, 1947

Studied at Cornell University, Ithaca, New York (BFA, 1969)

Lives in New York

ONE-ARTIST EXHIBITIONS

1999 Monika Sprüth Galerie, Cologne

1998 *www.stadiumweb.com*

1997 a+a company, New York

Hirshhorn Museum and Sculpture Garden, Smithsonian Institution, Washington, D.C.

Metro Pictures, New York

GROUP EXHIBITIONS

1999 Kestner Gesellschaft, Hannover, Germany, "Das Versprechen der Fotografie"

The Museum of Modern Art, New York, "The Museum as Muse: Artists Reflect"

1998 Boijmans Van Beuningen Museum, Rotterdam, "Scratches on the Surface of Things"

Centre Georges Pompidou, Paris, "dijon/le consortium.coll"

P.S.1 Contemporary Art Center, Long Island City, New York, "Deep Storage: Collecting, Storing, and Archiving in Art"

BIBLIOGRAPHY

Fehlau, Fred. "Louise Lawler Doesn't Take Pictures." *Artscribe*, no. 81 (May 1990), pp. 62–65.

Fraser, Andrea. "In and Out of Place." *Art in America*, 73 (June 1985), pp. 122–29.

Meinhardt, Johannes. "The Places of Art— The Photography of Louise Lawler." In *Hugo-Erfurth-Preis* (exhibition catalogue). Leverkusen, Germany: Museum Morsbroich Leverkusen, 1991, pp. 26–29.

———. "Ersatzobjekte und Bedeutende Rahmen: Allan McCollum, Louise Lawler, Barbara Bloom." *Kunstforum*, 99 (March–April 1989), pp. 200–20.

———. "Louise Lawler: Kontext, Situation, Markt." *Zyma: Art Today*, no. 1 (January–February 1992), pp. 4–9.

RUTH LEITMAN

Born in Philadelphia, 1961

Studied at Philadelphia University of Arts (BFA, 1984)

Lives in Atlanta

SCREENINGS

1999 Adelaide, "Australia International Documentary Conference"

Chicago, "18th Annual International Film and Video Festival: Women in the Director's Chair"

East Hampton, New York, "The Hamptons International Film Festival: The Best of '98"

Greece, "Thessaloníki Documentary Festival: Images of the 21st Century"

Grimstad, Norway, "22. Kortfilmfestivalen"

Munich, "14. Internationales Documentarfilm Festival"

"Nashville Independent Film Festival"

Toronto, "Canadian International Documentary Festival"

Waterville, "Maine International Film Festival"

1998 Amsterdam, "International Documentary Film Festival"

BIBLIOGRAPHY

Elkins, Elizabeth. "*Alma* Spills the Family Secrets." *ETC*, October 15, 1999, p. 25.

Feaster, Felicia. "Chasing Reality: The New Documentary Aesthetic." *Art Papers Magazine*, 22 (September–October 1998), pp. 28–33.

———. "Eat the Document" and "*Alma* Matters: Sexual Abuse and the Southern Gothic Family." *Creative Loafing*, February 28, 1998, pp. 27, 29.

Fuchs, Dina. "Family and Forgiveness." *Atlanta Jewish Times*, October 15, 1999, pp. 31–32.

Murray, Steve. "*Alma* Finds the Soul of a Troubled Atlantan." *The Atlanta Journal-Constitution*, February 22, 1998, p. L5.

ANNETTE LEMIEUX

Born in Norfolk, Virginia, 1957

Studied at Hartford Art School, University of Hartford, Connecticut (BFA, 1980)

Lives in Boston

ONE-ARTIST EXHIBITIONS

1999 Cambridge River Festival, Massachusetts, "Charles River Project"

Elias Fine Art, Allston, Massachusetts

1998 McKee Gallery, New York

Museo de Arte Carrillo Gil, Mexico City

1997 Anders Tornberg Gallery, Lund, Sweden

GROUP EXHIBITIONS

1999 Kunsthalle Nürnberg, Germany, "Forget About the Ball and Get On with the Game"

University Gallery, University of Massachusetts, Amherst, "Head to Toe: Impressing the Body"

1998 Museum of Fine Arts, Boston, "PhotoImage: Printmaking 60s to 90s" (traveled)

Palazzo Abatelus, Palermo, "Maschile Femminile"

1997 Joseloff Gallery, Hartford Art School, University of Hartford, Connecticut, "Critical Intervention"

BIBLIOGRAPHY

Arnason, H.H., Marla F. Prather, and Daniel Wheeler. *History of Modern Art* (1968). 4th ed. New York: Harry N. Abrams, Inc., 1998, p. 791.

Godfrey, Tony. *Conceptual Art (Art and Ideas)*. London: Phaidon Press Limited, 1998, pp. 350–51, 401.

Meyer-Hermann, Eva. *Annette Lemieux* (exhibition catalogue). Krefeld, Germany: Museum Haus Esters, 1994.

Moos, David. *Annette Lemieux: Time to Go* (exhibition catalogue). Modena, Italy: Emilio Mazzoli, 1994.

Schjeldahl, Peter. "Annette Lemieux." In Schjeldahl, *Columns and Catalogues*. Great Barrington, Massachusetts: The Figures, 1994, pp. 30–33.

LES LeVEQUE

Born in Cortez, Colorado, 1952

Studied at Syracuse University, New York
(MFA, 1992)

Lives in New York

SCREENINGS

1999 Montreal, "Festival International
du Nouveau Cinéma"

The Film Society of Lincoln Center,
New York, "The New York
Video Festival"

Park City, Utah, "Sundance
Film Festival"

1998 Artists' Television Access,
San Francisco, "Confessions of an
Opium Eater"

Exit Art, New York, "Hybro Video"

The Film Society of Lincoln Center,
New York, "The New York
Video Festival"

Los Angeles, "LA Freewaves"

The Ottawa Art Gallery,
"Close Encounters"

P.A.R.K. TV., Amsterdam

1997 Artists Space, New York,
"Station to Station"

BIBLIOGRAPHY

Fortin, Sylvie. "Close Encounters." In *Close
Encounters* (exhibition brochure). Ottawa:
The Ottawa Art Gallery, 1998.

Holden, Stephen. "A Revolution Made of
Gritty Intimacy." *The New York Times*, July 17,
1998, p. E1.

Knecht, John. "Muses and Fuses: Traumas in
the Technosphere." In *Some Questions
Concerning Technology* (exhibition brochure).
New York: Artists Space, 1990.

Leggat, Graham. "Is It Love?: An Installation
by Les LeVeque." In *Is It Love?: Solo Exhibition
by Les LeVeque* (exhibition brochure). Buffalo,
New York: Hallwalls Contemporary Arts
Center, 1996.

Milutis, Joe. "From Hi-8 to High Culture."
Afterimage, 27 (September–October 1999), p. 3.

SHARON LOCKHART

Born in Norwood, Massachusetts, 1964

Studied at San Francisco Art Institute
(BFA, 1991); Art Center College of Design,
Pasadena, California (MFA, 1993)

Lives in Los Angeles

ONE-ARTIST EXHIBITIONS

1999 Museum Boijmans Van Beuningen,
Rotterdam (traveling)

Pitti Immagine Discovery, Florence

1998 Blum & Poe, Santa Monica, California

Wako Works of Art, Tokyo

1997 University of California, Berkeley Art
Museum and Pacific Film Archive

GROUP EXHIBITIONS

1999 Galerie für Zeitgenössische Kunst,
Leipzig, "Life Cycles"

Stedelijk Van Abbemuseum,
Eindhoven, The Netherlands,
"Cinéma Cinéma: Contemporary Art
and the Cinematic Experience"

1998 The Museum of Modern Art, New York,
and The Film Society of Lincoln Center,
New York, "New Directors/New Films"

1997 SITE Santa Fe, New Mexico,
"Truce: Echoes of Art in an Age of
Endless Conclusions"

Whitney Museum of American Art,
New York, "1997 Biennial Exhibition"

BIBLIOGRAPHY

DeBord, Matthew. "The Recurrent American
Rhetoric of Contradiction." *Siksi: The Nordic Art
Review*, 12 (Autumn 1997), pp. 76–79.

Margulies, Ivone. "At the Edge of My Seat:
Teatro Amazonas." In *Sharon Lockhart*: Teatro
Amazonas (exhibition catalogue). Rotterdam:
Museum Boijmans Van Beuningen, 1999.

Martin, Timothy. "Documentary Theater."
In *Sharon Lockhart*: Teatro Amazonas
(exhibition catalogue). Rotterdam: Museum
Boijmans Van Beuningen, 1999.

Reynaud, Bérénice. "Goshogaoka." In *Sharon
Lockhart* (exhibition catalogue). Santa Monica,
California: Blum & Poe; Tokyo: Wako Works
of Art, 1998, pp. 25–30.

ANNE MAKEPEACE

Born in Waterbury, Connecticut, 1947

Studied at Stanford University, California
(BA, 1969; MA, Education, 1971; MA, Film
Production, 1982)

Lives in Santa Barbara, California

SCREENINGS

1998 Austin, Texas, "South by Southwest
'98 Film Competition"

Channel 4 Television, London

Chicago, "Windy City International
Documentary Festival"

Mint Museum of Art, Charlotte,
North Carolina, "1998 Charlotte Film
& Video Festival"

Museum of Fine Arts, Boston
"The New York Women's Film Festival"

Northwest Film Center,
Portland Art Museum, Oregon

Park City, Utah, "Sundance
Film Festival"

P.O.V. (Point of View), PBS

1997 Amsterdam, "International
Documentary Film Festival"

BIBLIOGRAPHY

Goodman, Tim. "Bay City Best: Television."
San Francisco Examiner Magazine, May 31, 1998,
p. 4.

Leonard, John. "John Leonard's TV Notes."
New York, June 8, 1998, p. 140.

Lovell, Glenn. "Baby, It's You." *Variety*,
February 9–15, 1998, p. 74.

Moss, Marilyn. "TV Reviews." *The Hollywood
Reporter*, June 1, 1998, p. 28.

Rosenberg, Howard. "PBS Offers a Tender
Look at Conception." *Los Angeles Times*,
June 2, 1998.

IÑIGO MANGLANO-OVALLE

Born in Madrid, 1961

Studied at Williams College, Williamstown, Massachusetts (BA, 1983); The School of The Art Institute of Chicago (MFA, 1989)

Lives in Chicago

ONE-ARTIST EXHIBITIONS

1999 Institute of Visual Arts, University of Wisconsin-Milwaukee

1998 Max Protetch Gallery, New York

Southeastern Center for Contemporary Art, Winston-Salem, North Carolina

1997 ArtPace, A Foundation for Contemporary Art, San Antonio, Texas

Museum of Contemporary Art, Chicago

GROUP EXHIBITIONS

1999 The Aldrich Museum of Contemporary Art, Ridgefield, Connecticut, "Best of the Season: Selected Work from the 1998–99 Manhattan Exhibition Season"

California College of Arts and Crafts, Oakland, "Searchlight: Consciousness at the Millennium"

1998 Brazil, "XXIV Bienal de São Paulo"

Christopher Grimes Gallery and Track 16 Gallery, Santa Monica, California, "Amnesia" (traveling)

1997 Bohen Foundation, New York

BIBLIOGRAPHY

Arning, Bill. "São Paulo Bienal." *World Art*, no. 20 (January 1999), pp. 72–74.

Clearwater, Bonnie. "Bonnie Clearwater Speaks on the Phone with Iñigo Manglano-Ovalle." *Trans*, 1–2 (1997), pp. 81–89.

Cooke, Lynne. "Iñigo Manglano-Ovalle: The El Niño Effect." In *Iñigo Manglano-Ovalle 97.4* (exhibition brochure). San Antonio, Texas: ArtPace, A Foundation for Contemporary Art, 1997.

Isé, Claudine. "Confinement and Solitude: Feeling 'The El Niño Effect.'" *Los Angeles Times*, May 1, 1998, p. F47.

Platt, Ron. *Iñigo Manglano-Ovalle: The Garden of Delights* (exhibition catalogue). Winston-Salem, North Carolina: Southeastern Center for Contemporary Art, 1998.

JOSEPH MARIONI

Born in Cincinnati, 1943

Studied at Cincinnati Art Academy (1962–66); San Francisco Art Institute (1966–70)

Lives in New York

ONE-ARTIST EXHIBITIONS

1999 Columbus Museum of Art, Ohio

Diözesanmuseum Köln, Cologne

1998 Peter Blum, New York

Rose Art Museum, Brandeis University, Waltham, Massachusetts

1997 Charlotte Jackson Fine Art, Santa Fe, New Mexico

GROUP EXHIBITIONS

1999 Patricia Sweetow Gallery, San Francisco, "Color-Based Painting: High Modernism"

1998 Oliver Art Center, California College of Arts and Crafts, Oakland, "Undercurrents and Overtones: Contemporary Abstract Painting"

Howard Yezerski Gallery, Boston, "Color-Based Paintings"

1997 Galerie Nächst St. Stephan, Vienna, "Color and Paper"

Peter Blum, New York, "Drawing the Line and Crossing It"

BIBLIOGRAPHY

Belz, Carl, and Barbara Rose. *Joseph Marioni* (exhibition catalogue). Waltham, Massachusetts: Rose Art Museum, Brandeis University, 1998.

Fried, Michael. "Joseph Marioni." *Artforum*, 37 (September 1998), p. 149.

Kraus, Stefan, et al. *Joseph Marioni: Triptych* (exhibition catalogue). Cologne: Diözesanmuseum Köln, 1999.

Kuspit, Donald. "Joseph Marioni." *Artforum*, 36 (March 1997), p. 91.

Schwabsky, Barry. "Colors and Their Names." *Art in America*, 87 (June 1999), pp. 86–90.

JOSIAH McELHENY

Born in Boston, 1966

Studied at Rhode Island School of Design, Providence (BFA, 1988); Apprentice to master glassblowers Jan-Erik Ritzman and Sven-Åke Carlsson, Transjö, Sweden (1989–91); Apprentice to master glassblower Lino Tagliapietra (1992–97)

Lives in Seattle and New York

ONE-ARTIST EXHIBITIONS

1999 Henry Art Gallery, University of Washington, Seattle

Isabella Stewart Gardner Museum, Boston

1997 AC Project Room, New York

GROUP EXHIBITIONS

1999 Nordic Institute for Contemporary Art, Stockholm, "Patientia"

1998 Art in General, New York, "Personal Touch"

The Art Institute of Chicago, "At Home in the Museum"

The Saatchi Gallery, London, "Young Americans 2: New American Art at The Saatchi Gallery"

Whitney Museum of American Art at Champion, Stamford, Connecticut, "Interlacings: The Craft of Contemporary Art"

BIBLIOGRAPHY

Hickey, Dave, and Jennifer R. Gross. *Josiah McElheny* (exhibition catalogue). Boston: Isabella Stewart Gardner Museum, 1999.

Israel, Nico. "Josiah McElheny at AC Project Room." *Artforum*, 36 (March 1997), pp. 100–01.

Martin, Richard, Josiah McElheny, et al. *An Historical Anecdote About Fashion* (exhibition catalogue). Seattle: Henry Art Gallery, University of Washington, 1999.

Saltz, Jerry. "Josiah McElheny, 'Non-Decorative Beautiful Objects.'" *Time Out New York*, October 30–November 6, 1997.

Scanlan, Joe. "Josiah McElheny." *Frieze*, no. 38 (January 1998), p. 92.

FRANCO MONDINI-RUIZ

Born in San Antonio, Texas, 1961

Lives in San Antonio, Texas, and New York

ONE-ARTIST EXHIBITIONS

1999 Center for Curatorial Studies,
Bard College, Annandale-on-Hudson,
New York

GROUP EXHIBITIONS

1999 Trans Hudson Gallery, New York,
"The Ecstatic"

1998 Salon 300, Brooklyn, New York,
"Trade"

San Antonio Museum of Art, Texas

1997 Contemporary Arts Museum, Houston,
"Simply Beautiful"

BIBLIOGRAPHY

Arévalo, Felipe. "*Infinito Botanica*: Enigmatic
Divinities." *ArtLies*, no. 16 (Fall 1997),
pp. 24–26.

Colpitt, Frances. *Synthesis and Subversion:
A Latino Direction in San Antonio Art* (exhibition
catalogue). San Antonio: University of Texas
at San Antonio Art Gallery, 1993.

Diaz, Alejandro. "Gorgeous Politics: The Life
and Work of Franco Mondini-Ruiz." MA thesis.
Annandale-on-Hudson, New York: Center for
Curatorial Studies, Bard College, 1999.

Fuller, David. "Fat." *Poliester*, 2 (Fall 1993),
pp. 70–71.

Mondini-Ruiz, Franco. "Water for the Spirits
of Danny and Drew." In Jean McMann, *Altars
and Icons: Sacred Spaces in Everyday Life*. San
Francisco: Chronicle Books, 1998, pp. 23–24.

ERROL MORRIS

Born in Hewitt, New York, 1948

Studied at University of Wisconsin-Madison
(BA, 1969); Princeton University, New Jersey;
University of California, Berkeley (MA, 1976)

Lives in Cambridge, Massachusetts

SCREENINGS

1999 Amsterdam, "International
Documentary Film Festival"

Harvard Film Archives,
Cambridge, Massachusetts

Japan, "Yamagata International
Documentary Film Festival"

Los Angeles County Museum of Art

The Museum of Modern Art, New York

1997 Colorado, "Telluride Film Festival"

"Edinburgh International
Film Festival"

The Film Society of Lincoln Center,
New York, "The New York
Film Festival"

Park City, Utah, "Sundance
Film Festival"

"Toronto International Film Festival"

BIBLIOGRAPHY

Bowen, Peter. "Lost Horizons" (interview).
Filmmaker, 6 (Fall 1997), pp. 48–51, 74–76.

Gourevitch, Philip. "Interviewing the
Universe." *The New York Times Magazine*,
August 9, 1992, p. 18.

Livesey, Margot. "Errol Morris." *Bomb*, no. 69
(Fall 1999), pp. 26–33.

Singer, Mark. "The Friendly Executioner."
The New Yorker, February 1, 1999, pp. 33–39.

Singer, Mark. "Profiles (Errol Morris)." *The New
Yorker*, February 6, 1989, pp. 38–72.

MANDY MORRISON

Born in New York, 1957

Studied at Rhode Island School of Design,
Providence (BFA, 1980); University of Illinois
at Chicago (MFA, 1994)

Lives in Brooklyn, New York

SCREENINGS

1999 Courtroom Project Space, Brooklyn,
New York

"11th Annual New York Lesbian & Gay
Film Festival"

GAle GAtes et al., Brooklyn, New York,
"Size Matters"

1998 Experimental Mix, New York

BIBLIOGRAPHY

Connors, Thomas. "Reviews: Chicago,
Illinois." *Sculpture*, 13 (May–June 1994),
pp. 72–73.

Grabner, Michelle. "Mandy Morrison." *Frieze*,
32 (January–February 1997), pp. 79–80.

Marzahls, Kevin. "Reviews: Doll House."
New Art Examiner, 24 (November 1996), p. 39.

Schleifer, Kristin Brooke. "Cynthia Morgan,
Mandy Morrison, Christina Nordholm." *New
Art Examiner*, 21 (April 1994), pp. 40–41.

Zdanovics, Olga. "Mandy Morrison." *Art Papers
Magazine*, 21 (July–August 1997), p. 51.

VIK MUNIZ

Born in São Paulo, 1961

Lives in New York

ONE-ARTIST EXHIBITIONS

1999 Centre National de la
Photographie, Paris

Galleri Lars Bohman, Stockholm

1998 International Center of Photography,
Midtown, New York (traveled)

1997 Galeria Camargo Vilaça, São Paulo

GROUP EXHIBITIONS

1999 "The Liverpool Biennial of
Contemporary Art"

The Museum of Modern Art, New York,
"The Museum as Muse: Artists Reflect"

1998 Kunstforeningen, Copenhagen, "The
Garden of the Forking Paths" (traveled)

Memphis Brooks Museum of Art,
Tennessee, "The Cottingley Fairies and
Other Apparitions"

1997 The Museum of Modern Art, New York,
"New Photography 13"

BIBLIOGRAPHY

Aletti, Vince. "Organized Confusion: Vik
Muniz Constructs Perceptual Time Bombs."
The Village Voice, December 2, 1997, p. 38.

Durant, Mark Alice, and Charles Ashley
Stainback. *Vik Muniz: Seeing Is Believing*
(exhibition catalogue). New York:
International Center of Photography, 1998.

Grundberg, Andy. "Sweet Illusion." *Artforum*,
36 (September 1997), pp. 102–05.

Katz, Vincent. "The Cunning Artificer:
An Interview with Vik Muniz." *On Paper*,
1 (March–April 1997), pp. 26–31.

Siegel, Katy. "Vik Muniz." *Artforum*, 37
(December 1998), p. 122.

SHIRIN NESHAT

Born in Qazvin, Iran, 1957

Studied at University of California, Berkeley
(BA, 1979; MA, 1981; MFA, 1982)

Lives in New York

ONE-ARTIST EXHIBITIONS

1999 The Art Institute of Chicago

Patrick Painter, Santa Monica,
California

1998 Tate Gallery, London

Whitney Museum of American Art
at Philip Morris, New York

1997 Annina Nosei Gallery, New York

GROUP EXHIBITIONS

1999 Carnegie Museum of Art, Pittsburgh,
"1999 Carnegie International"

"48th Venice Biennale"

Museum Ludwig, Cologne, "Art-Worlds
in Dialogue"

SITE Santa Fe, New Mexico, "Third
International Biennial: Looking
for a Place"

1998 Walker Art Center, Minneapolis,
"Unfinished History"

BIBLIOGRAPHY

Bertucci, Lina. "Shirin Neshat: Eastern
Values." *Flash Art*, 30 (November–December
1997), pp. 84–87.

Cotter, Holland. "Shirin Neshat: *Turbulent*."
The New York Times, November 27, 1998, p. E43.

Goodman, Jonathan. "Poetic Justice: Shirin
Neshat Defends the Faith." *World Art*, no. 16
(1998), pp. 49–52.

Jones, Ronald. "Sovereign Remedy: The Art
of Shirin Neshat." *Artforum*, 38 (October 1999),
pp. 110–13.

Miller, Paul D. "Motion Capture: Shirin
Neshat's *Turbulent*." *Parkett*, no. 54 (1998–99),
pp. 156–60.

NIC NICOSIA

Born in Dallas, 1951

Studied at University of North Texas,
Denton (BA, 1974)

Lives in Dallas

SCREENINGS

1999 Contemporary Arts Museum, Houston

1998 Contemporary Arts Museum, Houston,
"Projected Allegories"

The McKinney Avenue Contemporary,
Dallas, "Wired for Living"

Nexus Contemporary Art Center,
Atlanta, "Union/Reunion"

Stephen Wirtz Gallery, San Francisco

1997 P.P.O.W., New York

BIBLIOGRAPHY

Ennis, Michael. "Time of Nic." *Texas Monthly*,
27 (November 1999), pp. 52–57.

Freudenheim, Susan. "Making It Real." In *Nic
Nicosia: Real Pictures* (exhibition catalogue).
New York: Facchetti Gallery, 1988.

Friis-Hansen, Dana, Lynn M. Herbert, and
Dave Hickey. *Nic Nicosia: Real Pictures 1979–1999*
(exhibition catalogue). Houston:
Contemporary Arts Museum, 1999.

PAUL PFEIFFER

Born in Honolulu, 1966

Studied at San Francisco Art Institute (BFA, 1987); Hunter College, The City University of New York (MFA, 1994); Whitney Museum of American Art Independent Study Program (1997–98)

Lives in New York

ONE-ARTIST EXHIBITIONS

1998 The Project, New York (with Nader)

GROUP EXHIBITIONS

1999 Art in General, New York, "Surface Tension"

Greene Naftali, New York, "A Place Called Lovely"

Rare, New York, "Hocus Focus"

1998 Asian Art Museum of San Francisco, "At Home & Abroad: 20 Contemporary Filipino Artists" (traveled)

BIBLIOGRAPHY

Adelman, Shonagh. "Paul Pfeiffer." *Frieze*, no. 45 (March–April 1999), pp. 93–94.

Bliss, Kimberly. "Crazy." *Dutch*, no. 18 (1998), p. 30.

Cotter, Holland. "Paul Pfeiffer and Nader." *The New York Times*, November 13, 1998, p. E40.

Turner, Grady T. "Abstracted Flesh." *Flash Art*, 32 (January–February 1999), pp. 66–69.

———. "Paul Pfeiffer and Nader." *Review: The Critical State of Visual Art in New York*, November 1, 1998, pp. 30–31.

CARL POPE

Born in Indianapolis, 1961

Studied at Southern Illinois University at Carbondale (BA, 1984); Indiana University, Bloomington (MFA, 1999)

Lives in Indianapolis

ONE-ARTIST EXHIBITIONS

1999 SoFA Gallery, Henry Radford Hope School of Fine Arts, Indiana University, Bloomington

Wadsworth Atheneum, Hartford, Connecticut (with Karen Pope)

1998 Indiana State Museum, Indianapolis

GROUP EXHIBITIONS

1999 Galerie Hertz, Louisville, Kentucky, "Focus '99"

1998 Indianapolis Museum of Art, "Falling Toward Grace"

SoFA Gallery, Henry Radford Hope School of Fine Arts, Indiana University, Bloomington, "MFA Group Exhibition"

1997 SoFA Gallery, Henry Radford Hope School of Fine Arts, Indiana University, Bloomington, "MFA Group Exhibition"

BIBLIOGRAPHY

Adrian Piper/Carl Pope (exhibition catalogue). Indianapolis: Herron Gallery, Indianapolis Center for Contemporary Art, Herron School of Art of Indiana University, 1992.

Calhoon, Sharon L. "Carl Pope: Living the Dream." *Nuvo Newsweekly*, February 1–8, 1995, p. 12.

Golden, Thelma. *Black Male: Representations of Masculinity in Contemporary American Art* (exhibition catalogue). New York: Whitney Museum of American Art, 1994.

McDaniel, Craig, and Jean Robertson. "Studio View." *New Art Examiner*, 24 (October 1996), p. 37.

Rosoff, Patricia. "My Body Is the Parchment." *The Hartford Advocate*, February 18, 1999, p. 17.

WALID RA'AD

Born in Chbanieh, Lebanon, 1967

Studied at Boston University; Rochester Institute of Technology, New York (BFA, 1989); University of Rochester, New York (MA, 1993; PhD, 1996)

Lives in New York

SCREENINGS

1999 University of California, Berkeley Art Museum and Pacific Film Archive

Centre pour l'Image Contemporaine, Geneva, "8th Biennial of Moving Images"

The Film Society of Lincoln Center, New York, "The New York Video Festival"

The Museum of Modern Art, New York, "Investigating the Real: Selections from the 44th Robert Flaherty Film Seminar"

New Mexico, "Taos Talking Picture Festival"

Oberhausen, Germany, "45. Internationale Kurzfilmtage"

San Francisco Cinematheque

"17th San Francisco International Asian American Film Festival"

Toronto, "The Images Festival of Independent Film and Video"

University of Illinois at Chicago, "No Cross, No King, No Margaritas in the Sun"

BIBLIOGRAPHY

Mermin, Liz. "A Real Retreat: The Robert Flaherty Film Seminar." *The Independent Film & Video* (November 1998), pp. 16–19.

Taubin, Amy. "Mixed Tapes." *The Village Voice*, July 20, 1999, p. 142.

MARCOS RAMÍREZ ERRE

Born in Tijuana, 1961

Studied at Universidad Autonoma de Baja California, Tijuana (BA, 1982)

Lives in San Diego and Tijuana

ONE-ARTIST EXHIBITIONS

1999 Institute of Visual Arts, University of Wisconsin-Milwaukee

 Iturralde Gallery, Los Angeles

 Museum of Contemporary Art, San Diego

GROUP EXHIBITIONS

1999 Museum of Contemporary Art, San Diego, "Selections from the Permanent Collection: The 1990s"

1998 Ruta Tijuas-Defe, Plaza de la Constitución, Mexico City, "El Camino de Regreso"

1997 Museo de Monterrey, Mexico, "Tercera Bienal Monterrey"

 San Diego, "inSITE 97: New Projects in Public Spaces by Artists of the Americas"

 "6th Biennial of Havana"

BIBLIOGRAPHY

Canclini, Néstor García. "Why the Horse of Troy Is Useless," translated by Robert A. González. AULA, 1 (Spring 1999), pp. 81–90.

Costa, Eduardo. "Report from Havana—The Installation Biennial." Art in America, 86 (March 1998), pp. 50–57.

Knight, Christopher. "New Border Customs." Los Angeles Times, October 1, 1994, pp. F1, F8.

Ollman, Leah. "Ramírez's Poignant Sculptures Cut Straight to Heart of Matters." Los Angeles Times, March 12, 1999, p. F34.

Pagel, David. "A Paean to Workers in Savvy, Productive 'Hands.'" Los Angeles Times, December 19, 1996.

JENNIFER REEDER

Born in Columbus, Ohio, 1971

Studied at Ohio State University, Columbus (BFA, 1994); The School of The Art Institute of Chicago (MFA, 1996)

Lives in Chicago

SCREENINGS

2000 Art in General, New York, "Manly"

1999 Chicago Project Room

 Everson Museum of Art, Syracuse, New York, "Society of Spectacle"

 "48th Venice Biennale"

 MWMWM Gallery, Brooklyn, New York

 P.S.1 Contemporary Art Center, Long Island City, New York, "Generation Z"

 Wexner Center for the Arts, Columbus, Ohio

1998 Artists Space, New York, "Scope 3"

 The New Wight Gallery, University of California, Los Angeles, "Second Nature"

BIBLIOGRAPHY

Kipnis, Laura, and Jennifer Reeder. "White Trash Girl: The Interview." In Matt Wray and Annalee Newitz, eds. White Trash: Race and Class in America. New York and London: Routledge, 1997, pp. 113–30.

Rosenfeld, Kathryn. "Jennifer Reeder." New Art Examiner, 27 (December 1999–January 2000), p. 51.

Stratman, Deborah. "Secret Histories: An Interview with Jennifer Reeder." Lumpen Magazine, 8 (October–November 1999), pp. 21–25.

Talbot, Margaret. "Getting Credit for Being White." The New York Times Magazine, November 30, 1997, pp. 116–19.

Zalcock, Bev. Renegade Sisters: Girl Gangs on Film. San Francisco: Creation Books, 1998, pp. 103–05.

LAURIE REID

Born in Minneapolis, 1964

Studied at Reed College, Portland, Oregon (BA, 1986); California College of Arts and Crafts, Oakland (MFA, 1996)

Lives in Berkeley, California

ONE-ARTIST EXHIBITIONS

1999 Stephen Wirtz Gallery, San Francisco

1997 Stephen Wirtz Gallery, San Francisco

GROUP EXHIBITIONS

1999 Orange County Museum of Art, Newport Beach, California, "1999 Biennial"

 San Francisco Museum of Modern Art, "SECA Art Award 1998"

1998 Oliver Art Center, California College of Arts and Crafts, Oakland, "Undercurrents and Overtones: Contemporary Abstract Painting"

 Stephen Wirtz Gallery, San Francisco, "Paper Thin"

1997 Center for the Arts, Yerba Buena Gardens, San Francisco, "Bay Area Now"

BIBLIOGRAPHY

Baker, Kenneth. "Ulrike Palmbach, Laurie Reid." Art News, 96 (December 1997), p. 168.

Bonetti, David. "Four Deserving Artists Honored." San Francisco Examiner, February 10, 1999, pp. C1–C2.

Dubin, Zan. "What It's All About." Los Angeles Times, February 6, 1999, pp. F2, F22.

Thym, Jolene. "Artist Finds Her Wrinkle with Watercolors on Paper." The Oakland Tribune, January 26, 1999, pp. CUE-1, CUE-5.

Whiting, Sam. "Underexposed Artists in the Spotlight: Laurie Reid Finds Wonder in Paper Work." San Francisco Sunday Examiner & Chronicle Datebook, February 28, 1999, p. 32.

KAY ROSEN

Born in Corpus Christi, Texas, 1949

Studied at Newcomb College, Tulane University, New Orleans (BA); Northwestern University, Evanston, Illinois (MA)

Lives in Gary, Indiana

ONE-ARTIST EXHIBITIONS

1998 Beaver College Art Gallery, Glenside, Pennsylvania

The Museum of Contemporary Art, Los Angeles, and Otis Gallery, Otis College of Art and Design, Los Angeles

Ten in One Gallery, Chicago

1997 Galerie Michael Cosar, Düsseldorf

List Visual Arts Center, Massachusetts Institute of Technology, Cambridge

GROUP EXHIBITIONS

1999 Galerie Helga Maria Klosterfelde, Hamburg, "Wallpaintings"

Massachusetts Museum of Contemporary Art, North Adams, "Billboard"

Museum of Contemporary Art, Sydney, "Word"

1998 Main Line Train Stations Site-Specific Projects, Philadelphia, "Points of Departure: Art on the Line"

BIBLIOGRAPHY

Artner, Alan G. "Chicago's Finest: 23 People Who Made Significant Contributions to the Arts in 1998." *Chicago Tribune*, December 27, 1998, pp. 1, 4, 6, 9.

Butler, Cornelia H., and Terry R. Meyers. *Kay Rosen: lifeli[k]e* (exhibition catalogue). Los Angeles: The Museum of Contemporary Art and Otis Gallery, Otis College of Art and Design, 1998.

Kirshner, Judith Russi. "Read Read Rosens." *Artforum*, 29 (December 1990), pp. 91–95.

Lieberman, Rhonda. "Recent Painting by a Jewish Woman in Indiana." *Art + Text*, no. 46 (September 1993), pp. 54–59.

Myles, Eileen. "True to Type." *Art in America*, 87 (September 1999), pp. 110–15.

MICHAL ROVNER

Born in Tel Aviv, 1957

Studied at Tel Aviv University (BA, 1981); Bezalel Academy of Arts & Design, Jerusalem (BFA, 1985)

Lives in New York

ONE-ARTIST EXHIBITIONS

1999 Stedelijk Museum, Amsterdam

1998 Rhona Hoffman Gallery, Chicago

1997 The Museum of Modern Art, New York

PaceWildensteinMacGill, New York

Tate Gallery, London

GROUP EXHIBITIONS

1999 Museum of Contemporary Art, Chicago, "Apposite Opposites: Photography from the MCA Collection"

Whitney Museum of American Art at Champion, Stamford, Connecticut, "Zero-G: When Gravity Becomes Form"

1998 Pori Art Museum, Finland, "Animal.Anima.Animus," organized by The Finnish Fund for Art Exchange (traveling)

Pusan Metropolitan Art Museum, South Korea, "'98 Pusan International Contemporary Art Festival"

Whitney Museum of American Art, New York, "Hindsight: Recent Work from the Permanent Collection"

BIBLIOGRAPHY

Conkelton, Sheryl. *New Photography 10: Shimon Attie, Abelardo Morell, Jorge Ribalta, Michal Rovner* (exhibition brochure). New York: The Museum of Modern Art, 1994.

Madoff, Steven Henry. "In the Zone of Transition." In Sylvia Wolf, *Michal Rovner* (exhibition catalogue). Chicago: The Art Institute of Chicago, 1993.

Morris, Frances. *Art Now 10: Michal Rovner* (exhibition brochure). London: Tate Gallery, 1997.

Snodgrass, Susan. "Michal Rovner at The Art Institute of Chicago and Rhona Hoffman." *Art in America*, 82 (May 1994), pp. 124–25.

Weinberg, Adam D. *Border* (program note). New York: The Museum of Modern Art, 1997.

®™ARK

Incorporated in the United States, 1991

SCREENINGS

1999 Amsterdam, "17th Worldwide Video Festival"

"Chicago Underground Film Festival"

New Mexico, "Taos Talking Pictures Festival"

Osnabrück, Germany, "European Media Art Festival"

Rotterdam, "28th International Film Festival"

NEW MEDIA PROJECTS AND EXHIBITIONS

1999 *gatt.org*

gwbush.com

yesrudy.com

1998 *Deconstructing Beck* (compact disk)

"Phone in Sick Day" (participatory event)

BIBLIOGRAPHY

Baimbridge, Richard. "Subversion, Inc." *The Independent* (August–September 1999).

Lyall, Sarah. "Shirkers Unite! April 6 Is Your Day." *The New York Times*, April 5, 1998, p. 9.

Mirapaul, Matthew. "A Different Kind of Demonstration Software." *The New York Times*, March 18, 1999.

Raney, Rebecca Fairley. "Bush Shows How Not to Handle the Internet, Experts Say." *The New York Times*, June 8, 1999.

Smith, Ethan. "Mischief Executives." *New York*, September 6, 1999, p. 14.

KATHERINE SHERWOOD

Born in New Orleans, 1952

Studied at University of California, Davis (BA, 1975); San Francisco Art Institute (MFA, 1979)

Lives in Rodeo, California

ONE-ARTIST EXHIBITIONS

1999 Walter/McBean Gallery, San Francisco Art Institute, "1999 Adaline Kent Award Exhibition"

1998 Gallery Paule Anglim, San Francisco

GROUP EXHIBITIONS

1999 Worth Ryder Gallery, Department of Art Practice, University of California, Berkeley, "Faculty Exhibition"

1997 Blake House, University of California, Kensington, "Blake House Collection"

Thompson Gallery, School of Art and Design, San Jose State University, California, "From Within: An Exhibition About Motherhood and the Creative Process"

University Art Gallery, University of California, San Diego, "Seduced by Surface"

BIBLIOGRAPHY

Baker, Kenneth. "Painter Puts Symbols into Artistic Mix." *San Francisco Chronicle*, August 19, 1995, p. E1.

Breslin, James E.B. *Katherine Sherwood: Luck* (exhibition catalogue). San Francisco: Gallery Paule Anglim, 1995.

Jana, Reena. "A Cosmic Conflux: Katherine Sherwood at Gallery Paule Anglim." *Artweek*, September 17, 1992, p. 28.

Porges, Maria. "Katherine Sherwood." *Artforum*, 34 (November 1995), p. 96.

Rodriguez, Juan. "Gesturing from Within." In *Katherine Sherwood: 1999 Adaline Kent Award Exhibition* (exhibition catalogue). San Francisco: San Francisco Art Institute, 1999.

JOHN F. SIMON, JR.

Born in Louisiana, 1963

Studied at Brown University, Providence, Rhode Island (BS, 1985; BA, 1985); Washington University, St. Louis (MA, 1987); School of Visual Arts, New York (MFA, 1989)

Lives in New York

NEW MEDIA PROJECTS AND EXHIBITIONS

1999 Mario Diacono Gallery, Boston, "Cyber Cypher Either End"

Sandra Gering Gallery, New York

1998 Sandra Gering Gallery, "Formulations"

Walker Art Center, Minneapolis, "Beyond Interface" (online exhibition; *www.walkerart.org/gallery9/beyondinterface*)

1997 HOMEPORT (online project with Lawrence Weiner and äda 'web; *adaweb.walkerart.org/project/homeport*)

Sandra Gering Gallery, New York

Postmasters Gallery, New York, "MacClassics (the immaculate machines)"

The Robert J. Shiffler Collection & Foundation, *Color Balance* (Internet project; *www.bobsart.com/Art/art.html*)

Stadium (*www.stadiumweb.com*)

BIBLIOGRAPHY

Atkins, Robert. "State of the (On-Line) Art." *Art in America*, 87 (April 1999), pp. 89–95.

Mirapaul, Matthew. "In John Simon's Art, Everything Is Possible." *The New York Times on the Web*, April 17, 1997 (*www.nytimes.com/library/cyber/mirapaul/041797mirapaul.html*).

Pollack, Barbara. "Collecting On-Line: A Leap of Faith." *Art News*, 96 (March 1997), p. 65.

Rush, Michael. *New Media in Late 20th-Century Art*. London: Thames and Hudson, 1999, pp. 193–94.

Weinbren, Grahame. "The PC Is a Penguin." In Yvonne Spielmann and Gundolf Winter, eds., *Bild-Medium-Kunst*. Munich: Wilhelm Fink Verlag, 1999, pp. 271–84.

AL SOUZA

Born in Plymouth, Massachusetts, 1944

Studied at University of Massachusetts, Amherst (BS, 1967; MFA, 1972); Art Students League, New York (1967–70); School of Visual Arts, New York (1970–72)

Lives in Houston

ONE-ARTIST EXHIBITIONS

1998 Galveston Arts Center, Texas

Moody Gallery, Houston

Roswell Museum and Art Center, New Mexico

1997 Moody Gallery, Houston

Quint Contemporary Art, La Jolla, California

GROUP EXHIBITIONS

1998 Tiroler Volkskunstmuseum, Innsbruck, Austria, "The Bird of Self-Knowledge"

1997 Austin Museum of Art—Laguna Gloria, Texas, "Art Patterns"

Museum of Contemporary Art, San Diego, "Primarily Paint"

Museum of Fine Arts, Houston, "The Glass Canvas"

University of Texas at San Antonio, Art Gallery, "Picture Play: 7 Texas Painters"

BIBLIOGRAPHY

Floss, Michael M. *Matrix/Berkeley 124: Al Souza* (exhibition brochure). Berkeley: University Art Museum, University of California, Berkeley, 1989.

Ostrow, Saul. "Al Souza: Puzzles, Spit Balls and Other Historicized Pastimes." In *Al Souza's Stuff* (exhibition brochure). Roswell, New Mexico: Roswell Museum and Art Center, 1998.

Rifkin, Ned. *Currents: Al Souza* (exhibition catalogue). New York: The New Museum, 1982.

Al Souza (exhibition catalogue). Guernsey, England: International Artist in Residence Programme, Guernsey College of Further Education, Art and Design, 1996.

Weiermair, Peter. *Al Souza: Photoworks* (exhibition catalogue). Zurich: Work Gallery, 1981.

DARCEY STEINKE

Born in Oneida, New York, 1963

Studied at Goucher College, Baltimore (BA, 1985); University of Virginia, Charlottesville (MFA, 1987)

Lives in Brooklyn, New York

BIBLIOGRAPHY

Moody, Rick, and Darcey Steinke, eds. *Joyful Noise: The New Testament Revisited*. Boston: Little, Brown and Company, 1999.

Steinke, Darcey. *Jesus Saves*. New York: Atlantic Monthly Press, 1997.

———. *Suicide Blonde*. New York: Atlantic Monthly Press, 1992.

———. *Up Through the Water*. New York: Doubleday, 1989.

ELISABETH SUBRIN

Born in Boston, 1964

Studied at University of Wisconsin-Madison; Massachusetts College of Art, Boston (BFA, 1990); The School of The Art Institute of Chicago (MFA, 1995)

Lives in Brooklyn, New York

SCREENINGS

1999 The Museum of Modern Art, New York

Pleasure Dome, Toronto

Walker Art Center, Minneapolis

1998 American Museum of Natural History, New York, "Margaret Mead Film & Video Festival"

University of California, Berkeley Art Museum and Pacific Film Archive

The Film Center, The School of The Art Institute of Chicago

The Film Society of Lincoln Center, New York, "The New York Film Festival"

Filmforum, Los Angeles

The Institute of Contemporary Art, Boston, "Transience and Sentimentality: From Boston and Beyond"

Rotterdam, "27th International Film Festival"

San Francisco Cinematheque

Wexner Center for the Arts, Columbus, Ohio

BIBLIOGRAPHY

Arthur, Paul. "The Avant-Garde in '98." *Film Comment*, 35 (January–February 1999), pp. 38–39.

Dargis, Manohla. "Elisabeth Subrin in Person." *LA Weekly*, February 27–March 5, 1998, p. 68.

Halprin, Mikki. "Don't Look Back." *Filmmaker*, 6 (Summer 1998), pp. 31–32.

Rich, B. Ruby. *Chick Flicks: Theories and Memories of the Feminist Film Movement*. Durham, North Carolina: Duke University Press, 1998, pp. 383–84.

Rosenbaum, Jonathan. "Remaking History." *Chicago Reader*, November 20, 1998, pp. 48–49.

CHRIS SULLIVAN

Born in Pittsburgh, 1960

Studied at Carnegie-Mellon University, Pittsburgh; Minneapolis College of Art and Design (BFA, 1983)

Lives in Chicago

SCREENINGS

1999 University of California, Berkeley Art Museum and Pacific Film Archive

University of Wisconsin-Milwaukee

1998 Michigan, "36th Ann Arbor Film Festival"

Museum of Fine Arts, Boston

Rhode Island School of Design, Providence

Solomon R. Guggenheim Museum, New York, "International Puppet Film Festival"

BIBLIOGRAPHY

Hayford, Justin. "Curse of the Happy Artist." *Chicago Reader*, p. 44.

———. "The Unpretentious." *Chicago Reader*, p. 30.

Relyea, Lane. "Chris Sullivan." *New Art Examiner*, 16 (January 1989), p. 59.

Steele, Mike. "'Performance Artist' Leaves You Feeling Good—and Makes Sense." *Star Tribune* (Minneapolis-St. Paul), October 22, 1988, p. 10E.

SARAH SZE

Born in Boston, 1969

Studied at Yale University, New Haven (BA, 1991); School of Visual Arts, New York (MFA, 1997)

Lives in Brooklyn, New York

ONE-ARTIST EXHIBITIONS

1999 Fondation Cartier pour l'Art Contemporain, Paris

Galerie für Zeitgenössische Kunst, Leipzig

Museum of Contemporary Art, Chicago

1998 Institute of Contemporary Arts, London

1997 White Columns, New York

GROUP EXHIBITIONS

1999 Carnegie Museum of Art, Pittsburgh, "1999 Carnegie International"

"48th Venice Biennale"

1998 Akademie der Künste, Berlin, "Berlin Biennale"

1997 Musée d'Art Moderne de la Ville de Paris, "Migrateurs"

P.S.1 Contemporary Art Center, Long Island City, New York, "Some Young New Yorkers"

BIBLIOGRAPHY

Birnbaum, Daniel. "Just So." Frieze, no. 48 (September–October 1999), pp. 90–93.

Boris, Staci, and Francesco Bonami. Sarah Sze (exhibition catalogue). Chicago: Museum of Contemporary Art, 1999.

Hanru, Hou. "Sarah Sze." In Cream: Contemporary Art in Culture. London: Phaidon Press Limited, 1998, pp. 380–83.

Kastner, Jeffrey. "Sarah Sze: Tipping the Scales." Art + Text, no. 65 (May–July 1999), pp. 68–73.

Slyce, John. "The Imagined Communities of Sarah Sze." In Sarah Sze (exhibition catalogue). London: Institute of Contemporary Art, 1998, pp. [5–13].

TRAN, T. KIM-TRANG

Born in Saigon, 1966

Studied at University of Iowa, Iowa City (BFA, 1989); California Institute of the Arts, Valencia (MFA, 1993)

Lives in Los Angeles

SCREENINGS

1999 Linz, Austria, "Ars Electronica 99: Life Science"

The Museum of Modern Art, New York

Utrecht, The Netherlands, "Impakt Festival '98"

1998 University of California, Berkeley Art Museum and Pacific Film Archive

Helsinki, "MuuMediaFestival 98"

São Paulo, "12° Videobrasil: Festival Internacional de Arte Electrônica"

1997 Amsterdam, "15th World Wide Video Festival"

Novi Sad, Yugoslavia, "VideoMedeja: Second International Video Summit"

Kassel, Germany, "14. Kasseler Dokumentarfilm- und Videofest"

BIBLIOGRAPHY

Frank, Peter. "New California Video 1994–95, Recent Acquisitions in Video." LA Weekly, August 11–17, 1995, p. 70.

Isé, Claudine. "New California Video 1994–95 at the Long Beach Museum of Art." Artweek, 26 (September 1995), pp. 25–26.

Koehler, Robert. "Art-Tape 'Visions of U.S.' Worth Viewing at EZTV." Los Angeles Times, May 1, 1993, p. F8.

Marks, Laura U. The Skin of the Film: Intercultural Cinema, Embodiment, and the Senses. Durham, North Carolina: Duke University Press, 2000, pp. 137–38.

Willis, Holly. "Getting Experimental in L.A.: Like Ghosts in the City of Angels." Release Print, 18 (September 1995), pp. 10–13.

RICHARD TUTTLE

Born in Rahway, New Jersey, 1941

Studied at Trinity College, Hartford, Connecticut (BA, 1963)

Lives in New York and Albiquiu, New Mexico

ONE-ARTIST EXHIBITIONS

1999 The Arts Club of Chicago

1998 Kunsthaus Zug, Switzerland

Ludwig Forum für Internationale Kunst, Aachen, Germany

Sperone Westwater, New York

GROUP EXHIBITIONS

1999 Museu Serralves, Museu de Arte Contemporânea, Porto, Portugal, "Circa 1968"

1998 Modern Art Museum of Fort Worth, Texas, "Agnes Martin/Richard Tuttle" (traveled)

The Museum of Contemporary Art and The Geffen Contemporary, Los Angeles, "Afterimage: Drawing Through Process"

1997 Arthur M. Sackler Museum, Harvard University Art Museums, Cambridge, Massachusetts, "Drawing Is Another Kind of Language: Recent American Drawings from a New York Private Collection" (traveled)

"47th Venice Biennale"

BIBLIOGRAPHY

Auping, Michael. Agnes Martin/Richard Tuttle (exhibition catalogue). Fort Worth, Texas: Modern Art Museum of Fort Worth, 1998.

Murdock, Robert M., and Robert Rainwater. Richard Tuttle: Books & Prints (exhibition brochure). New York: The New York Public Library, 1996.

Princenthal, Nancy. "Numbers of Happiness: Richard Tuttle's Books." The Print Collector's Newsletter, 24 (July–August 1993), pp. 81–86.

Storr, Robert. "Just Exquisite? The Art of Richard Tuttle." Artforum, 36 (November 1997), pp. 86–93, 130.

Tuttle, Richard, and Charles Bernstein. Reading Red. Cologne: Verlag der Buchhandlung Walther König, 1998.

AYANNA U'DONGO

Born in South Bend, Indiana, 1952

Studied at The School of The Art Institute of Chicago

Lives in Oakland, California

SCREENINGS

1999 Institute of Contemporary Arts, London, "Voices: New Work from Chicago"

1998 The School of The Art Institute of Chicago, "Sexing the Myth"

1997 Marwen Foundation Gallery, Chicago

Museum of Contemporary Art, Chicago, "History of Art in Chicago: 1947–1997"

BIBLIOGRAPHY

McGough, Laura. "Ayanna U'Dongo" (interview). *geekgirl.com.au*, 6 (March 1996), pp. 18–19.

Sanchez, John. "On Video: Girls in the Director's Chair...Take to the Streets." *Chicago Reader*, March 21, 1997, p. 46.

U'Dongo, Ayanna. "Aftershocks: Re-shifting the Sexual Landscape Through Language, Image and Action." *Felix: A Journal of Media Arts and Communication*, 2 (1995), pp. 214–17.

CHRIS VERENE

Born in Galesburg, Illinois, 1969

Studied at Emory University, Atlanta (BA, 1991); Georgia State University, Atlanta (MFA, 1996)

Lives in Atlanta

ONE-ARTIST EXHIBITIONS

1999 Cheekwood—Tennessee Botanical Garden and Museum of Art, Nashville

1998 Paul Morris Gallery, New York

Vaknin Schwartz Gallery, Atlanta

GROUP EXHIBITIONS

1999 University Art Gallery, University of California, San Diego, "New Voices/New Visions"

1998 Paul Morris Gallery, New York, "Portraits"

1997 Georgia Museum of Art, University of Georgia, Athens, "To See a World"

Thread Waxing Space, New York, "You Should Know Better"

Vaknin Schwartz Gallery, Atlanta, "Tableaux: Ten Contemporary Photographers"

BIBLIOGRAPHY

Cullum, Jerry. "Chris Verene." *Art News*, 97 (December 1998), p. 156.

Feaster, Felicia. "Chris Verene at Paul Morris." *Art in America*, 86 (October 1998), p. 136.

————. "On the Edge." *Creative Loafing*, November 29, 1997, pp. 1, 29, 30.

Watson, April. "Chris Verene." *Art Papers Magazine*, 20 (September–October 1996), p. 56.

Yablonsky, Linda. "Chris Verene, 'Camera Club.'" *Time Out New York*, May 28–June 4, 1998, p. 57.

ANNETTE WEINTRAUB

Born in Brooklyn, New York, 1946

Studied at The Cooper Union for the Advancement of Science and Art, New York (BFA, 1967); University of Pennsylvania, Philadelphia (MFA, 1970)

Lives in New York

NEW MEDIA PROJECTS AND EXHIBITIONS

1999 Herbert F. Johnson Museum of Art, Cornell University, Ithaca, New York, "Contact Zones" (traveled)

SIGGRAPH 99, Los Angeles, "26th International Conference on Computer Graphics and Interactive Techniques: TechnOasis" (*siggraph. org/artdesign/gallery/S99/index.html*)

Thirteen/WNET, New York, "Reel New York.Web" (online exhibition; *www.wnet.org/archive/reelnewyork4*)

1998 *Pedestrian: Walking as Meditation and the Lure of Everyday Objects* (Internet project; *www.turbulence.org/Works/pedestrian/ intro.html*)

Walker Art Center, Minneapolis, "Beyond Interface" (online exhibition; *www.walkerart.org/gallery9/beyondinterface*)

1997 The Cooper Union for the Advancement of Science and Art, School of Art, New York, "Techno-Seduction"

BIBLIOGRAPHY

Atkins, Robert. "State of the (On-Line) Art." *Art in America*, 87 (April 1999), pp. 89–95.

Broun, Elizabeth. "The Work." In *Beyond Interface* (online exhibition; *www.walkerart.org/ gallery9/beyondinterface/weintraub_work.html*). Minneapolis: Walker Art Center, 1998.

Goodman, Carl. "*Sampling Broadway* by Annette Weintraub." In *Reel New York.Web* (online exhibition; *www.wnet.org/ reelnewyorkweb/weintraub/index.html*). New York: Thirteen/WNET, 1999.

"Interaction." *I.D. Magazine*, 45 (June 1998), p. 58.

YVONNE WELBON

Born in Chicago, 1962

Studied at Vassar College, Poughkeepsie, New York (BA, 1984); The School of The Art Institute of Chicago (MFA, 1994); Northwestern University, Evanston, Illinois

Lives in Chicago

SCREENINGS

1999 Chicago, "Black Harvest International Film and Video Festival"

"Los Angeles Gay & Lesbian Film Festival"

"San Francisco International Lesbian & Gay Film Festival"

"Toronto International Film Festival"

Women in the Director's Chair Theater, Chicago

1997 Burkina Faso, "Panafrican Film and Television Festival of Ouagadougou"

Randolph Street Gallery, Chicago, "Trace"

BIBLIOGRAPHY

Behrens, Bill. "Ruth Ellis' 100 Years Told on Video." *Chicago Free Press*, August 25, 1999, pp. 44, 51.

Redding, Judith M., and Victoria A. Brownworth. *Film Fatales: Independent Women Directors*. Seattle: Seal Press, 1997, pp. 112–16.

Shen, Ted. "Film Explores Pride, Prejudice of a Lifestyle." *Chicago Tribune*, August 26, 1999, pp. 1, 11.

Walker, Cary. "Rethinking the Past: Learning to Question Mainstream Perceptions." *Focus*, 17 (1997), pp. 13–22.

Willis, Holly. "50 Creatives to Watch." *Variety*, August 23–29, 1999, p. A68.

KRZYSZTOF WODICZKO

Born in Warsaw, 1943

Studied at Akademia Sztuk Pieknych, Warsaw (MFA, 1968)

Lives in New York and Cambridge, Massachusetts

ONE-ARTIST EXHIBITIONS

1999 Hiroshima City Museum of Contemporary Art

1997 Fonds Régional d'Art Contemporain des Pays de la Loire, Nantes, France

Galerie Gabrielle Maubrie, Paris

The University of North Texas Art Gallery, Denton

GROUP EXHIBITIONS

1999 Almeers Centrum Hedendaagse Kunst—De Paviljoens, Almere, The Netherlands, "Private Room/Public Space"

Knittelfeld, Austria, "Steirische Landesausstellung 1999: Verkehr"

1998 The Institute of Contemporary Art/ Vita Brevis, Boston, "Let Freedom Ring"

The Jewish Museum, New York, "Light x Eight: The Hanukkah Project"

1997 Galeria Sztuki Wspólczesnej Zacheta, Warsaw, "Art from Poland: 1945–1996" (traveled)

BIBLIOGRAPHY

Borja-Villel, Manuel J., et al. *Krzysztof Wodiczko: Instruments, Projections, Vehicles* (exhibition catalogue). Barcelona: Fundació Antoni Tàpies, 1992.

Boswell, Peter, et al. *Public Address: Krzysztof Wodiczko* (exhibition catalogue). Minneapolis: Walker Art Center, 1992.

Rajchman, John, et al. *The 4th Hiroshima Art Prize: Krzysztof Wodiczko* (exhibition catalogue). Hiroshima: Hiroshima City Museum of Contemporary Art, 1999.

Wodiczko, Krzysztof. *Art Public, Art Critique: Textes, Propos et Documents*. Paris: École Nationale Supérieure des Beaux-Arts, 1995.

———. *Critical Vehicles: Writings, Projects, Interviews*. Cambridge, Massachusetts: The MIT Press, 1999.

YUKINORI YANAGI

Born in Fukuoka, Japan, 1959

Lives in New York

ONE-ARTIST EXHIBITIONS

1999 Haines Gallery, San Francisco

1998 Art Gallery, School of the Arts, University of California, Irvine

1997 Chisenhale Gallery, London

The Fabric Workshop and Museum, Philadelphia

Fuji Television Gallery, Tokyo

GROUP EXHIBITIONS

1998 Kunsthalle Tirol, Hall, Austria, "Sehnsucht Heimat"

Pori Art Museum, Finland, "Animal.Anima.Animus," organized by The Finnish Fund for Art Exchange (traveling)

Taipei Fine Art Museum, "1998 Taipei Biennial"

1997 Halle Tony Garnier, Lyon, "4e Biennale de Lyon Art Contemporain"

Offenes Kulturhaus Linz, Austria, "Atlas Mapping" (traveled)

BIBLIOGRAPHY

Davidson, Kate, and Michael Desmond. *Islands: Contemporary Installations from Australia, Asia, Europe and America* (exhibition catalogue). Canberra, Australia: National Gallery of Australia, 1996.

Farver, Jane. *Yukinori Yanagi: Project Article 9* (exhibition catalogue). Flushing, New York: Queens Museum of Art, 1995.

Koplos, Janet. "Testing Taboos." *Art in America*, 83 (October 1995), pp. 116–17, 138.

Munroe, Alexandra. "Wandering Position." *Flash Art*, 25 (March–April 1992), pp. 71–74.

Park, Kyong. "Wandering Position." In *Hi-no-maru 1/36: A Project by Yukinori Yanagi* (exhibition brochure). New York: Storefront for Art & Architecture, 1990.

LISA YUSKAVAGE

Born in Philadelphia, 1962

Studied at Tyler School of Art, Temple
University, Philadelphia (BFA, 1984);
Yale University School of Art, New Haven
(MFA, 1986)

Lives in New York

ONE-ARTIST EXHIBITIONS

1999 greengrassi, London

1998 Marianne Boesky Gallery, New York

1997 Studio Guenzani, Milan

GROUP EXHIBITIONS

1999 The Saatchi Gallery, London,
"Young Americans 2: New American
Art at The Saatchi Gallery"

"6th International Istanbul Biennial:
The Passion and the Wave"

1998 The Aldrich Museum of
Contemporary Art, Ridgefield,
Connecticut, "Pop Surrealism"

Phyllis Kind Gallery, New York,
"The Risk of Existence"

San Francisco Museum of Modern Art,
"A Portrait of Our Times: An
Introduction to the Logan Collection"

BIBLIOGRAPHY

Cameron, Dan. "Lisa Yuskavàge." In *Cream:
Contemporary Art in Culture*. London: Phaidon
Press Limited, 1998, pp. 436–39.

Dobrzynski, Judith H. "A Painter and Her Art
Trade Places." *The New York Times*, January 28,
1999, p. E1.

Schjeldahl, Peter. "Purple Nipple." *The Village
Voice*, September 29, 1998, p. 138.

Schwabsky, Barry. "Picturehood Is Powerful."
Art in America, 85 (December 1997), pp. 80–85.

Siegel, Katy. "Lisa Yuskavage." *Artforum*, 37
(November 1998), pp. 115–16.

WORKS IN THE EXHIBITION*

*as of January 18, 2000

Dimensions are in inches followed by centimeters; height precedes width precedes depth.

DENNIS ADAMS
Outtake, 1998–99
Video projection, color, sound; 136 minutes
Kent Gallery, New York, and the artist

DOUG AITKEN
Electric Earth, 1999
Eight-laserdisc installation and architectural environment, dimensions variable
Collection of Norman and Norah Stone; courtesy Thea Westreich, Art Advisory Services, New York, and 303 Gallery, New York. Additional support provided by Fondazione Sandretto Re Rebaudengo Per L'Arte, Turin, Italy

GHADA AMER
Untitled (Orange), 1998
Acrylic, embroidery, and gel medium on canvas, 64 x 72 (162.6 x 182.9)
Collection of Irving Blum

Untitled (John Rose), 1999
Acrylic, embroidery, and gel medium on canvas, 72 x 72 (182.9 x 182.9)
Collection of Gilles and Kelly Bensimon

MARK AMERIKA
Grammatron, 1997–present
(www.grammatron.com)
Website

LUTZ BACHER
Olympiad, 1997
Video projection, black-and-white, silent; 36 minutes
Pat Hearn Gallery, New York, and Rupert Goldsworthy Gallery, New York

CRAIG BALDWIN
Spectres of the Spectrum, 1999
16mm film, color, sound; 88 minutes

LEW BALDWIN
Redsmoke, 1995–present (www.redsmoke.com)
Website

RINA BANERJEE
Infectious Migrations, from the series *An Uncertain Bondage Is Deserved When Threatening Transmission*, 1999
Incense sticks, kumkum, Vaseline, turmeric, Indian blouse, gauze, fake fingernails and eyelashes, chalk, foam, feathers, fabric, Spanish moss, light bulbs, wax, Silly Putty, quilting pins, plastic tubing, latex and rubber gloves, acrylic, and dry pigment, dimensions variable
Collection of the artist

REBECCA BARON
okay bye-bye, 1998
16mm film, color, sound; 39 minutes

VANESSA BEECROFT
VB 39 US NAVY, 1999
Live event at the Museum of Contemporary Art, San Diego
Digital print, dimensions variable
Deitch Projects, New York

Intrepid, 2000
Live event of a military formation with the U.S. Navy on the flight deck of the aircraft carrier *Intrepid*, part of the Intrepid Sea Air Space Museum, New York
A collaboration of the Whitney Museum of American Art, New York, Public Art Fund, and Deitch Projects, New York

ROLF BELGUM
Driver 23, 1998
Video transferred to 35mm film, color, sound; 72 minutes

BEN BENJAMIN
Superbad, 1995–present (www.superbad.com)
Website

SADIE BENNING
Flat Is Beautiful, 1998
Video, black-and-white, sound; 56 minutes

ROBIN BERNAT
effortless: three préludes by Chopin, 1998
Video, color, sound; 3 minutes
Solomon Projects, Atlanta

LINDA BESEMER

Fold #27, 1999
Acrylic over aluminum rod, 36 x 72
(91.4 x 182.9)
Collection of Byron R. Meyer; courtesy
Angles Gallery, Santa Monica, California

Fold #28, 1999
Acrylic over aluminum rod, 36 x 72
(91.4 x 182.9)
Collection of Penny Cooper and Rena
Rosenwasser; courtesy Angles Gallery,
Santa Monica, California

Zip Fold #1, 1999
Acrylic, fiberglass, and aluminum, 72 x 24
(182.9 x 61)
Collection of Kenneth L. Freed; courtesy
Angles Gallery, Santa Monica, California

DAWOUD BEY

Demitri, 1998
Internal dye diffusion transfer prints
(Polaroids), three panels, 30 1/2 x 70 1/2
(77.5 x 179.1) overall
Rhona Hoffman Gallery, Chicago

Ginew, 1999
Internal dye diffusion transfer prints
(Polaroids), three panels, 30 1/2 x 70 1/2
(77.5 x 179.1) overall
Rhona Hoffman Gallery, Chicago

John, 1999
Internal dye diffusion transfer prints
(Polaroids), two panels, 30 1/2 x 47
(77.5 x 119.4) overall
Rhona Hoffman Gallery, Chicago

CHAKAIA BOOKER

It's So Hard to Be Green, 2000
Rubber tires, metal, and wood, 96 x 216 x 24
(243.8 x 548.6 x 61)
Alston Van Putten, Jr., Masters by Design;
Edward Robles, MSS Digital Productions;
Nelson Tejada; Richard Lewis; Constructive
Display; Floyd and Jennifer Slaten; Gwendolyn
Barnes; Norma Nager, Ph.D.; Conrad K.
Harper; courtesy Archibald Arts, New York

M.W. BURNS

Conveyor, 2000
Sound installation with twelve wall-mounted
speakers, dimensions variable
Collection of the artist

CAI GUO-QIANG

How Is Your Feng Shui?:
Year 2000 Project for Manhattan,
1999–2000
Ninety-nine stone lions, photographs,
drawings, three computer monitors, and
computer software, dimensions variable
Collection of the artist, supported
by funds from SHISEIDO and Annie Wong
Art Foundation

INGRID CALAME

b-b-b, rr-gR-UF!, b-b-b, 1999
Enamel on mylar, 348 x 300 (883.9 x 762)
Karyn Lovegrove Gallery, Los Angeles

#53 Working Drawing, 1999
Color pencil on mylar, 72 x 60 (182.9 x 152.4)
Karyn Lovegrove Gallery, Los Angeles

#54 Working Drawing, 1999
Color pencil on mylar, 72 x 60 (182.9 x 152.4)
Karyn Lovegrove Gallery, Los Angeles

LUIS CAMNITZER

The Waiting Room, 1999
Installation with mixed media,
dimensions variable
Collection of the artist

JEM COHEN WITH FUGAZI

Instrument, 1999
Video, 16mm film and Super-8 film
transferred to video, color, sound;
115 minutes

JOHN COPLANS

Self-Portrait (Interlocking Fingers, No. 1), 1999
Gelatin silver print, 37 x 29 (94 x 73.7)
Andrea Rosen Gallery, New York,
and the artist

Self-Portrait (Interlocking Fingers, No. 2), 1999
Gelatin silver print, 37 x 29 (94 x 73.7)
Andrea Rosen Gallery, New York,
and the artist

Self-Portrait (Interlocking Fingers, No. 5), 1999
Gelatin silver print, 37 x 29 (94 x 73.7)
Andrea Rosen Gallery, New York,
and the artist

Self-Portrait (Interlocking Fingers, No. 8), 1999
Gelatin silver print, 37 x 29 (94 x 73.7)
Andrea Rosen Gallery, New York,
and the artist

PETAH COYNE

Untitled #978, 1999–2000
Wood, fiberglass, drywall, plaster, and wax,
144 x 192 x 46 (365.8 x 487.7 x 116.8)
Galerie Lelong, New York, and the artist

JOHN CURRIN

The Old Fence, 1999
Oil on canvas, 76 x 40 (193 x 101.6)
Carnegie Museum of Art, Pittsburgh;
Purchase, A.W. Mellon Acquisition
Endowment Fund

Homemade Pasta, 1999
Oil on canvas, 50 x 42 (127 x 106.7)
Collection of Howard Rachofsky

E.V. DAY

Bombshell, from the series
Exploding Couture, 1999
Dress, monofilament, and turnbuckles,
dimensions variable
Track 16 Gallery, Santa Monica, California,
and the artist

WILLIAM DE LOTTIE

Love Letters Straight from Your Heart, Part I, 1999
Fabric, aluminum plates and poles,
photocopies, latex paint, and quartz lamps,
approximately 120 x 216 x 360
(304.8 x 548.6 x 914.4)
Derek Eller Gallery, New York, and the artist

ROMAN DE SALVO

Face Time, 2000
Vacuum-thermoformed plastic and mirrors,
approximately 8 x 12 x 14
(20.3 x 30.5 x 35.6) each
Quint Contemporary Art, La Jolla, California,
and the artist

TIC Headquarters, 2000
Signage, quartz clock movement, carbon fiber
composite, lead, and fluorescent enamel,
dimensions variable
Quint Contemporary Art, La Jolla, California,
and the artist

THORNTON DIAL

Bad Picture (Diana's Last Ride), 1997–98
Mixed-media assemblage, 87 x 105 x 41
(221 x 266.7 x 104.1)
Collection of William S. Arnett

Stone Walls (Diana's Land), 1997–98
Mixed media on canvas, 132 x 144
(335.3 x 365.8)
Collection of William S. Arnett

KIM DINGLE

63MG 4ME, 1999
MG Midget with mixed media, approximately
48 x 144 x 53 (121.9 x 365.8 x 134.6)
Sperone Westwater, New York, and the artist

ANTHONY DISCENZA

Phosphorescence, 1999
Video, color, sound; 14 minutes
jennjoygallery, San Francisco, and the artist

TARA DONOVAN

Ripple, 1998
Cut electrical cable, 191 x 191 (485.1 x 485.1)
Reynolds Gallery, Richmond, Virginia,
and the artist

NATHANIEL DORSKY

Variations, 1992–98
16mm film at 18 fps, color, silent; 24 minutes

JAMES DRAKE

Anna, from the series *Que Linda La Brisa
(How Lovely the Breeze)*, 1999
Chromogenic color print, 15 1/2 x 23 1/4
(39.4 x 59.1)
Pamela Auchincloss, Arts Management, New
York; Rhona Hoffman Gallery, Chicago; Adair
Margo Gallery, El Paso, Texas; and the artist

La Brisa con Jacaranda, from the series
Que Linda La Brisa (How Lovely the Breeze), 1999
Chromogenic color print, 23 1/4 x 15 7/8
(59.1 x 40.3)
Pamela Auchincloss, Arts Management, New
York; Rhona Hoffman Gallery, Chicago; Adair
Margo Gallery, El Paso, Texas; and the artist

Jacaranda, from the series *Que Linda La Brisa
(How Lovely the Breeze)*, 1999
Chromogenic color print, 19 3/8 x 20 1/2
(49.2 x 52.1)
Pamela Auchincloss, Arts Management, New
York; Rhona Hoffman Gallery, Chicago; Adair
Margo Gallery, El Paso, Texas; and the artist

Lisa and Samantha, from the series *Que Linda
La Brisa (How Lovely the Breeze)*, 1999
Chromogenic color print, 23 1/4 x 15 1/2
(59.1 x 39.4)
Pamela Auchincloss, Arts Management, New
York; Rhona Hoffman Gallery, Chicago; Adair
Margo Gallery, El Paso, Texas; and the artist

Lisa and Tanya, from the series *Que Linda
La Brisa (How Lovely the Breeze)*, 1999
Chromogenic color print, 23 1/4 x 15 7/8
(59.1 x 40.3)
Pamela Auchincloss, Arts Management, New
York; Rhona Hoffman Gallery, Chicago; Adair
Margo Gallery, El Paso, Texas; and the artist

Lisa, Lisa, Tanya, from the series *Que Linda La
Brisa (How Lovely the Breeze)*, 1999
Chromogenic color print, 15 1/4 x 23 1/2
(38.7 x 59.7)
Pamela Auchincloss, Arts Management, New
York; Rhona Hoffman Gallery, Chicago; Adair
Margo Gallery, El Paso, Texas; and the artist

Lisa, Samantha, and Tanya, from the series
Que Linda La Brisa (How Lovely the Breeze), 1999
Chromogenic color print, 15 3/4 x 23 1/2
(40 x 59.7)
Pamela Auchincloss, Arts Management, New
York; Rhona Hoffman Gallery, Chicago; Adair
Margo Gallery, El Paso, Texas; and the artist

Lorena's Bed, from the series *Que Linda La Brisa
(How Lovely the Breeze)*, 1999
Chromogenic color print, 15 1/2 x 23 1/4
(39.4 x 59.1)
Pamela Auchincloss, Arts Management, New
York; Rhona Hoffman Gallery, Chicago; Adair
Margo Gallery, El Paso, Texas; and the artist

Paulina's Room, from the series *Que Linda La
Brisa (How Lovely the Breeze)*, 1999
Chromogenic color print, 23 1/4 x 15 7/8
(59.1 x 40.3)
Pamela Auchincloss, Arts Management, New
York; Rhona Hoffman Gallery, Chicago; Adair
Margo Gallery, El Paso, Texas; and the artist

Sagrado Corazon, from the series *Que Linda
La Brisa (How Lovely the Breeze)*, 1999
Chromogenic color print, 15 3/4 x 23 3/8
(40 x 59.4)
Pamela Auchincloss, Arts Management, New
York; Rhona Hoffman Gallery, Chicago; Adair
Margo Gallery, El Paso, Texas; and the artist

Samantha, from the series *Que Linda La Brisa
(How Lovely the Breeze)*, 1999
Chromogenic color print, 15 1/2 x 23 1/4
(39.4 x 59.1)
Pamela Auchincloss, Arts Management, New
York; Rhona Hoffman Gallery, Chicago; Adair
Margo Gallery, El Paso, Texas; and the artist

Samantha and Jacaranda, from the series *Que
Linda La Brisa (How Lovely the Breeze)*, 1999
Chromogenic color print, 15 1/2 x 23 1/4
(39.4 x 59.1)
Pamela Auchincloss, Arts Management, New
York; Rhona Hoffman Gallery, Chicago; Adair
Margo Gallery, El Paso, Texas; and the artist

Tanya, from the series *Que Linda La Brisa
(How Lovely the Breeze)*, 1999
Chromogenic color print, 23 1/4 x 15 7/8
(59.1 x 40.3)
Pamela Auchincloss, Arts Management, New
York; Rhona Hoffman Gallery, Chicago; Adair
Margo Gallery, El Paso, Texas; and the artist

Tanya and Samantha, from the series *Que Linda
La Brisa (How Lovely the Breeze)*, 1999
Chromogenic color print, 15 3/4 x 23 1/4
(40 x 59.1)
Pamela Auchincloss, Arts Management, New
York; Rhona Hoffman Gallery, Chicago; Adair
Margo Gallery, El Paso, Texas; and the artist

Tanya's Portrait, from the series *Que Linda La
Brisa (How Lovely the Breeze)*, 1999
Chromogenic color print, 15 1/2 x 23 1/4
(39.4 x 59.1)
Pamela Auchincloss, Arts Management, New
York; Rhona Hoffman Gallery, Chicago; Adair
Margo Gallery, El Paso, Texas; and the artist

THERESA DUNCAN AND JEREMY BLAKE

The History of Glamour, 1998
Video, color, sound; 39 minutes

LEANDRO ERLICH
Rain, 1999–2000
Mixed media with water and light,
three parts, 96 x 192 x 264
(243.8 x 487.7 x 670.6) overall
Kent Gallery, New York; Moody Gallery,
Houston; and the artist

FAKESHOP
Fakeshop, 1997–present (*www.fakeshop.com*)
Website

VERNON FISHER
Tunis, from the *Zombie* series, 1999
Acrylic on canvas with cast epoxy, 84 x 84
(213.4 x 213.4)
Private collection; courtesy Dunn and
Brown Contemporary, Dallas

Taza, from the *Zombie* series, 1999
Acrylic on canvas with cast epoxy,
84 x 84 (213.4 x 213.4)
Charles Cowles Gallery, New York,
and the artist

SUZAN FRECON
double red, 1997
Watercolor on paper, 5 1/2 x 25 1/2 (14 x 64.8)
Collection of Sarah-Ann and
Werner H. Kramarsky

elementary matter, 1997
Watercolor on paper, 5 3/4 x 25 3/4
(14.6 x 65.4)
Kulturmanagement Häusler, Munich

bole generated painting, 1998
Oil and bole on board, 12 x 16 (30.5 x 40.6)
Lawrence Markey Gallery, New York,
and the artist

untitled (nwe), 1998
Oil and gold leaf on panel, 38 7/8 x 24 x 1 1/2
(98.7 x 61 x 3.8) Lawrence Markey Gallery,
New York, and the artist

strokes then turn, 1999
Watercolor on paper, 17 1/2 x 13 1/4
(44.5 x 33.7)
Collection of Sarah-Ann and
Werner H. Kramarsky

untitled (lateral), 1999
Oil and gold leaf on panel, 23 x 37 1/2
(58.4 x 95.3)
Galerie Friedrich, Bern, Switzerland

BRIAN FRIDGE
Vault Sequence, 1997
Video, black-and-white, silent; 7 minutes
Collection of the artist

DARA FRIEDMAN
Bim Bam, 1999
16mm film installation with two slot-loading
projectors, metal armature, CD player, and
speakers, dimensions variable
Collection of George Lindemann

JOE GIBBONS
Multiple Barbie, 1998
Video, black-and-white, sound; 9 minutes

ROBERT GOBER
Untitled, 1999
Plaster, beeswax, human hair, cotton, leather,
aluminum, and enamel, 33 1/2 x 40 x 24 3/4
(85.1 x 101.6 x 62.9)
Philadelphia Museum of Art;
Gift (by exchange) of Mrs. Arthur Barnwell

Untitled, 1999–2000
Plaster, beeswax, human hair, cotton, leather,
aluminum, and enamel, 50 3/4 x 47 x 26 1/4
(128.9 x 119.4 x 66.7)
Collection of the artist

JILL GODMILOW
What Farocki Taught, 1998
16mm film, color, sound; 30 minutes

KEN GOLDBERG
Ouija 2000, 2000 (*ouija.berkeley.edu*)
Website commissioned by the University
of California Berkeley Art Museum
(originally presented as Ken Goldberg/
MATRIX 186/*Ouija 2000*)
Project team: Billy Chen, Rory Solomon,
Steve Bui, Bobak Farzin, Jacob Heitler, Derek
Poon, and Gordon Smith; Graphic design:
Gil Gershoni; Illustration: Dave Garvey;
Flash: Paulina Wallenberg Olsson; courtesy
Catharine Clark Gallery, San Francisco

KOJO GRIFFIN
No. 4, Immaturity, Line No. 5, 1999
Mixed media on panel, 18 x 19 (45.7 x 48.3)
Collection of Betsy Beaman and Burn Sears

No. 32, Duration, Line No. 3, 1999
Mixed media on panel, 60 x 48 (152.4 x 121.9)
Collection of Linda Mitchell and
Jeffrey Diamond

No. 34, Great Power, Line No. 3, 1999
Mixed media on panel, 18 x 19 (45.7 x 48.3)
Collection of Peter Mannes

Untitled, 1999
Mixed media on panel, 18 x 19
(45.7 x 48.3)
Vaknin Schwartz Gallery, Atlanta

Untitled, 1999
Mixed media on panel, 48 x 60 (121.9 x 152.4)
Collection of Kathleen and Norman Radow

JOSEPH GRIGELY
Untitled Conversations, 1999–2000, 2000
Ink and graphite on paper,
dimensions variable
Galerie Air de Paris, Paris

HANS HAACKE
Sanitation, 2000
Mixed-media installation, dimensions variable
Collection of the artist

TRENTON DOYLE HANCOCK
Ambijest, 1998
Acrylic on paper, 28 1/2 x 22 1/4 (72.4 x 56.5)
Dunn and Brown Contemporary, Dallas,
and the artist

Goods, 1998
Acrylic on paper, 10 x 10 (25.4 x 25.4)
Dunn and Brown Contemporary, Dallas,
and the artist

Hag Bag, 1998
Acrylic on paper, 15 x 13 1/4 (38.1 x 33.7)
Dunn and Brown Contemporary, Dallas,
and the artist

!OOOOOOO!, 1998
Acrylic on paper, 15 x 11 1/2 (38.1 x 29.2)
Dunn and Brown Contemporary, Dallas,
and the artist

A Vile Pile Poof, 1998
Acrylic on paper, 11 x 14 1/4 (27.9 x 36.2)
Dunn and Brown Contemporary, Dallas,
and the artist

And for My Next Trick, I'll..., 1999
Acrylic and collage on paper, 22 1/4 x 26
(56.5 x 66)
Dunn and Brown Contemporary, Dallas,
and the artist

The Dick Backpack, 1999
Acrylic and canvas on paper, 42 1/4 x 37 3/4
(107.3 x 95.9)
Dunn and Brown Contemporary, Dallas,
and the artist

*Me and My Mama, Me and My Mama, Going to the
Dentist Today*, 1999
Acrylic, felt, collage, and canvas on paper,
44 x 37 1/2 (111.8 x 95.3)
Dunn and Brown Contemporary, Dallas,
and the artist

Mound, 1999
Acrylic on paper, 42 1/2 x 37 3/4 (108 x 95.9)
Dunn and Brown Contemporary, Dallas,
and the artist

That's Not Winston, 1999
Ink on paper, 10 x 12 1/4 (25.4 x 31.1)
Dunn and Brown Contemporary, Dallas,
and the artist

Torpedo Boy and the Great Acid Caper, 1999
Acrylic, collage, and canvas on paper, 48 x 37
(121.9 x 94)
Dunn and Brown Contemporary, Dallas,
and the artist

JOSEPH HAVEL
Curtains, 1999
Bronze, 104 x 24 x 46 (264.2 x 61 x 116.8)
Collection of the artist; courtesy Devin
Borden Hiram Butler Gallery, Houston;
Dunn and Brown Contemporary, Dallas;
and Galerie Gabrielle Maubrie, Paris

Drape, 1999
Bronze, 119 x 56 x 56 (302.3 x 142.2 x 142.2)
Collection of the artist; courtesy Devin
Borden Hiram Butler Gallery, Houston;
Dunn and Brown Contemporary, Dallas;
and Galerie Gabrielle Maubrie, Paris

Table Cloth, 1999
Bronze, 77 1/2 x 11 x 12 (196.9 x 27.9 x 30.5)
Collection of the artist; courtesy Devin
Borden Hiram Butler Gallery, Houston;
Dunn and Brown Contemporary, Dallas;
and Galerie Gabrielle Maubrie, Paris

SALOMÓN HUERTA
Untitled Figure, 1999
Oil on canvas, 72 x 32 (182.9 x 81.3)
Patricia Faure Gallery, Santa Monica,
California, and the artist

Untitled Figure, 1999
Oil on canvas, 72 x 32 (182.9 x 81.3)
Patricia Faure Gallery, Santa Monica,
California, and the artist

Untitled Head, 1999
Oil on canvas, 11 3/4 x 12 (29.8 x 30.5)
Patricia Faure Gallery, Santa Monica,
California, and the artist

Untitled Head, 1999
Oil on canvas, 12 x 14 (30.5 x 35.6)
Hansen, Jacobson, Teller, Hoberman,
Newman & Warren Hertz & Goldring L.L.P.,
Santa Monica, California

Untitled House, 1999
Oil on canvas, 14 x 14 (35.6 x 35.6)
Creative Artists Agency, Beverly Hills,
California

ARTHUR JAFA
Untitled (Griffin), 1999
Video projection, color, silent;
running time varies
Collection of the artist

MICHAEL JOO
Visible, 1999
Urethane, nylon, glass, wood, lacquer,
and aluminum, 60 x 48 x 48
(152.4 x 121.9 x 121.9)
Anton Kern Gallery, New York, and the artist

Assisted, 1999–2000
Urethane, nylon, glass, stainless steel,
aluminum, and wood, 40 x 48 x 36
(101.6 x 121.9 x 91.4)
Anton Kern Gallery, New York, and the artist

Obscured, 1999–2000
Vinyl, glass, stainless steel, dextrose, and
nylon, 70 x 60 x 48 (177.8 x 152.4 x 121.9)
Anton Kern Gallery, New York, and the artist

KURT KAUPER
Diva Fiction #7, 1998
Oil on panel, 70 x 54 (177.8 x 137.2)
Collection of Dean Valentine and
Amy Adelson

Diva Fiction #8, 1999
Oil on panel, 88 x 47 1/2 (223.5 x 120.7)
Collection of Heidi Schneider

Diva Fiction #9, 1999
Oil on panel, 84 x 60 (213.4 x 152.4)
Collection of Robert Harshorn Shimshak
and Marion Brenner

SILVIA KOLBOWSKI
An Inadequate History of Conceptual Art, 1999
Video, color, sound; running time varies
American Fine Arts Co., New York,
and the artist

HARMONY KORINE
Gummo, 1998
35mm film, color, sound; 95 minutes

LOUISE LAWLER
Pink and Yellow and Black I (Red Disaster),
from the series *On a Wall, On a Cow, In a Book,
In the Mail*, 1999
Silver dye bleach print (Ilfochrome),
25 x 32 1/2 (63.5 x 82.6)
Metro Pictures, New York, and the artist

*Pink and Yellow and Black II (Green Coca-Cola
Bottles)*, from the series *On a Wall, On a Cow,
In a Book, In the Mail*, 1999
Silver dye bleach print (Ilfochrome),
27 x 27 (68.6 x 68.6)
Metro Pictures, New York, and the artist

Pink and Yellow and Black III (Brillo),
from the series *On a Wall, On a Cow, In a Book,
In the Mail*, 1999
Silver dye bleach print (Ilfochrome),
37 x 68 1/2 (94 x 174)
Metro Pictures, New York, and the artist

Pink and Yellow and Black IV (Space Allotted),
from the series *On a Wall, On a Cow, In a Book,
In the Mail*, 1999
Catalogue page, 5 x 8 (12.7 x 20.3)
Metro Pictures, New York, and the artist

Pink and Yellow and Black V (1928–1987),
from the series *On a Wall, On a Cow, In a Book,
In the Mail*, 1999
Postcard, 4 x 6 (10.2 x 15.2)
Metro Pictures, New York, and the artist

RUTH LEITMAN
Alma, 1998
16mm film, color, sound; 94 minutes

ANNETTE LEMIEUX
Bob, from *Foot Play*, 1997
Wax and candle wick, 6 x 9 1/4 x 3 1/4
(15.2 x 23.5 x 8.3)
McKee Gallery, New York, and the artist

Break, from *Foot Play*, 1997
Plaster, wood, and rope, 4 1/2 x 4 1/2 x 24 1/2
(11.4 x 11.4 x 62.2)
McKee Gallery, New York, and the artist

Corner Piece, from *Foot Play*, 1997
Wax and paper, 25 1/2 x 9 x 10
(64.8 x 22.9 x 25.4)
Private collection

Duel, from *Foot Play*, 1997
Wax, bricks, and wood, 15 1/2 x 47 3/4 x 7 3/4
(39.4 x 121.3 x 19.7)
McKee Gallery, New York, and the artist

Halt, from *Foot Play*, 1997
Wax and bricks, 16 1/4 x 32 x 16
(41.3 x 81.3 x 40.6)
McKee Gallery, New York, and the artist

Kick the Ball, from *Foot Play*, 1997
Plaster and rubber ball, 16 x 13 1/4 x 4 1/2
(40.6 x 33.7 x 11.4)
McKee Gallery, New York, and the artist

Paintin', from *Foot Play*, 1997
Wax and paintbrush, 4 1/2 x 14 3/4 x 3 1/2
(11.4 x 37.5 x 8.9)
McKee Gallery, New York, and the artist

Ropewalk, from *Foot Play*, 1997
Hydrostone and rope, 6 1/2 x 159 x 4
(16.5 x 403.9 x 10.2)
McKee Gallery, New York, and the artist

Trip, from *Foot Play*, 1997
Hydrostone and bricks, 9 1/2 x 7 3/4 x 7 1/2
(24.1 x 19.7 x 19.1)
McKee Gallery, New York, and the artist

Waitin', from *Foot Play*, 1997
Wax, 6 1/2 x 11 x 11 (16.5 x 27.9 x 27.9)
McKee Gallery, New York, and the artist

LES LeVEQUE
2 Spellbound, 1999
Video, color and black-and-white, sound;
8 minutes

SHARON LOCKHART
*On Kawara: Whole and Parts, 1964–1965,
Museum of Contemporary Art, Tokyo,
January 24–April 5, 1998*, 1998
Four chromogenic color prints,
64 1/2 x 49 (163.8 x 124.5) each,
64 1/2 x 244 (163.8 x 619.8) overall
Albright-Knox Art Gallery, Buffalo, New York;
Sarah Norton Goodyear Fund

*Enrique Nava Enedina: Oaxaca Exhibit Hall,
National Museum of Anthropology, Mexico City*,
1999
Three chromogenic color prints,
49 x 61 1/2 (124.5 x 156.2) each,
49 x 217 1/2 (124.5 x 552.5) overall
Museum of Contemporary Art, San Diego;
Museum purchase, Contemporary
Collectors Fund

Teatro Amazonas, 1999
35mm film, color, sound; 40 minutes
Blum & Poe, Santa Monica, California

ANNE MAKEPEACE
Baby, It's You, 1998
16mm film, color, sound; 56 minutes

IÑIGO MANGLANO-OVALLE
Le Baiser/The Kiss, 1999
Video installation and projection,
CD audio recording, and mixed media,
dimensions variable
Max Protetch Gallery, New York,
and the artist

JOSEPH MARIONI
Blue Painting, 1997
Acrylic on linen, 24 x 22 (61 x 55.9)
Collection of Charlotte Jackson

Red Painting, 1999
Acrylic on linen, 60 x 48 (152.4 x 121.9)
Peter Blum Gallery, New York

White Painting, 1999
Acrylic on linen, 96 x 72 (243.8 x 182.9)
Collection of Jayne and Mark Murrel

JOSIAH McELHENY
An Historical Anecdote About Fashion, 1999
Blown-glass objects in glass and metal
case, text, drawing, and photograph,
dimensions variable
Henry Art Gallery, University of Washington,
Seattle; Kayla Skinner Fund and Henry
Contemporaries Acquisition Fund purchase;
courtesy Donald Young Gallery, Chicago

FRANCO MONDINI-RUIZ
Infinito Botanica NYC 2000, 2000
Mixed-media installation with performance,
dimensions variable
ArtPace, a Foundation for Contemporary
Art, San Antonio, Texas; Sandra Cisneros;
and the artist

ERROL MORRIS
Fast, Cheap & Out of Control, 1997
35mm film, color, sound; 82 minutes

MANDY MORRISON
Desperado, 1997
Video, color, sound; 4 minutes

VIK MUNIZ
The Raft of the Medusa, 1999, from the series
Pictures of Chocolate, 1997–present
Silver dye bleach print (Ilfochrome),
two parts, 90 x 120 (228.6 x 304.8) overall
Brent Sikkema Gallery, New York

SHIRIN NESHAT
Untitled, 2000
Video installation, dimensions variable
Commissioned by the Wexner Center for the
Arts at The Ohio State University through the
Wexner Center Residency Award program,
funded by the Wexner Center Foundation.
Additional support provided by a grant from
the National Endowment for the Arts;
courtesy Barbara Gladstone Gallery, New York
Director: Shirin Neshat; Concept: Shirin
Neshat and Shoja Y. Azari; Director of
photography: Ghasem Ebrahimian; Music and
sound design: Sussan Deyhim; Line producer:
Hamid Fardjad; Still photographer:
Larry Barns; Producer: Barbara Gladstone

NIC NICOSIA
Middletown, 1997
Video, black-and-white, sound; 15 minutes
P.P.O.W., New York, and Dunn and Brown
Contemporary, Dallas

PAUL PFEIFFER
The Pure Products Go Crazy, 1998
Digital video loop, DVD player, miniature
projector, and metal armature; image,
3 x 4 (7.6 x 10.2)
The Project, New York, and the artist

Fragment of a Crucifixion (After Francis Bacon),
1999
Digital video loop, DVD player, miniature
projector, and metal armature; image,
3 x 4 (7.6 x 10.2)
The Project, New York, and the artist

CARL POPE WITH **KAREN POPE**
Palimpsest, 1999
Video installation with sound and
light-reflective text, dimensions variable
Collection of the artist

WALID RA'AD
The Dead Weight of a Quarrel Hangs, 1999
Video, color, sound; 18 minutes

MARCOS RAMÍREZ ERRE
Stripes and Fence Forever (Homage to Jasper Johns),
1997
Corrugated sheet metal, welded mesh,
concrete, clay, and soil, approximately
96 x 108 x 168 (243.8 x 274.3 x 426.7)
Quint Contemporary Art, La Jolla, California,
and the artist

Democracia, 1999
Automotive paint, serigraph, and airbrush
on aluminum, three parts,
80 x 40 x 6 (203.2 x 101.6 x 15.2) each,
80 x 130 x 6 (203.2 x 330.2 x 15.2) overall
Quint Contemporary Art, La Jolla, California,
and the artist

JENNIFER REEDER
Nevermind, 1999
Video, color, sound; 18 minutes

LAURIE REID
Ruby Dew (Pink Melon Joy), 1998
Watercolor on paper, 192 x 240 (487.7 x 609.6)
Stephen Wirtz Gallery, San Francisco,
and the artist

KAY ROSEN
Banner Yet Wave, 1999–2000
Seven vinyl banners, dimensions variable
Collection of the artist

MICHAL ROVNER
Field 1, from *Overhanging*, 1999
Video, color and black-and-white, sound;
14 minutes
Collection of the artist

®™ARK
®™ark, 1997–present (*rtmark.com*)
Website

Bringing IT to YOU!, 1998
Video, color, sound; 11-minute excerpt

KATHERINE SHERWOOD
Facility of Speech, 1999
Mixed media on canvas, 108 x 84
(274.3 x 213.4)
Collection of Catherine Klaus Schear and
Richard Newman

Seeds of Thought, 1999
Mixed media on canvas, 108 x 84
(274.3 x 213.4)
Private collection

JOHN F. SIMON, JR.
Every Icon, 1997
(*www.numeral.com/everyicon.html*)
Internet project
Sandra Gering Gallery, New York,
and the artist

AL SOUZA
The Peaceful Kingdom, 1998
Puzzle pieces and glue on wood, 84 x 216
(213.4 x 548.6)
Moody Gallery, Houston; Quint Contemporary
Art, La Jolla, California; and the artist

DARCEY STEINKE
Blindspot, 1999
(*adaweb.walkerart.org/project/blindspot*)
Internet project commissioned by *äda 'web*;
Digital Arts Study Collection, Walker Art
Center, Minneapolis

ELISABETH SUBRIN
Shulie, 1997
Super-8 film transferred to video transferred
to 16mm film, color, sound; 37 minutes

CHRIS SULLIVAN
Consuming Spirits (Part 1), 1997–2000
16mm film transferred to video, color, sound;
40 minutes

SARAH SZE
Untitled, 2000
Mixed-media installation, dimensions
variable Marianne Boesky Gallery, New York,
and the artist

TRAN, T. KIM-TRANG
ocularis: Eye Surrogates, 1997
Video, color and black-and-white, sound;
21 minutes

ekleipsis, 1998
Video, color and black-and-white, sound;
23 minutes

RICHARD TUTTLE
"Rough Edges, 1", 1999
Acrylic on plywood, 16 x 16 x 1/2
(40.6 x 40.6 x 1.3)
Sperone Westwater, New York

"Rough Edges, 2", 1999
Acrylic on plywood, 16 x 16 x 1/2
(40.6 x 40.6 x 1.3)
Sperone Westwater, New York

"Rough Edges, 3", 1999
Acrylic on plywood, 16 x 16 x 1/2
(40.6 x 40.6 x 1.3)
Sperone Westwater, New York

"Rough Edges, 4", 1999
Acrylic on plywood, 16 x 16 x 1/2
(40.6 x 40.6 x 1.3)
Sperone Westwater, New York

"Rough Edges, 5", 1999
Acrylic on plywood, 16 x 16 x 1/2
(40.6 x 40.6 x 1.3)
Sperone Westwater, New York

AYANNA U'DONGO
Aborigitron: Affairs of the Hybrid Heart, 2000
Video, color and black-and-white, sound;
approximately 30 minutes

CHRIS VERENE
Untitled, 1999, from the *Camera Club* series,
1996–98
Chromogenic color print, 20 x 24 (50.8 x 61)
Collection of Deb and Rob Stone

Untitled, 1999, from the *Camera Club* series,
1996–98
Chromogenic color print, 20 x 24 (50.8 x 61)
Collection of Adair and Joe B. Massey

Untitled, 2000, from the *Camera Club* series,
1996–98
Chromogenic color print, 20 x 24 (50.8 x 61)
Vaknin Schwartz Gallery, Atlanta,
and the artist

Untitled, 2000, from the *Camera Club* series,
1996–98
Chromogenic color print, 24 x 20 (61 x 50.8)
Vaknin Schwartz Gallery, Atlanta,
and the artist

Untitled, 2000, from the *Camera Club* series,
1996–98
Chromogenic color print, 20 x 24 (50.8 x 61)
Vaknin Schwartz Gallery, Atlanta,
and the artist

Untitled, 2000, from the *Camera Club* series,
1996–98
Chromogenic color print, 20 x 24 (50.8 x 61)
Vaknin Schwartz Gallery, Atlanta,
and the artist

ANNETTE WEINTRAUB
Sampling Broadway, 1999
(*www.turbulence.org/Works/broadway/index.html*)
Internet project commissioned by Turbulence
with a grant from the Jerome Foundation,
and supported in part by a grant from
The City University of New York PSC-CUNY
Research Award Program
RealAudio narration: Bill Rice; Second voice:
Annie Shaver-Crandell; Sound mixing:
John Neilson; Photography assistant:
Reyna DiCiurcio

YVONNE WELBON
Living with Pride: Ruth Ellis @ 100, 1999
Video, color and black-and-white, sound;
60 minutes

KRZYSZTOF WODICZKO
Ægis: Equipment for a City of Strangers,
from the series *Immigrant Instruments*, 1999
Two augmented laptop computers, two LCD
screens, two loudspeakers, augmented speech
recognition software, aluminum structure,
electric engine, batteries, and plastic,
dimensions variable
Initial testing by Kelly Dobson, Interrogative
Design Group, Center for Advanced Visual
Studies, Massachusetts Institute of
Technology, Cambridge, and Brooklyn Model
Works, New York
Galerie Lelong, New York; Galerie Gabrielle
Maubrie, Paris; and the artist

YUKINORI YANAGI
Study for American Art—192 One Dollar Bills,
2000
Plexiglass, sand, and ants, 93 x 72
(236.2 x 182.9)
Collection of the artist

Study for American Art—Three Flags, 2000
Plexiglass, sand, and ants, 32 x 48
(81.3 x 121.9)
Collection of the artist

LISA YUSKAVAGE
True Blonde at Home, 1999
Oil on linen, 60 x 72 (152.4 x 182.9)
Private collection;
courtesy greengrassi, London

Day, 2000
Oil on linen, 77 x 62 (195.6 x 157.5)
Private collection; courtesy Marianne Boesky
Gallery, New York

Night, 2000
Oil on linen, 77 x 62 (195.6 x 157.5)
Private collection; courtesy Marianne Boesky
Gallery, New York

PHOTOGRAPH AND REPRODUCTION CREDITS

Nubar Alexanian: 164 (bottom); J.W. Burleson: 154; courtesy Claire S. Copley Gallery: 23 (bottom left); ©Paula Court: 23 (bottom right); Catherine Crouch ©1999: 216; D. James Dee: 79; Todd Eberle, courtesy Deitch Projects, New York: 51 (top; vb39.290.te.tiff); Brian Forrest, courtesy Angles Gallery, Santa Monica, California: 60; Claire Garoutte: 160; personal computer and future concept home computer powering *The American Century* Orientation Gallery DVD presentation courtesy of Intel Corporation, Santa Clara, California, and Desktop Architecture Labs, Hillsboro, Oregon: 127 (left); based on the painting *Three Flags* (1958) by Jasper Johns: 220; Armin Linke, courtesy Deitch Projects, New York: 51 (bottom; vb39.313.ali.tiff); photograph by Peter Moore: 23 (top left); courtesy the MORA Foundation, London: 204; Roy Porello, copyright Roman de Salvo, 1999: 87; David H. Ramsey: 123; Shelby Roberts: 71; Fred Scruton: 80; Art ©2000 Richard Serra/ Artists Rights Society (ARS), New York, photograph by Peter Moore: 21; advertising campaign ©TBWA/CHIAT DAY, New York, 1999: 127 (right); Nelson Tejada: 64; photograph of Whitney Museum of American Art, New York, by Jerry L. Thompson, digital mock-up by Terry Lopez: 187; Saverio Truglia: 63; based on *Cow Wallpaper* (1966) by Andy Warhol, as installed in *The American Century: Art & Culture 1900–2000, Part II* at the Whitney Museum of American Art, New York: 144; Graydon Wood: 116

As the curatorial team, we worked on this project as "outsiders." This means that most of the heavy lifting was done by Maxwell L. Anderson and the Whitney Museum staff under his direction. Foremost among them is the exceptionally competent and diplomatic Maura Heffner, administrator of the 2000 Biennial, and Anne Wehr, who, in her role as liaison *extraordinaire*, shepherded the many components of this catalogue on their frequent journeys between the authors and the Publications and New Media Department. They have had very able support (but not limited to) Alpesh Patel and Glenn Phillips, who worked on the film and video sections of the catalogue and exhibition. In addition, we would like to thank the many other individuals and departments at the Whitney Museum who have made this exhibition possible.

We are further indebted to the following individuals:
Todd Alden; Alejandro Anreus; Marilou Aquino; Elizabeth
Armstrong; Kenneth Aronson; J. Marie Autry; Craig Baldwin;
Andrea Barnwell; Nicholas Baume; Corinne Baynes-Cassel; Carol
Becker; Holly Block; Doreen Bolger; Francesco Bonami; Victoria
Espy Burns; Cornelia Butler; Annette Carlozzi; Steve Clark;
Rebecca Dimling Cochran; Susan Colegrove; Sabrina Craig;
Donna De Salvo; Jeffrey Deitch; Peter Doroshenko; Tom Eccles;
Okwui Enwezor; Laura Farbrother; Jennie Fleming; Lynda Forsha;
Dana Friis-Hansen; Sherry Geldin; Kathy Geritz; Susanne Ghez;
Kathy Goncharov; Alexander Gray; Dara Greenwald; Kathlene
Gusel; Andee Hales; Dan Hanford; Susan Harris; Auriea Harvey;
Karen Hellman; Lela Henkel; Lynn M. Herbert; Louis Hicks;
Rhona Hoffman; Sammy Hoi; Laura Hoptman; Kate Horsfield;
Anne Hubbel; Chrissie Iles; Karen Indeck; Chris Ingalls; Hitomi
Iwasaki; Anthony Jones; Milena Kalinovska; Toby Kamps;
Alexandra L.M. Keller; Jackie Lard; Brian Lau; Irina Leimbacher;
Alan Licht; Rick Lowe; Paula Massood; Susan Miller; John L.
Moore; Jana Napoli; Linda Pace; Jennifer Paluso; Cristobal Perez;
Steve Polta; Marla Price; Nancy Princenthal; Carrie Przybilla; John
Ravenal; James Rondeau; Jason Sanders; Ingrid Schaffner; Paul
Schullenberger; Andrea Scott; Steve Seid; Kay Shaw; Elizabeth
Smith; Gavin Smith; Kari Steeves; Chris Straayer; Terrie Sultan;
Brian Tate; Maria Troy; Tracy Tucker; Olga Viso; Stephen Vitiello;
Hamza Walker; Michael Zryd.

WHITNEY MUSEUM OF AMERICAN ART
OFFICERS AND TRUSTEES*

Leonard A. Lauder, *Chairman*

Joel S. Ehrenkranz, *President*

Emily Fisher Landau, *Vice Chairman*

Thomas H. Lee, *Vice Chairman*

Robert W. Wilson, *Vice Chairman*

Samuel J. Heyman, *Vice President*

Robert J. Hurst, *Vice President*

Joanne Leonhardt Cassullo, *Secretary*

Raymond J. McGuire, *Treasurer*

Maxwell L. Anderson, *Director*

Steven Ames

Michele Beyer

Murray H. Bring

Melva Bucksbaum

Joan Hardy Clark

Beth Rudin DeWoody

Fiona Donovan

Joseph C. Farina

Arthur Fleischer, Jr.

Aaron I. Fleischman

Anne Sutherland Fuchs

Henry Louis Gates, Jr.

Philip H. Geier, Jr.

Sondra Gilman Gonzalez-Falla

Ulrich Hartmann

J. Tomilson Hill

George S. Kaufman

Henry Kaufman

Raymond J. Learsy

John A. Levin

Faith G. Linden

Gilbert C. Maurer

Adriana Mnuchin

Diane Moss

Nancy Brown Negley

Brooke Garber Neidich

Brian O'Doherty

Allen Questrom

Fran W. Rosenfeld

Henry R. Silverman

Norah Sharpe Stone

Laurie Tisch Sussman

Flora Miller Biddle, *Honorary Trustee*

B.H. Friedman, *Honorary Trustee*

Susan Morse Hilles, *Honorary Trustee*

Michael H. Irving, *Honorary Trustee*

Roy R. Neuberger, *Honorary Trustee*

Thomas N. Armstrong III, *Director Emeritus*

Marvin G. Suchoff, *Assistant Treasurer*

Marilou Aquino, *Assistant Secretary*

*as of January 1, 2000

272 This exhibition and publication were organized by
Maxwell L. Anderson, Director, Whitney Museum of American Art,
New York; Michael Auping, Chief Curator, Modern Art Museum
of Fort Worth, Texas; Valerie Cassel, Director, Visiting Artists
Program, The School of The Art Institute of Chicago; Hugh M. Davies,
Director, Museum of Contemporary Art, San Diego; Jane Farver,
Director, List Visual Arts Center at MIT, Cambridge, Massachusetts;
Andrea Miller-Keller, independent curator based in Hartford,
Connecticut; Lawrence R. Rinder, Director, CCAC Institute, California
College of Arts and Crafts, San Francisco and Oakland

Maura Heffner, Biennial administrator; Anne Wehr, Biennial assistant;
Alpesh Patel, assistant; Glenn Phillips, assistant; Karen Hellman,
Lela Henkel, and Tracy Tucker, interns

This publication was produced by the Publications and New Media
Department at the Whitney Museum: Mary E. DelMonico,
Director, Publications and New Media; Nerissa Dominguez Vales,
Assistant Director; *Editorial*: Sheila Schwartz, Senior Editor;
Dale Tucker, Associate Editor; Susan Richmond, Production Editor;
Design: Makiko Ushiba, Senior Graphic Designer; Christine Knorr,
Graphic Designer; *Production*: Zack Nishimura, Production Assistant;
New Media: Michael Gee, Web Manager/New Media Designer;
Doris Chon, Assistant; *Rights and Reproductions*: Anita Duquette,
Manager, Rights and Reproductions; Jennifer Belt, Photographs
and Permissions Coordinator. Additional editorial assistance:
Hillery Hugg. Intern: R. David Mowry.

Texts on artists written by Todd Alden, Susan Harris,
Alexandra L.M. Keller, Paula Massood, Nancy Princenthal,
Ingrid Schaffner, and Andrea K. Scott.

Catalogue Design: J. Abbott Miller, Scott Devendorf, Roy Brooks,
Elizabeth Glickfeld, Pentagram
Printing: Dr. Cantz'sche Druckerei, Ostfildern, Germany
Color Separations: C+S Repro, Filderstadt, Germany
Binding: Buchbinderei Nething, Weilheim-Teck, Germany
Printed and bound in Germany

MAR 1 4 2001